University of Applied Sciences Basel FHBB

School of Art and Design Basel HGK

Department of Interior Design	Prof.Andreas Wenger	58
(No) Logo	Steffen Blunk	60
Interfaces	Matthias Gerber	62
Renderzone	Hans-Jörg Sauter	64
Follow me / Lighting	Oliver Betschart	65
Netz_Raum	Patrick Rothmund	66
Future Building	Steffen Blunk	67

University of Applied Sciences Basel FHBB

School of Art and Design Basel HGK

Department of Visual Communication	Prof.Michael Renner	69
Interacting Squares	Roman Schnyder	71
Drawing Machine	Roman Schnyder	72
Visual Programming	Roman Schnyder	74
Technical Flower	Roman Schnyder	76
Bildautomaten	Andres Wanner	78
move	Andres Wanner	80
Animation Machine	Dirk Koy	82
Light Object Generator	Dirk Koy	84
In search of time	Nathan Aebi	86
Interactive Landscapes	Thomas Bircher	88

University of Applied Sciences Basel FHBB

Department HyperWerk	Mischa Schaub	91
deif chair	Christian Schefer	93
don't beat – TALK!	Matt Inauen	94
Instant Gain in Grace	Dr.Irena Kulka	95
Draussen	Patrick Juchli	96
Betarhythmica	Anja Kaufmann	97
Enter Propaganda	Michael Huber	98
Mahlzeit	Marc Dietrich	99
JayWalker City Furniture	Daniel Pfister	100
SchappeLan	Hanspeter Portmann	101
FragWerk	Peter Olibet	102
winomat	Glenn Hürzeler	103
Adaptive Intranets?	Angie S.Born	104
Scribit	Matthias Käser	105
NETinfo	Armon Ruben	106
Dendron	Sam Sherbini	107
BarrioCom	Andreas Springer	108
V.O.N.S numériques	Anja Gilgen	109
dot:in	Benjamin Füglister	110
More than meets the eye		111

University of Applied Sciences Geneva HES-GE

School of Fine Arts ESBA

atelier zero1	Pedro Jimenez Morras	113
Call Me	Alex Muller Filippo Vanini	114
TinyTin	Alfred Orla Théo Quiriconi	117
Echo	Martina Loher Pascal Robert Fabian Stalder	120
Trauma Zone	Stephan Perrinjaquet	122
ONYX.0+33	Manuel Schmalstieg	125
My own rock and roll show	Benoit Guignat	131

University of Applied Sciences and Arts Zurich

School of Art and Design HGKZ

Department of New Media SNM	Prof.Giaco Schiesser	135
Noisaikk	Roland Roos Valentina Vuksic	137
Love Heroes	Felix Eggmann	140
Re:tour	Stefano Vannotti	142
Luxus4all.org	Mario Purkathofer	144
ASCII-art	Silvan Leuthold	146
Slave & Master	Anne-Lea Werlen Carmen Weisskopf Christoph Burgdorfer Cindy Aebischer Marco Klingmann Mascha Leummens Roger Wigger Thomas Comiotto Nico Dreher Andrea del Carmen Cruz Gonzales	148
MetaWorx	Mischa Schaub	157

Appendix: the seven courses of studies	167
Index of exhibits	174
Copyright, Imprint, Acknowledgement	176

Foreword

Prof. Dr. Georg Christoph Tholen
Head of the Department of Media Studies
at the University of Basel

The crucial questions of whether or not new media causes a far reaching change within society, culture and perception and whether it should therefore become the focus of artistic, design, and academic pursuits, have been of great central importance lately. According to the current state of academic research, it is agreed that this focus first became possible with the worldwide spread of the computer as a multimedia. The associated media competence, which is still most readily tied to the book culture, should, though not be replaced, but be complemented by a contemporary *media literacy*. Otherwise, it would not be possible to solve the societal tasks of technical and cultural intelligentsia, of which designers, artists as well as educators, city planners, and communication specialists are an integral part.

Due to the dynamics of digital technologies of information and communication, the recognition in the last two decades has grown that it is in no way sufficient to explore or modernize simply the respective forms and formats of the individual types of mass media (e.g. the telephone, film, radio, television, video, and the classic forms of print media). Even if the old values and technical abilities within the corresponding areas of media remain points of reference – which they should remain to be – the above mentioned multimedia aspects of computers evoke a fundamental reflection of the possibilities and limitations of mediated approaches to the world. Since the 80ies, theorists as well as practitioners have been encouraged to investigate not only the culture of media, but also the media of culture(s) [1], mainly for two reasons. First and foremost, it was the increasing commonness of multimedia in the life of television and computer kids. In addition, there has been the ever-growing telepresence of consumer strategies transmitted by the media.

1 Media are, according to a basic hypothesis in cultural studies, the productions as well as the very conditions of culture. *It is not only to be understood as (modern) technical media, but also historically and systematically as that which allows perception, sensation, and thought / cognition to find their characteristic forms and representations. Therefore, the medial form, the process of mediation, is a central aspect to all areas of cultural studies [...].* Hartmut Böhme / Klaus R. Scherpe (Eds.), *Literatur und Kulturwissenschaften. Positionen. Theorien. Modelle.* Reinbeck 1996, p. 17.

Association MetaWorx
Editor

Approaches to Interactivity

With a foreword by Prof.Dr.Georg Christoph Tholen
and an essay by '

metaworx

young swiss interactive

Birkhäuser – Publishers for Architecture
Basel · Boston · Berlin

Contents

Foreword Prof.Dr.Georg Christoph Tholen 4

Volatile Milieus — Vera Bühlmann 6
The Poetics of Interactivity

University of Applied Sciences Aargau FHA

Department of Design and Art Maria Stergiou 25

Findus Rachel Bühlmann 27

FlugiFlüg Stephan Haltiner 30
 Priska Ryffel

En passant Ursula Meyer-König 32
 Simone Vogel

_okay✓ Manou Vonwiller 36

voice-trans-it Philippe Lehmann 40

Lebensraum Michael Aschwanden 43

University of Applied Sciences Basel FHBB

School of Art and Design Basel HGK

Department of Visual Art / Media Art Reinhard Storz 47

Moveables Bruno Steiner 49

2Screens / l'étang noir Workshop 50

In Bed With Me Marc Mouci 52

Affective Cinema Jan Torpus 53

The Video Orchestra Silvia Bergmann 54
 Katja Loher and guests

When media, then, make revolutionary marks upon society, culture, and upon art, the all too familiar disclaimer that media is simply a neutral and innocent means of or tool for communication and art, remains unsatisfactory[2]. When we attempt to construe media as an extension or an amputation of man, to say nothing of the claim that media might corrupt the creativity of life, we misconstrue the very nature and meaning of media, we ignore its specific peculiarity (Eigensinnigkeit). When we depict media as an enforced disturbance or even as an enemy of pure sensuality, we fail to recognize that, with each new form of media, there are unrealized opportunities for humanization. The topography of media is not one of homeland but one of nomadism. Media interrupt pursuits of happiness (or render them ironic) which are at the same time also evoked by them – as, for example the illusion of an utopian, harmonic cyberspace very well illustrates.

Media provide various approaches to the world, by which we give reality to what exists. They are a means of framing and cutting reality, by providing us with a space to explore the possibilities of construction. At the same time, media function as dispositives of power that often hide not only their true objects, but also their gesture of hiding. Conversely, media themselves observe their own observations and at the same time they demonstrate how they observe. And yet, the inherent blindspot from which any observation operates, remains inaccessible. This is the main concern of present media theory, media art, and media design.

MetaWorx is the realization of an innovative project which is long overdue – not only in Swiss academic circles. It involves the display of experimental concepts of media oriented education and academic pursuits. MetaWorx is a heuristic password of the postmodern search, belonging within the context of concepts like cyberspace, virtuality, hybridity, intermediality, and, of course, interactivity[3]. These concepts are all still undefined and ambiguous, yet they nevertheless do possess political academic significance. MetaWorx reflects the previously mentioned multifacetedness and unrestricted openness of the digital media community. The projects and concepts exhibited here sound out the forms of collaborative work in education and research. Even a cursory look into the catalog reveals a first impression of the many creative endeavors on display in the MetaWorx exhibition. This panorama of creativity demonstrates just how important it is to work for the acceptance of interactive media work, and how crucial it is to achieve an open dialog between the participating academic institutions.

Moreover, the interaction between the involved institutions, investigating the intermedial options of the digital age, could become a model for a vibrant network which makes the transitional channels of exchange – that are always necessary for communication – a key concept for the dynamic form in which modern education can take place. It could be a model for diverse institutions of higher education. Only then could the situational experiments in media culture and science be subsumed under a common paradigm. MetaWorx accepts this challenge and displays it publicly – in an inspirational exhibit of art and design. It is a pilot project that gives a fresh impetus to future endeavors.

Translated by Iman Makeba Laversuch.

2 For more on the structural change of media culture see, among others, Georg Christoph Tholen, *Die Zäsur der Medien*. Frankfurt am Main 2002, as well as Sybille Krämer (Ed.) *Medien-Computer-Realität. Wirklichkeitsvorstellungen und Neue Medien*. Frankfurt am Main 1998.

3 Compare, among others, Peter Gendolla u.a. (Eds.), *Formen interaktiver Medienkunst*. Frankfurt am Main 2001.

When atoms are travelling
Straight down through empty
Space by their own weight,
At quite indeterminate times
And places, they swerve ever
So little from their course,
Just so much that you would
Call it a change of direction.
If it were not for this swerve,
Everything would fall down –
Wards through the abyss of
Space. No collision would take
Place and no impact of atom
On atom would be created.
Thus nature would never have
Created anything.
Lucretius

Volatile Milieus
The Poetics
of Interactivity
- -

Vera Bühlmann

Studies in English language and literature,
philosophy, and media studies at the University in
Zurich. Main fields of interest: semiotics and
cultural studies, with a special focus on
the cultural implications of complexity theory.

MetaWorx – Approaches to Interactivity

*Wir leben in einer logischen Dämmerung, irgendwo zwischen spät-
aristotelisch und frühkomplex, aber das neue Denken hat bislang
weder Autorität noch Kontur, weswegen wir bei all unseren theoreti-
schen Unternehmungen zu Unbehagen verurteilt sind, weil offenliegt,
wie sehr wir mit jedem Gedanken in antithetische Primitivismen ver-
strickt bleiben. Noch lässt eine Logik des Komplexen auf sich warten.*
Peter Sloterdijk[1]

MetaWorx, Approaches to Interactivity is a collection of explorations
into the field of interactivity, or more specifically, of digitally enhan-
ced interactivity. Interactivity is a key concept in new media dis-
course today, which is rooted in scientific investigations into the very
material complexity of our world. Complexity theory is an interdisci-
plinary approach to understanding dynamic processes involving the
interaction of many parties in a non-linear, recursive sense. Taking
all the projects contributing to MetaWorx as an inspiring collage, this
essay explores the questions and implications the topic of interactivi-
ty opens up in relation to this amazing interplay between complexity
theory and the realm of new media: in their meaning and opening
possibilities for a wide range of disciplines as visual communication,
interior design/architecture, media arts, fine arts and interaction
management. All of these parties are involved in MetaWorx 2003. The
argumentation in this essay will try to balance, contextualize and
inspire both the theoretical and the practical issues by discussing
some of the projects that are being presented in this book. Due to
the wide range of topics, styles and forms, it was not possible, quite
unfortunately, to address all of the exhibits dedicatedly, albeit they all
influenced this essay.

1 Peter Sloterdijk. *Tau von den Bermudas.* Edition Suhrkamp, 2001. p. 10.

A situational cartography

As such, this project is an essay in a very literal sense, that is, I am very much aware of the project's dizzying scope – for interactivity in the context of complexity, most basically speaking, is concerned with the emergence of the new, with the transformations of our world. With volatile milieus.

And yet – to accept and deal with our always already personally involved, participating stance, and in consequence, one's own limitations and vulnerability, is at the very heart of a provisional logic of complexity. Theoretical investigations of this sort, I believe, do have their legitimacy as situational cartographies, revealing the authors' stance of being in the midst of ongoing events, circumstances in which I find myself, amazed and wondering about the richness there is to be explored.

Drawing a situational cartography of contemporary research within this field of artistic investigation is one of the main concerns of Meta-Worx. The implications involved in the concept of interactivity within complexity theory are radical. In terms of complex and open systems, interactivity differs fundamentally from an understanding of mutually complementing roles that are thought of as dialectically securing the equilibrium of a system. Within a logic of complexity, there is an onto-genetic dimension to interactivity: open and complex systems allow for the new to emerge. Our own involvement in whatever we pay attention to has a bearing upon how things are becoming in the future. The concept of information is returned to its ancient literal meaning as being *informing,* beyond an understanding of information in terms of transportation and mediation of pre-existing contents.

Just such a concept of informative, complex communication is performed in the interactive video installation **Echo** by Martina Loher, Pascal Robert and Fabian Stalder, which is presented within this book. In their installation, they confront us with a TV screen, displaying a mountain landscape. Holding in in front of that screen, viewing and listening to what is being presented – a situation from which we are so much accustomed to being entertained in an unpersonal way – we might, after a while, start wondering about the slow and quiet happenings in front of us. We might indeed state our worries as to whether the installation might be put on hold right now to our accompanying friend – and then be surprised at once to receive our own worries returned to us as an echo from the distant mountain landscape on the screen. The installation **Echo** captures live what happens in a scenery somewhere in the mountains, into which by an invisible loudspeaker, the sounds emerging live from within the distant exhibited installation are being displayed. The instant involvement of the viewer, striving to make sense of the installation, is briefly delayed and oddly estranged through the different context, brought back to her as an **Echo**, via projection on the TV screen. This is not the usual one to many transportation of contents. Rather, audible responses to how the presented content of the TV screen is being received by the viewer immediately fold into that very content. **Echo** presents us a truly interactive and communicative process, where the receiving and the sending poles mutually inform one another.

The poetics of interactivity

The project of this cartography I refer to as a poetics. There is an essential immediacy to the poetic way of relating to the world, through which an instantly, newly experienced facet of the real is brought into existence by personally feeling addressed by whatever we encounter: the dancing windblows on my bear arms just now, while writing, soft, cool, tender, as if I was addressed myself by this announcement of an early evening summer storm. *La poésie ne s'impose pas, elle s'expose* the poet Paul Celan says. This affirmative gesture of exposing one-self is crucial for the stance of a cartographer, who fundamentally depends on being able to relate to what she encounters, out of a poetic awareness towards what cannot be fully understood, as her view within whatever she explores, can only ever be situational and partial. For my own exploration into the field of contemporary research on interactivity, it is therefore crucial to try different, coexisting ways of approaching the topics. I present these approaches in the manner of plateaus, situational sketches of my own exploration, each asking the eventscape wanderer, interested in interactivity and welcoming support in her orientation, for a participative, interactive approach themselves.

Interactive works ask for participation. The recipient is asked to play an active role, to contribute to a work's being. In this gesture, the interactive work remains essentially open, affirming the various facets within shared objectivity. It never addresses you in representation of a generality, but as an individual recipient, situating the work, through your way of relating, in your personal and singular context. And with that, the interactive work affirms pulsating vividness, fluctuating variations and ambiguities. It affirms processuality, collaboration, and involvement rather than distanced and detached observation, analysis, and objectification. With these characteristics, the interactive work is committed to repetition – yet repetition which in its very enacting brings about difference rather than sameness. Repetition in order to perceive difference. In order to sensitize your awareness, to broaden your spectrum of the familiar. Creative repetition.

Creative repetition

Re:tour, the diploma project by Stefano Vanotti, presented within this book, invites us to such far-leading moments of poetic return, of repetition. Supplied with one of Vanotti's maps, generated for you according to your personal preferences, you might set out to find your way around Zurich by way of published advertisements for which the predominant color might be lemon-green, for example. The map defines moments of encounter, according to which you are then asked to decide on the direction to take next, or when to cross a street: such events are arranged into algorithmic patterns, drawing your attentiveness to details that else might never cross your mind. Realizing the many-facetedness of our everyday surroundings, the various networks that coexist and add to our sense familiarity, soundscapes, colorscapes, streetscapes, house corner-scapes or plane tree-scapes, public telephone-scapes or indian restaurants-scapes, surprising moments can arise. By breaking down the complexity of the familiar into literally digital information units, **Re:tour** reveals how the richness of digitalization consists in the mutually enriching interplay between our analogue way of interacting, that is, of relating such estranged and discreet bits of information anew in our own way and context, and the digital ordering principle of the database.

This dynamic interplay between a concrete, phenomenal dimension and an abstract, formalized dimension allows the dimension of mediation, the meta-level of familiar reality, to continually transform. The movement implied in this interplay is metaphorical or diagrammatic: the poetic metaphor, just like the formal figure of the diagram, is not foremost concerned with representation but with the production of meaning. By providing several dimensions to be actively related to each other by the interpreter, metaphors as well as diagrams always already leap afar, in a hyperbolic, anterior mode. As a figure or model of thought they ask for a poetic way of thinking, interested in the nuances at play within the creative space of the in-between, between the most abstract and the most concrete.

Situational knowledge

To affirm the world in its manifold complexity directs our attention towards questions of growth and transformation. Everyday experiences of familiarity may at once be transformed through a different, mediated ordering principle. Whatever we recognize as objective givenness fundamentally depends on how we measure, on the assumptions from which we depart in our inquiry. Technology plays a crucial role in the crystallization of these assumptions – it has a

deep impact on how we make sense of our surrounding world. The predominant idea of networking today departs from the long assumed ordering principle of linear causality, on towards recursive causality, the core idea of cybernetic feedback. The long attempted recognition of initial causes, and the thus promised knowledge (and mastery) of eternal being, looses its relevance once we realize our own involvement in knowledge, which in consequence can only be partial. Assumptions of complexity, of networking, ask for an interactive theory of signification. In our way of interacting with information, we are always already involved in the pragmatic/evolutive (co)production of circumstances to come. What becomes significant to us depends on whether and how we can relate to it. Situational knowledge is how such an understanding of semiotic signification can be referred to (Haraway 2000). The semiotic theory of signification is essentially relational and dynamic: it goes beyond an understanding of signification as an ideally static representation of an object through the mediating sign. The semiotic sign involves the interpreter as a part of the initial signifying relation – meaning is the product of three irreducible interacting components: the sign, that which is being perceived as significant; the signified, that which the sign is interpreted as referring to; and the interpretant, for whom something is significant in the first place. We are always interactively partaking. Interpretation, involving such an understanding of the sign, consequently is processual, referred to as the process of semiosis, of ongoing interpretation. Meaning in a semiotic sense is not there for us to detect, but comes into being through every act of interpretation. Meaning is being (inter)actively produced, rather than autonomously existing in a world surrounding us. The milieus in which we live, are volatile. There is an ontogenetic dimension to interpretation: new facets of the real can come into being, familiarity is only provisional, processual, forever growing. The moment of growth is irreducibly tied to transitoriness: setting out in search of the new is not possible without leaving things behind.

Nomadic transitions

Such a nomadic sense of being, today, is not so much bound to packing your bags and travelling around the continents in a physical sense anymore. Explorations into the unknown can be undertaken in an intensive sense as well: telematic presence paradoxically brings near the most distant, as coexisting layers of different realms. As an expression of complexity itself. The Airstream trailers of the Meta-Worx exhibition 2003 are a tenderly nostalgic metaphor for digitally enhanced, or virtual explorations into the world. The fascination of virtuality lies in its enlivening relation to the realm of reality, to which it is not opposed but coexisting, as the virtual potential for future becomings, very much in the geological sense of an evolutive unfolding of reality. Similar to processual encrustenings of lava into dynamic landscapes of mountains, valleys, deserts et cetera, the most fami-

liar can be viewed as a material capable of undergoing intensive changes of state, phase transitions, surfacing as ever new expressions of virtual immanence – expressions that are experiential before they can be objectified. They can be experienced through nomadic explorations into the unknown, leading to intensive transitions within the familiar.

Awakening to such a nomadic sense of being from our own private and postmodern interiority, where we are almost drowning in telematic information overload, doubting everything at the same time, we might at once hear the birds sing in the magnolia bush blooming just outside our window. We might feel the warmth from our left toes (which happen to be exposed to the sun) rising through the entire foot and towards the knee. We might actually leave our room and step outside, at first just to reflect some more upon how things really are, how things could turn to the good, after all. Waiting at the pedestrian crossing for a gap in the daily traffic, we might notice the very peculiar substance the yellow stripes are painted with. It is not just the color that we have never seen before, it is something about the pavement too. With the cracks in it and the tar with which some of them have been filled. It is then that we might realize the curious look of the driver, who is kindly waiting to let us cross the street. Oddly feeling caught doing something that we shouldn't, we might smile apologetically at the woman in the lilac car. She might return our smile – again a surprise – without the slightest trace of impatience. A lilac car – what an odd color, we might think to ourselves. Did they always use to design cars like that?

Nomadic machine-making

It is in this explorative spirit that the collaborative project **Slave & Master. Recombinant Engine** presented in this book sets out to reconsider techno-junk, left-over moments of technology, in order to re-interpret outmoded "hardware handshakes" – as they refer to the (re)investigated hardware components. In a process of defamiliarization of technological functions, the project playfully seeks new ways of relating to the concept of the machinic. What would a machine be like, assembling and interconnecting various and distinct functions in a truly complex way? A machine that combines different master/slave relations without submitting them to one and final productive function? Such a machine would primarily be productive in the sense that it would allow the detection of poietic qualities, of unrealized potential for other ways of productivity within closed input-output circuits. Gilles Deleuze and Felix Guattari[2] have introduced the con-

2 A term coined by Gilles Deleuze and Felix Guattari. In: *Tausend Plateaus. Kapitalismus und Schizophrenie.* Merve Verlag 1992.

cept of thought as machine-making between the thinking subject and the object under reflection into the philosophical discourse, pointing precisely to the ever latent potential of relating differently, exploratively, to issues that we have assimilated into a coherent framework. Thinking about something means inter-connecting, interacting with the object of thought. In a literally productive, if not creative, sense. **Slave & Master** introduces us to such a moment of machine-making in the Deleuzian sense, a sense that is paradoxically productive with no need for the pre-definition of the final product.

Nomadic transitions in contemporary science

A similar awakening is also taking place in contemporary science, where an awareness is growing for a world which cannot be scrutinized and measured in accordance with the laws of classical science. While for so long, scientific investigations into the nature of our world have been preconcerned with static order, exploring the building blocks of matter at higher and higher energies, smaller and smaller scales, shorter and shorter periods of time, complex and irregular objects of everyday experience have not been understood at all. The world, which had been assumed to be essentially ordered and linear turns out to be highly complex and non-linear:

Now that science is looking, chaos seems to be everywhere. A rising columns of cigarette smoke breaks into wild swirls. A flag snaps back and forth in the wind. A dripping faucet goes from a steady pattern to a random one. Chaos appears in the behavior of weather just as in the behavior of cars clustering on an expressway.[3]

Opening itself up to questions of complexity, scientific interest is shifting from an epistemological hold on objectivity towards a productive responsibility of knowledge. The introduction of irreversible time into science led to an opening of systems under investigation to dis-equilibrium, to consider systems as open for flows of energy to enter in and out. By this, the number and type of possible historical outcomes increases greatly. Instead of one unique and simple form of stability, open systems allow for multiple coexisting forms of varying complexity, called "attractors". Areas where a system transits from one stable state to another are called "points of bifurcation", and the event of transformation is referred to as "phase transition", they can be initiated by minor fluctuations. Such open systems are characterized not only by dis-equilibrium, but also by strong mutual interactions among the components, by non-linearity. Bearing in mind the self-organizing open-endedness of complexity, non-linear interaction differs fundamentally from concepts of interactive systems as we

3 James Gleick. *Chaos.* Minerva Press 1997. p.5.

know them from closed, complementary systems, where interacting sub-systems such as master/slave, teacher/student, male/female et cetera are understood in their service of securing static social structures. While such a conception of interactivity is preconcerned with securing the equilibrium of a system, interactive processes in the context of complexity are genuinely open in their outcome. Interactivity so understood is preconcerned not with static structure, but with dynamic and adaptive stability, continually reestablishing itself.

Geological history I

Out of these developments, a new awareness for the role of historical processes has evolved. In terms of complexity, different historical stages can be seen as phase transitions rather than as dialectic developments of a linear process (Manuel de Landa 2002). To reconsider human history within non-linear terms fosters an understanding of co-existence and complex interactivity. Such an approximation of the material and cultural evolution sensitizes us to the far-reaching variability and creativity of our world:

We live in a world populated by structures – a complex mixture of geological, biological, social and linguistic constructions that are nothing but accumulations of materials shaped and hardened by history. Immersed as we are in this mixture, we cannot help but interact in a variety of ways with the other historical constructions that surround us, and in these interactions we generate novel combinations, some of which possess emergent properties. In turn, these synergistic combinations, whether of human origin or not, become the raw material for further mixtures. This is how the population of structures inhabiting our planet has acquired its rich variety, as the entry of novel materials into the mix triggers wild proliferations of new forms. [4]

Inquiring into the unknown complexity of our world, reconsidering familiar and everyday phenomena anew in an intensive sense, we encounter nomadic transitions everywhere. Our own involvement in evoking future circumstances to (be)come, through viewing causality not in distinctly linear terms of action-reaction progresses but in terms of action-action-action circuits, asks for a fundamental affirmative self-understanding: there is a great promise in assuming the open-endedness of situations we encounter. Our stance as interactive participants, as opposed to the long held stance of a detached objective observer is genuinely enlivening – entering the train from Basel to Zurich at 5 o'clock in the evening on a working day, looking out for a free place to sit, encountering a young man who occupies three seats for himself while stretching his legs and accumulating his bags beside him, we might be irritated by this seemingly arrogant gesture. When asking to free one seat, he might feel uneasy – perhaps because of his awareness of his own inappropriateness, or because he really feels bothered by our presence. A simple sympathizing smile, in any case, instead of reproachful looks on our part will tremendously relax the atmosphere of the next 60 minutes. What is important to me, here, is the open-mindedness towards potential outcomes of any situation. Even though we readily have different preconceived models about how to react available for almost any situation, there are always other possibilities. To interact is to focus on the very peculiarities of a situation, in this very moment just now, it is to focus on what makes a situation different from the general – on which cognitive models are always based. Interpreting situations in awareness of the power of interactivity to contribute to what is happening, instead of evaluating an objectively appropriate reaction to what seems to be happening independent of our own contribution, leaves us with a great freedom – the semiotic freedom of meaning in a prospective, instead of a retrospective sense.

Digital media and complexity

To scientifically approach questions of complexity, involving emergent phenomena and the open-endedness of the future, could not be achieved without computers. Emergent properties of large non-linear equation systems cannot be solved analytically, for they arise unpredictably out of the complex interactions among a phenomenon's components. Splitting up a contextual phenomenon into its constituents, and then attempting to model it by adding up the parts, will fail to capture any property that might emerge through time. In terms of complexity, the whole is more than the sum of its parts. However, with the help of digital media, we can gain insights into dynamic processes that would be impossible to model without the efficient support of digital computation. Through computer simulations, it is possible to discover new principles about the dynamics of complex and adaptive systems that would very likely not have been detected by standard mathematical techniques[5]. Computers very efficiently calculate with variables, and are thus sensitized to minor changes and varying initial conditions. This allows us to explore complex interactions by simulation and thus discover potentially emergent properties of any assumed model – just think of the legendary and completely unexpected detection of chaotic behavior within a simple differential equation by the meteorologist E. N. Lorenz in 1961, marking the moment of awakening of science to chaos.

4 Manuel de Landa. *A Thousand Years of Non-linear History.* Zone Books 2000. p. 25 / 26.

5 This is not intended to reduce the importance of *classical* mathematics. Likewise, important principles of complex dynamic systems have been discovered by means of non-numerical mathematics, to mention only a few: H. Poincaré, N. Rashevsky and A. Turing.

Digital media allow a complex image of the world to be investigated scientifically, and at the same time, they contribute to the increasingly shared relevance of such an image of the world to all of us – by rendering experiential what complex interactivity and open networking, with its characteristic emergent possibilities and perspectives, is all about.

Media-objects as cultural referents

New media not only allow us to differently investigate the world we live in, any form of media always also forms our cultural representation of the world. Any new media object – be it a web site, computer game, or digital image – represents, and also helps to construct, some outside referent: a physically existing object, historical information presented in other documents, a system of categories currently employed by a certain culture or by particular social groups. As cultural referents, new media objects represent/construct some features of physical reality at the expense of others, one worldview among many, one system of categories among numerous others. Specifically, the computer interface also functions as a cultural representation: by organizing data in particular ways, particular models of the world and of the human subject are being privileged. For instance, two predominant models today are a hierarchical file system (Microsoft Explorer, Macintosh Finder), and a flat, non-hierarchical or heterarchical network of hyperlinks (World Wide Web). These two models in fact represent the world in two fundamentally different ways. On the one hand, a hierarchical file system suggests that the world can be reduced to a logical and hierarchical order, where every object has a distinct and well defined place. The World Wide Web, on the other hand, assumes that every object has the same importance as every other object, and that everything is, or can be, connected to everything else. The new media are having a revolutionary and profound impact on the development of modern society and culture – today we are in the middle of a new media revolution (Manovich 2002): the shift of all culture to computer mediated forms of production, distribution and communication. Unlike the introduction of earlier novel technologies, the introduction of new media affects not only all stages of communication – including acquisition, manipulation, storage and distribution – but also all types of media – texts, still images, moving images, sound, and spatial and temporal constructions. All existing media are translated into numerical data composed of discrete entities, accessible through the computer. This is what the process of digitization refers to.

One implication of the digitization of all sorts of cultural objects is the predominantly consumerist and abstract stance of the user through the *offer-demand-click-being served* dynamics of the interface. It is such a misleading understanding of interactivity that the project **Moveables** by Bruno Steiger subverts: his project lives from a peculiar affinity to seismographic groping – the visitor to his website has no possibility to direct her own intention onto the screen by clicking. All action takes place according to how the visitor explores the site with the mouse cursor, whereby the coming into appearance and the (re)diffusion into blank space of simple drawn black figures and objects is initiated. **Moveables** are sketches drawn by hand, exploring the (potential) corporeal quality of animated digital space by affection. Never quite knowing where our actions may lead, we tenderly caress the strangely touching and seemingly out of place – a-placed – creatures while slowly becoming acquainted with their peculiar transformations and rhythms. One touch leads to another, drawn by our own undirected curiosity and the interrelations within this strange environment. Interactivity here is literally touching: not only are the sketches the product of close groping rather than form-imposing moments of looking, but our own exploration is similarly involved in a corporeal engagement, since we are unable to abstract any essentiality out of what happens. As Bruno Steiger says, welcoming the visitor to his site, the animated creatures in **Moveables** are grounded within their very insurmountable bodiliness, tenderly rooting ourselves in our own.

The digital database

A crucial implication of digitization is that data is stored in media databases: in the computer age of today, the database has come to function as a cultural form in its own right. It offers a particular model of the world and of human experience, and it affects how the user conceives the data it contains. Probably the most fundamental implication of this way of representing data – of modeling the world – is the introduction of variables into the process of interpretation. Working with databases, the information we find depends on the parameters we decide on. Database documentation reveals that minimal investigatory units do not exist as constants, but are constructed according to selected variables. Size, degree of detail, format, color, shape, interactive trajectory, trajectory through space, duration, rhythm, point of view, the presence or absence of particular characters, the development of plot – all of these factors are to be understood as variables according to which the user freely constructs and modifies her identified cultural object. Within such terms, any identification of a cultural object is not a precise representation but could also have been conceptualized slightly differently. This logic of the database evokes a semiotic understanding of signification, where meaning

always involves not only the representing sign and the represented object, but also the interpreting person. In any act of interpretation, when we identify something as significant, we apply certain variables we consider to be more or less important.

This is also the main concern of visual communication with regard to interactivity: to find ways of how situational and subtle nuances accompanying and contributing to every act of communication can enter communicational acts taking place across the digital interface. Interaction design explores the broad field around 'neutral' and 'objectified' communication. One such exploration is the project **Visual Programming** by Roman Schnyder. His search for a more playful and less formalized programming environment for designers, fosters the moment of explorative, unguided activity within the very process of development.

Another project concerned with how exploratory moments of communication can be fostered through interaction design is **Interactive Landscapes**, a project by Thomas Bircher (also presented in this book). Bircher emphasizes that within any interpretation of an image, there remains a peculiar materiality to what is to be interpreted, due to the spatial and chronological dimension the image lives in. By not providing the user with explicit buttons indicating the very spots where his interactive images are responsive, he challenges the user to consider precisely this complexity which any act of interpretation is ultimately folded into. The user is literally groping – yet not in the frightening dark, but through pleasurable, inviting landscapes.

Story-telling and the logic of the database

One of the most influential effects of new media culture is that the long privileged form of narrative as cultural expression is being accompanied or even replaced by a new logic of the database, of the archive (Manovich 2002). New media objects do not tell stories, they do not have a beginning and an end. They are stored in distinct units, without a thematic or formal development organizing the elements into a sequence. New media objects are computerized collections on which the user can perform various actions such as viewing, navigation, searching. As postmodernism reveals, the world no longer appears to us as an inclusively coherent and linear narrative, but as an endless and unstructured collection of images, texts, and other data records that can be explored and constructed in a variety of ways – just like in the internet, where a web page is a sequential list of separate elements, text blocks, images, digital video clips, linking to other pages. Web sites never have to be complete and inclusive. They

are meant to keep growing. New elements and links are added while others are replaced. Such an open structure contributes essentially to the development of non-linear logic, for which cybernetic principles known from scientific research into matters of complexity are a key reference. Indeed, the new ways of approaching and conceptualizing the world through computer technology can be understood as an experiential performance of complex principles as abstract as circular causality or as unforeseeable as points of bifurcation – they are introduced through slight changes in the variables fed into computational systems. Within computer operations, all processes or tasks are performed as productive interactions between structured behavior and varying database resources. Thus the computer, acting as a filter, performs how endless variations of elements can be produced, how input can be transformed to yield new output. In its sensitivity to variables, digitally enhanced interactivity can perform the creativity of iteration.

Explorable story-spaces

Contrasting a logic of the chronological narrative with a logic of the inherently pure spatial archive remains caught within the separation of time and space. One of the key insights from scientific investigations into matters of complexity is that the two realms of space and time cannot be separated from each other, but are to be thought of as interconnected in a continuous, topological understanding of space-time. It is only through the reconciliation of chronological way of storing information in narratives and the spatial way of storing information in databases that the cultural implications of this procedural and complex dimension of merged space-time can be explored. Interactive storytelling introduces space into the timely sequences of the narrative. This move allows for a fundamental change not only in narrative itself, but also in the seemingly static and objective database: in navigable spaces, the narrative turns into a set of enwrapped, multi-layered story-fragments which can be unfolded and related to each other in different and personal ways, eventually forming coherent narratives through the interactions of the navigating interpreter, while at the same time allowing for other possible ways of relating the story fragments into a whole. As a consequence, the database as a navigable space becomes dynamic and subjective. It is not dictated by external reference but by internal relationality, as explored in the movies and installations of Dziga Vertov or Peter Greenaway, for example. Amazingly, what is needed to explore such story-spaces is the intention to get engaged intensively with the story-fragments presented.

To explore these implications of databased storytelling are also the key concern for one of the exhibits within MetaWorx. In his CD-ROM based installation called **Enter Propaganda**, Michael Huber has

created an "architextural" environment where the viewer / user can physically explore documentary texts by mapping the encountered "textiles" – a term coined by Hanjo Berressem[6], representing text not as a static, woven texture but as a fluctuating, dynamic event that literally takes place everytime it is read, and thus includes the interpreter as an irreducible element of meaning in a semiotic sense – in an essentially personal way: depending on what the user / viewer pays attention to, the chronology of the meaningful interpretation as well as the internal, meaning constituting relations among the textiles will vary from person to person, from reading-event to reading-event. **Enter Propaganda** is concerned with making us aware of our own necessary involvement in every act of signification, leaving us as interpreters of factual states of affairs in a fundamentally responsible stance – not only retrospectively, but also, in an immediate sense, for the future to come.

Containing the outside

And this is the crucial question that the virtual continually poses to the real: How can the real expand itself? Elizabeth Grosz[7]

On our nomadic search for transitions within the database, in its figurative sense as the accumulation of the already encountered, the already familiar, we expect to find otherness, the unknown, not in some beyond outside, but in an intensive sense within the already known, the already familiar. A logic of complexity, with this sensitivity for situational variables, implies a semiotic, fundamentally interactive and processual way of orienting oneself. Here the Outside is conceived of as being contained, in an intensive, immanent sense, within the very realm of the known, of the familiar. The philosophical concept of virtuality in the tradition of Henri Bergson, Gilles Deleuze, Brian Massumi is concerned with this dimension of immanent potentiality, with the virtual multi-facetedness of the world. The virtual does not exist in the form of a (digital) database, where unrealized possibilities are stored. The virtual does not refer to distinct elements, but rather to how they can be related. Objects in a semiotic sense do not exist autonomously in a given form. Their meaning fundamentally depends on how the interpreter enters into relation to what she perceives as significant. The dimension of the virtual, we might say, refers to this realm of potential relationality. In a semiotic sense, meaningful objects are essentially relational – identity here is not defined according to primary, essential attributes, in any static sense. Identity in a semiotic sense is procedural in that it comes into being through relations,

relations between the interpreter and the materiality perceived by her as significant, between the signifying materiality and the according signified objectivity, and also between the interpreter's universe of known objectivity and her sense of curiosity towards the richness of the world. These complex interrelations feed back into the semiotic triad of the sign, they are mutually influential in their recursive feedback. Such a conceptualization of virtually contained potential otherness entails that knowledge itself is always situational.

Geological history II

A situational, semiotic understanding of knowledge, and a correspondingly dynamic (virtually enhanced, we might say) understanding of reality, can be very plastically visualized by approaching history in geological terms:

In terms of the nonlinear dynamics of our planet, the thin rocky crust on which we live and which we call our land and home is perhaps the earth's least important component. The crust is, indeed, a mere hardening within the greater system of underground lava flows which, organizing themselves into larger "conveyor belts" (convective cells), are the main factor in the genesis of the most salient and apparently durable structures of the crusty surface. Either directly, via volcanic activity, or indirectly, by forcing continental plates to collide, thereby creating the great folded mountain ranges, it is the self-organized activity of lava flows that is at the origin of many geological forms. If we consider that the oceanic crust on which the continents are embedded is constantly being created and destroyed (by solidification and re-melting) and that even continental crust is under constant erosion so that its materials are recycled into the ocean, the rocks and mountains that define the most stable and durable traits of our reality would merely represent a local slowing down of this flowing reality. It is almost as if every part of the mineral world could be defined simply by specifying its chemical composition and its speed of flow: very slow for rocks, faster for lava.[8]

Reality as an actualization from the dimension of virtuality can be viewed figuratively in terms of magma, encrustening into an enhardened surface, forming and reforming constantly, as an effect of immanent forces and constraints. Virtuality is not opposed to reality, but co-existant with it. Such an approach to reality implies a fundamental change in focus for our self-understanding as human beings. Our often articulated narcistic wound of acknowledging that the earth is not the center of the universe might only have been an introduction

6 Hanjo Berressem. *Folding Text (Hypertext)*. www.uni-koeln.de / phil-fak / englisch / berressem / docs / erfurt / deleuze.html

7 Elizabeth Grosz. *Architecture from the Outside. Essays on Virtual and Real Space.* MIT Press 2002. p. 90.

8 Manuel de Landa. *A Thousand Years of Non-linear History.* Zone Books 2000. p. 257 / 258.

into a self-relativizing direction. From this direction it seems to follow, that our predominant orientation and interest in what is explicitly and objectively comprehensible to us, what has already crystallized into a familiar form which we can reproduce, might better be broadened towards a system much more inclusive and in fact self-organizing and open-ended. A system of which we as human beings are merely a part. Questions of complexity suggest that this is what we need to better understand – and the concept of interactivity is core to such an understanding of human reality as a 'material' capable of undergoing continuous transformations.

The project **Lebensraum (Living Space)** by Michael Aschwanden (presented in this book) is concerned with this transitoriness. Seeking a figurative illustration for the volatile nature of our living spaces, Aschwanden turns to sound and water. The interface of his installation is a stone – a rather stable frame of reference for us to orient ourselves – and yet, the stone within the stream of water is swept further and further. Or it may come to sediment at one place or an other, but in any case, it is constantly being formed by where it passes through. Is water our first resource? he asks. Water, which is constantly circulating, while paradoxically seeming to stand still in its flowing. You can never enter the same situation twice, when stepping into a river at one and the same spot repeatedly. The flowing river as an image of passing time has a long philosophical tradition, revealing at the same time the changing intensities and speeds of timely continuity. **Lebensraum** draws attention to this liveliness by capturing and relating the different sounds of water – slow drippings from a mountain spring, or roaring and raging rivers just a little further down the stream. In this installation we are invited to dive into audible and visible moments of transforming reality.

Expressive communication

The world does not exist outside of its expressions. Gilles Deleuze

Such a philosophy of virtual immanence, of internal magma flows of pure potentiality for an open future, where objects, the concrete form our world has taken in that very moment are mere crustings of cooled down matter, implies that the world does not exist outside of its expressions. The new crustings into reality, the newly formed manifestations of life are best viewed as expressive events, as reality in the continual process of forming. What has traditionally appeared as a one-way determination of expressive form by the expressed content, reappears as a mutually formative polarity: the causal relation between form and content is complex. Translating this figure of thought from the realm of material genesis into the realm of commu-

nication, we can see that it is less that the subject willfully expresses her content, than that both subject and object are being spoken, by discourse – discourse as an anonymous murmur, as Michel Foucault has elaborated on. Expression is not guided by a self-governing, reflective individual who composes voluntarily bits of information into specific, merely decorative forms. Rather, expressed content is coming into being simultaneously while being expressed. Just like a certain landscape has not pre-existed as an essential form within the undifferentiated flows of magma. Content is not molded into an expressive form, it comes into being while finding a form. The process of forming, then, can be viewed as an expressive event.

Expressive events

I am speaking of an event, because as an event, expression is autonomous. It is prior both to subjectivity and to objectivity: as an essentially qualitative transformation, it is by nature imperceptible, always passing *between* perceptual encounters. The expressive event, as I will sketch it here, is the initial moment of the signifying process, the moment in which something becomes significant to somebody, yet still unmediated, still uninterpreted and without position in relation to a concrete objectivity. The semiotic theory of signs, following the tradition initiated by Charles S. Peirce, essentially departs from the assumption that there is an extra-linguistic force involved in the process of signification: there is a material pole in the semiotic triad, besides the referred to world of objectivity and the interpreting mind. The event of expression is a dynamical, transformative moment, where the interpretant is struck by a force, and is physically transformed by it. The person, once struck, becomes attentive to what is touching her, striving to make sense of it, to interpret what has suddenly become significant. The immediate effect of the force involved in the event of expression strikes the body directly and without mediation – *It passes transformatively through the flesh before being instantiated in subject-positions subsumed by a system of power,* as Brian Massumi explains.[9]

In his interactive video installation **Affective Cinema** (presented within this book), Jan Torpus seeks such an 'expressive eventfulness' of cinematic experience. His narrative is displayed according to the viewer's affective response: immediate and yet unconscious bodily reactions to viewing a film are being measured by means of galvanic skin response. These responses then influence the order and rhythm of the video, as well as the images and sounds that are displayed. There is a spatial dimension to the movie, as there are

9 Brian Massumi. *"Like a Thought"*. In: Massumi (Ed.) *A Shock to Thought. Expressions after Deleuze and Guattari.* Routledge 2002. p.17.

several entrance points and different dimensions the viewer might be able to access. Yet in **Affective Cinema**, access is not provided by specific skills like in a game environment, but by a more differentiated awareness and sensitized affective response to the images: *The narrative situation looks funny or somehow strange on the lowest levels but the entire significance can only be discovered by getting emotionally involved. Like in the real world, much can get lost in our closest neighborhood without us noticing it,* explains Jan Torpus in formulating the importance of our unconscious decision-making in our everyday lives.

In its autonomy, the expressive event is in fact only dynamic potential. The content, what is being signified, comes into existence, emerges out of this state of potentiality. In this sense, expression is anything but subjective, personal. It is autonomous, there is no way to own it, to master or control it. There is an autonomy to discourse, discourse as an anonymous murmur in which we are ever already immersed: *The subject, its embodiment, the meanings and objects it might own, the institutions that come to govern them, these are all conduits through which a movement of expression streams. Expression adopts them for its temporary forms and substances, towards its own furtherance, in ongoing self-redefinition* [10]. The expressive event, initial to any process of signification, contains a potential relay to a third: even as expression settles into a particular articulation, it is already extending to reach a subsequent articulation, constantly asking for re-interpretation. Expression as an event is always, already in its very beginning, shedding itself while being interpreted and can never be entirely assimilated, for we are always immersed within that anonymously murmuring discourse, speaking (through) us.

In her contribution to MetaWorx, Irena Kulka is interested in this initial expressive eventuality, which potentially carries interpretation further and further in creative sense. **An Instant Gain In Grace** is an interactive installation for dance performances, where the improvising dancer is surrounded by a cloud of de-contextualized, automatically interpreted, animated visual images of her own dance movements. These images confront the dancer with the limits of her own repertoire of expressive codes, and thus, with the limits of her creative expression. However, out of the awareness and confrontation with her own limits, the dancer, Irena Kulka believes, might accept the confrontation as an invitation – namely an invitation to interact with herself in the very moment of creative improvisation, as she repeatedly attends to herself from an estranged perspective. By re-interpreting her own expressions, the dancer might be able to

expand the structure which allows for expression in the first place, but which in its rigidity at the same time also hinders a potential more from coming into being – and this, for Irena Kulka as an artist, is her main interest.

The singularity of statements

Expressive events, semiotic expression, is concerned with the singular. Singular is what is not a member of a class, nor a particular instance of an existing type – singularity is an occurrence. There is always an element of chance, or accident, something which cannot be grouped or classified, something that is eventually discarded as insignificant within the process of interpretation. Yet it is precisely this asignified fall-out that makes an occurrence an event. As a whole, unassimilatable, an event is a singularity. It is a self-defining field, which is not reducible to anything within the logic of resemblance, not reducible to the general.

There is a formal dimension of language which operates within the realm of singularity – the statement. Within a statement, everything counts, including the blanks and the gaps. Distinguishably, phrases function dialectically in that they can complement or contradict each other, as they refer to a common context (e.g.: this sweatshirt you are wearing is blue. No, the sweater I am wearing is gray). Also different from statements, propositions function within a vertical hierarchy, based on abstract underlying axioms (e.g.: at night it is dark outside. It is dark outside now – therefore it must be night). The statement depends on the very situation it is being uttered in, on the situation's eventful singularity: I am speaking, here and now. This place of a subject uttering a statement cannot be occupied by somebody else. As soon as the same statement is said by another person, or even if it is repeated by myself at some later time, the meaning is changed. A wonderful illustration of this function of statements is a project by Simon Lamunière, **Hello, I Love You** (1992 – 1994) [11] where a number of people are video-documented while addressing the viewer with the statement *hello, I love you* (uttered in the respective mother tongue). There is an autonomy to the statement, a statement can persist through time, it can be repeated – yet always in a productive, creative sense as we know from iteration in the field of complex mathematics, where different variables are fed into a complex computational procedure and thus bring about unpredictable outcomes with every repetition. Repetition that is not a re-presenting of the same, but a bringing about of the different. Just as in a computational procedure, there are inherent variables within a statement. These variants ground a statement in a singular context, in the precise situation of utterance. The position of the speaking subject is such a variable as the same statement can be uttered by different persons. Then, the discursive object of a statement is a variable – love, for all the different

10 Brian Massumi. *"Like a Thought."* In: Massumi (Ed.) *A Shock to Thought. Expressions after Deleuze and Guattari.* Routledge 2002. p.21.

11 Simon Lamunière: www.newmedia-arts.org1/cgi-bin/show"oeu.asp?ID=00002230&lg=GBR

persons in Lamunières video installation probably refers to a slightly different concept, just as the statement's intention can be regarded as a variable, et cetera. Statements are multiplicities; they do not form a set or fixed structure or system in themselves. According to how the variables are occupied, the meaning of a statement changes drastically.

This is also what the StatementStation presented within the context of MetaWorx is concerned with: the authenticity of statements resulting from the immanent and singular quality of a statement as an expressive event. In one of the exhibition trailers, a system is being installed with the purpose of allowing the visitors of the exhibition to document their personal, video based statements which can then be contributed to asynchronous virtual 'discussion groups'. Yet such discussion groups are very peculiar, as an unusual intensity can be achieved by merely accumulating these statements while still preserving their singular contexts. It will be left to the audience to relate the statements to each other; the explicit mediation work is delegated to the viewer. Such intensive discussions, then, can be viewed as expressive events, involving the active participation of the interpreter in the process of signification in a semiotic sense.

Statements and expressive events

Statements, just like expressions, both have an autonomy of their own. They are, in a sense, pre-personal and pre-objective. This is – paradoxically – where their peculiar authenticity derives from. However, this paradox is only superficial, for the identity of the speaking/expressing subject can also be understood as a singularity. The fact that we all identify ourselves with our proper names beautifully illustrates this point: there is no inclusive number of attributes which could precisely describe and define whom a proper name refers to. Gabriel Cyrill Rosenberg, for example, in his singularity can never be subsumed under a certain generality. Any characterization we can give of him, or even any image of himself that he may have, will necessarily fail to grasp entirely who he is. It may be this infinitely elusive deeply personal dimension of the self which is involved in the utterance of statements, or in the moment of immediate expression. It is in this sense that the singular, the statement, the expressive event, are a-signifying. Or rather, they are prior to signification, and will eventually be ascribed meaning through the process of coping, of interpretation. But there will always remain a 'surplus potential', a fluctuating, maybe irritating because inassimilable dimension to every interpretation – a dimension of noise, so to speak, which secures the perpetual process of creative semiosis.

An ontology of becoming: creative semiosis

Thus, because of this persisting inassimilable dimension, one can say that there is an absurdity to the singular, the statement or the expressive event. This absurdity is not because an excess of signification is produced as in postmodern notions of the multiple, but because what they contain is an excess, a potential for future expressive emergence. They are multiplicities, preceding and nourishing multiple interpretations, significations. As it happens, the exemplary singular does not mean anything, it only expresses an event, which as a whole is incomprehensible, unpersonal and pre-objective. The absurdity of expressive events consists of its ontogenetic, unrealized potential wrapped in *this* event, the event as it happens, in its forceful intensity of a potential adding to reality – it is the absurdity of the excluded middle, of the evasive in-between.

The expressive event is a process, and by nature a process is relational. Therein lies the link between expressive events and topology – as topological space is essentially relational space. The expressive event is effective, but lacks content. It is in that sense that expressive events can never be communicative in any non-complex understanding. Rather they are transformative: our brains are kept within a creative uncertainty and thus allow for turbulence within the familiar, within the known. While being involved in expressive events, we are in a state of shock. For Deleuze and Guattari, this is thought – to harbor and convey unknown forces. Habit is the body's defense against such shocks of expressions. Habit recognizes every arriving perception in terms of familiarity, as being like something, something similar to what was experienced earlier, always departing form generalized categories. But before perception reaches the level where it can be experienced as memory, thought, or sensation consciously belonging to the life of an organism as a whole, it has already belonged to it, partially and non-consciously in a first moment of corporeal shock. Thought in its ontogenetic sense, that is, not in its traditionally supreme operation of making choices, but in harboring and conveying forces, is in fact felt at first, during the expressive event. There is no mastery involved here, on the contrary: *the brain is a subjectless subjectivity, an own event,* as Massumi writes.[12] Thinking in this sense involves submitting to the expressive event, consenting to participate in it, letting a transformative movement pass through it. Thinking's great capacity here becomes to deform, to view things differently, with different intensity. It is in this sense, that thinking can literally be creative.

12 Brian Massumi. *"Like a Thought."* In: Brian Massumi (Ed.) *A Shock to Thought. Expressions after Deleuze and Guattari.* Routledge 2002. p. 27.

Towards an expressionist ethics

Expressive potential, in manifesting itself in particular / singular events which we interpret, takes on a form, a body. Expression is not concerned with communication as the transportation of information but with the genesis of the definite, of the real. What emerges in expressive events does not mirror or conform to anything outside of itself. Formation and form, the emerging and the emerged, belong to different modes of reality: to the virtual and the actual. Such an understanding of expression accepts the reality of the potential (virtual) from which determinate being arises. Potential allows for an always-more in this very same reality. The event is an expression of potential. And with regard to this ontogenetic function, a theory of expression subsumes, similar to the semiotic theory of Charles Sanders Peirce, all three fundamental areas involved in the process of signification, of making (sense of) the world: aesthetics, ethics, and logic. This opens up a pragmatic question of responsibility, since being involved in expressive events (as we all constantly, inevitably are) means that in our way of interpretation we actually and actively contribute to what emerges out of the expressive event. Where expression stretches, potential determinably emerges as something new. So in fact, there is an ethics of expression. Just as for Peirce, besides the aesthetic and the logic element, there is an ethical element involved in the process of signification. In our way of making sense of the world, we are co-creative. Instead of discussing the appropriate axiomatics for absolute responsibility, we should all become aware of our partial responsibility for how we interact within such an ethics of emergence. The process of interpretation, the process of semiosis, is literally creative.

Event space

The notion of the event is central also in contemporary tendencies within the field of architecture and interior design. As soon as we depart from a semiotic, transformative understanding of objectivity, empty space in its function as a passive container where objects are merely being placed and moved – the notion of space as it has long been understood – must be reconsidered in terms of activity. Events are taking place in a time-space continuum, and transformations within the objective world can only be explained with regard to such a dimension of continuity, where identity depends on dynamic relations rather than on static essentiality. We are speaking of events rather than of objects in order to highlight their procedural nature – to which a time-space continuity is crucial – as opposed to the states of objects, devoid of time and independently existing within space. The contributions of IN3 to MetaWorx explore what it could mean to conceptualize space in terms of activity. With his installation (No) Logo. Install Yourself! Steffen Blunk asks the visitor who enters a room to constantly remember that the same room could well have been conceptualized completely differently. He welcomes the visitor by evoking the illusion of entering the room in its initial emptiness, by translating this state from the reality of three dimensions into a graphical, two dimensional projection spanning across room-high crosswalls, revealing a consistent image only from the position of the entrance point. Thus, no matter how the room actually presents itself, at different times in different contexts – the visitor is always, before he can orient himself within the actual site, confronted with the numerous latent possibilities that could be realized through his own interaction with the room. As the title (No) Logo suggests: nothing is self-evident or absolutely necessary. Install Yourself is an invitation to participate, the core idea of interactivity.

Virtual space

A dynamic understanding of space implies the immanent, virtual potential within the three dimensional, static space of reality. As the installation (No) Logo. Install Yourself! performs, virtual potential does not refer to a static database of possibilities. The future forms provided for by the notion of virtual potentiality will emerge through interaction with that potential, through a re-iterative, creative beginning anew, continually recalling the openness of becoming. Depending on our interpretation of an event, a situation can manifest itself in our perceived reality in different ways. To put it quite provocatively: the (future) objectivity of the world continually comes into being through how we relate to happening events. There is a mathematical and geometrical theory exploring the world in these terms to which I refer as *topology*, while being well aware that this reduction is imprecise to a certain degree. Yet the scale on which I am interested in these sciences is their common concern with such an active, processual conceptualization of space as an alternative to the traditionally static, Euclidean space of three dimensionality. Topology departs from a dynamic space-time continuity, and investigates processes not in terms of linear causality, but in terms of complex and creative interrelations. The topological conception of space involves pure relationality: identity here depends on the very locality of a singularity (singularity is the topological term to refer to objects). The form an identified singularity takes in any given moment (within the ongoing process) is due to the proximity relations one singularity maintains to other singularities in that moment of investigation – a triangular form can thus literally be identical to a rectangular form in topological terms. A singularity can never be visualized by us in

familiar terms in its entirety – due to their procedural nature, they are events much more than identities. Event is also the term used within topology to refer to processes of transformations, which is, broadly speaking, their object of investigation. In an abstracting gesture, it can be said that topological space is space of pure potentiality. As such, it cannot be visualized by us, and is therefore bound to remain abstract.

Topology and digital space

Abstract space of pure potentiality – one concrete way of approaching such an understanding of space is provided by the digital space. Like topologically conceived space, digital space is essentially dynamic and continuous. There is no entity referring to digital space – the reality of it comes into being (is being actualized from the virtual where is has existed as potentiality) in the very moment a new form, a new web site, for example, is being uploaded. There is no empty web-space pre-existing the appearance of the site, and yet, infinite web-space is potentially existing. The comparison of topology to digital space is indeed very revealing: in their abstractness, they both refer to nothing particular in its concreteness, but only to an immanent potential. In this way, they are both concerned with the dimension of virtuality, of open futurity. Thus, virtuality is not contained in the digital code, but lies in the topological characteristics of digital spatiality – the very surroundings where digital encoding and analog reception can take place.

The extraordinary potential of new media to approach the virtual lies in its peculiar characteristic as meta-media: in that new media combine various traditionally distinct media into one, digital media allow for an increase in image and sound content alongside text. Through this synesthetic quality, digital media offer more opportunities for resonance and interference in thought, sensation, and perception. The link between digital media and virtuality consists in the digital system of possibility and its potentializing effects for analogic pursuit of the virtual – *seeds of screened potential sown in non-silicon soil,* as Brian Massumi has expressed this interrelation between the virtual, the digital and the analog.[13] Virtual openness of digital media consists in the interactive openness of analog reception, where we intensify, while we create resonances and interference patterns that move through the digitally distinct appearances/images/interfaces.

Digitally enhanced architecture

In their conception of a dynamic, relational time-space continuum, topological mathematics and geometry allow us to approach the world in its basic condition of evolutive transformation and ongoing process. It is very interesting that these concerns are most vividly explored within the field of contemporary architecture – much more than in the broad discourse on new media culture, which in its focusing on virtuality as the dimension of simulation and duplication of the real, with all the therein contained cultural (and postmodern) problematic implications, fundamentally remains bound within pre-complex thinking centered on the non-creative representation of static factuality. It might be precisely because of architecture's self-understanding as being literally creative before being representational, which allows this discipline to investigate the radical implications of a dynamic understanding of objectivity more easily.

While architecture has been largely constrained by conventional models of Euclidean geometry and Cartesian philosophy until now, architectural practice is provided with new possibilities for visualizing and processing their calculations in its encounter with new media technologies: *to develop a critical, experimental practice aided by contemporary design software, architects must first rethink their approach to design based on time, topology, and parameters,* Greg Lynn explains.[14] This implies, in fact, a challenge for architecture towards the process of becoming, where structures function more as dynamic multiplicities than as static totalities, where they continually form in the context of a fluid, mutable media. It then becomes possible to anticipate architectural form in its animated and dynamic life – that is, not so much in resistance to forces such as gravity, but rather in interaction with outside forces. While previously, the underlying paradigms and technologies were of a fundamental formal stasis, digital technologies allow for the new paradigm of stability. Stability cannot, as it would in any non-complex conception of gravity, rely on stasis. Rather, in a more complex conception, it is mutual attraction through which motion is generated, and stability is maintained through the ordering of motion into rhythmic phases. While motion is eliminated at the start of striving for stability in cultural diagrams of stasis, motion is viewed as an ordering principle in a more complex understanding of gravity which respects time as an irreducible factor. It is only in such terms that sequential continuity, the complex interplay among more than two variables interacting with each other – the key problem which has been the impetus for contemporary scientific approaches to complexity – can be calculated. Issues of force, motion, and time, all of which have perennially eluded architectural description due to their vague essence,[15] can now be experimented with by supplanting the traditional tools of exactitude and stasis with tools of gradients, flexible envelopes, temporal flows, and forces.

14 Greg Lynn: www.walkerart.org/salons/shockoftheview/space/sv_space_r.html
15 Greg Lynn. *Animate Forms.* Princeton Architectural Press 1999. p.16/17.

13 Brian Massumi. *Parables of the Virtual.* Duke University Press 2002. p.141.

Animate space

The relevance of topology for architecture lies in its claim to the continuity, the relationality among all things. Architecture is thus challenged to think of buildings within an ecological scope – this means, that environmental forces are to be integrated into the search for the possible forms a building could take. The Cartesian space of neutral equilibrium can be rethought of in terms of a more active space of motion and flow by diagrammatic recourse to the topological time-space continuum. By paying respect to gradient forces of decay, wave behavior, attraction, density, for example, the registration of force on form is no longer thought of as a deformation of the pure. Deformation instead is understood here as a system of regulation and order that proceeds through the integration and resolution of multiple interacting forces and fields, allowing for the study of rhythms, movements, pulses and flows and their effects on form – animate space pursues movements, not moments. Topological mathematics and geometry allow us to approach the world in its basic condition of evolutive transformation and ongoing process. However, in order to visualize topological calculations, we must depend on their translation into familiar, Euclidean space. This undulating interrelation between topological and Euclidean spatiality can be visualized by thinking of Cartesian spatiality in terms of manifested, encrusted landscapes: landscape surfaces such as hills and valleys are our epitome for stability, even though they are mobile and continually transforming. Their activity is due to internal material motion rather than to the effect of distinct outside forces. To understand the dynamics of landscape, we need to relate its manifestations to immanent tensions and lava flows, perpetually manifest on the surface.

The landscape metaphor

It is surely no coincidence that as soon as we try to conceive of different phenomena in their complex interrelations among each other and to us as interacting participators, we adopt the metaphor of a landscape. In the respective contexts of music, interior design, and architecture, for example, we speak of soundscapes, cityscapes, lightscapes, colorscapes, et cetera. In her project **Betarhythmica – Loop Fiction & Sample Remix** Anja Kaufmann has created a sound environment in what I am tempted to call the gesture of topological *infotecture*. In her internet installation she collects audible fragments of everyday life, a-placed bits and pieces of situational recordings, each representing a singular moment in space and time. These pieces are stored in an open database, from which the visitor can choose and then place within the actual soundscape – a 3D area where the sounds take on the form of objects, interacting with each other through mutual resonance. A certain sound-object is audible only with respect to its proximity or distance to other soundobjects,

in resonance to which it will be perceived. The visitor can draw her object within this environment, exploring where it might sound pleasant; and the objects, without fusing into one, come to share a common skin, outline, and will part again, attracted by another sound-object, each always remaining singular and identical in a topological sense while nevertheless undergoing transformations, continually in the process of forming through interactions. Anyone visiting **Betarhythmica** will interact within one and the same soundscape – thus, it is not only the resonating sounds that interact, but also the visitors, who necessarily enter into relation to each other. Dance together, or play hide and seek, Anja Kaufmann invites the visitor. **Rendez-Vous** was her former working title. **Loop fiction & Sample Remix** – yet never in the manner of purely libidinal flows. Orientation can be gained through relating to an abstract dimension. The visitor is a cartographer, creating her own evolving soundstory.

Affirming adaptation in architectural practice

For architectural practice, this recourse to topological continuity means exploring its own potential for affirming adaptation. While architecture has so long been preoccupied with designing and creating buildings that last for centuries, persisting through all sorts of changes, it is now being challenged to search for new forms, for adaptive forms of expression. Within this exhibition, there are two projects which investigate in this direction.

JayWalker by Daniel Pfister presents a prototype of a mobile living space, to which he insightfully refers as 'city furniture'. Thinking of all the potential living spaces that lie fallow due to specific plans for the (not always near) future within Swiss cities, while at the same time affordable living space is very rare, his core question is how this space could temporarily and yet affordably be appropriated to meet that these problems, while at the same time following the principles of sustainability. A project similar in its interest in making a definite and limited space adaptable to different circumstances is **Adaptive Cells** by Matthias Gerber. He has developed a prototype for adaptive working environments to be installed for the temporary usage of an ancient cloister library, whereby he has been interested in finding a form that allows the working atmosphere to be adapt to individual preferences.

The topological character of digital space

The topological character of digital space – why is this so important? It is so important, I think, because it implies a fundamentally different axiomatics in our way to approach things. If cyberspace is approached in Cartesian terms, figuring the self as being surrounded by the neutral space of the infosphere, where the aimless, instantaneous delivery of everything in all directions is possible simultaneously, whe-

re digital space is conceived of as a formless mass of data points (bits) in parallel motion, the human body is left drowning, paddling in the unformed and infinite sea of information. Digital space in Euclidean terms, inert by virtue of overactivity – often cited as the information overload, resulting in a downpour of pure availability. The human self must filter, order, and organize, she must form the unformed. The self inhabiting this space is once again a directing will, an autonomous subject, a neutral mediator. Hiding detached behind the interface, externalizing her own activity, unable to meet her own expectations. These threatening tendencies are accounted for by the contemporary trend towards the personalization of machinic interfaces – with the disturbing consequence that human activity becomes increasingly formalized. Confronted with multiple choice forms, we are asked to situate ourselves within commonly available criteria. The attempt to objectively personalize the interface, the place of activity within digital space, paradoxically leads to the de-personalization of the human, to the exclusion of spontaneous vividness and towards a machinization of the self.

The interface as digital eventscape

To conceive of digital space in terms of topology, and of the interface as a digital eventscape requires an entirely different approach to presented information. Within such terms, there is no privileged site of mediation. The human being is not first and foremost asked to transport meaning, collected bits of contents into different contexts. To view the site of activity within digital space as an event, not entirely decidable and recognizable, not significant in itself but only coming to signify through our proper interaction in semiotic terms does not allow us to hide behind the interface. The interface as an eventscape does not present itself as bits of information available for us to mediate, to transport within a new context of concern. In times of instant availability of anything at all, problems of mediation and translation have become problems of combination and layout – in an everything but trivial sense, as Peter Sloterdijk argues (Sloterdijk, 2002). The quest in this provocative statement is to redirect our human capacities to criticize from the linear loopings of action-reaction circuits towards an essentially affirmative (yet never uncritical!), interactive process of action-action-action, et cetera. Re-design! There is an alternative to either impotent immersion or omnipotent imposition of the self-same. Rather than passively objectifying weaknesses, they can be actively re-directed in an affirmative criticism.

Affirmative criticism

Glenn Hürzeler performs such an affirmative criticism in his installation **winomat**, presented in this book. Interested in how he could evoke people's awareness for common but highly problematic issues in a pleasurable, non-moralizing way, he has appropriated the very interface – here used metaphorically – which symbolizes the passive, consumerist behavior he wishes to subvert. **winomat** is a re-designed and digitally enhanced vending machine that will be placed in public space, where it is freely accessible to everyone. Instead of serving us with the usual goods, he offers items and ideas that are directly relevant in the situational context where the machine is placed. In an appropriative gesture he affirmatively re-codes the cultural object of the vending machine, which allows him to profit from the machine's seductive characteristics, serving his own, subtle yet subversive interests.

To participate – this is the stance for the human subject within topological axiomatics. The often discussed change in the concept of authorship through new media is in fact affected by such thinking. Yet also here, it is not a question of either or, authorship or not, omnipotence or impotence. Topological space is space of non-exclusion, where there is no purity. Instead there is reciprocal becoming of a heterogeneity of elements. The affirmation of this heterogeneity poses an alternative to the dialectics of expansion: topological space is creative, infinitely. As Sloterdijk's poetics of combination suggests – different combinations, through their mutual transformative effects, are creative in an ontogenetic sense. Our responsibility is still to put things 'right', but not in a retrospective sense of accuracy but in a prospective sense of how we wish for things to be(come).

Creative communication

The radical semiotic implication of the ontogenetic dimension of language directs our attention to the fundamental creativeness of communication. If communication is not viewed as the act of transporting autonomously existing contents, but as the *interact* of bringing something into existence, Peter Sloterdijk's radical gesture of considering communication in terms of pneumatic animation is very revealing. In his theory of spheres (Sloterdijk 1998 and 1999), Sloterdijk reconsiders the Biblical Genesis Scene, initial for any Christian society's entire cultural being, in terms of complexity, that is, in terms of non-linear, recursive causality and mutual feedback. The relation between the creator and the created thus appears as an inter-relation, as an act of communication: in any act of communication, the sender is only sender if she receives feedback from the receiver, that is, only if the sender is also receiver and the receiver is also sender,

just as the creator is only creator if she is in synchrony with what she creates. She can in no way pre-exist the very act that defines herself. The initial act of animation, of inspiration, is the mutual falling into resonance, making the question of who was first irrelevant. Chicken or egg – who is to know, in a pre-objective world of symmetry?

Communicational kisses?

The mythological figuration of inspiration as a pneumatic act remains very accurate: communication is the falling into mutual resonance – an experience we are all very familiar with from our own intimate moments of kissing our beloved. What happens in such intimate moments is the opening up of mutually inhabited and shared spheres, nourishing and living from our attentiveness to each other and our continuous interaction. Engaged in an act of so conceived interactive, sphere-initiating communication, we realize the fundamentally inspiring creativeness of love. As Sloterdijk says: the emergence of spheres is essentially tied to love stories.[16] Moreover, life itself can only evolve through communication, through interactive, sphere-building activity.

Communication as informative visits

How is it that something new can come into being? Where do new ideas come from? Whether they are ascribed to the genius, and his being contacted by muses, or to chance, or to a creative misunderstanding – in any case, the birth of something new is the acknowledgement of something Other passing through the self, *paying a visit*, as Sloterdijk puts it. Through an act of inspiration. The mysterious origin of ideas, which can not be deduced from the mere application of rules and the mechanistic repetition of known patterns, within the linear movement of searching for something and finding it, may indeed lie in such an act of exposure – for nowhere are we confronted with our own vulnerability more than in moments of loving intimacy, in moments of welcoming the Other, of interacting with the unknown. I do not search, I find, Picasso said who must have known a lot about exposing himself. But just as the moment of exposure allows for growth, for the self to expand, it also bears a great threat. The original catastrophe, the expelling of Adam and Eve from para-

dise, sets in when the symbiotic mutuality is opened up towards an interesting outside – the new always intrudes into previously symbiotic intimacies as it comes forth, leaving it open every time who will be the one interestedly fascinated by the new, and who will be the one deserted, left behind. Transitoriness irreducibly belongs to the turnus of becoming.

Intimacy – spherical forms of creative intersubjectivity

Everything that exists in the world, everything that is the case, Sloterdijk argues, is carried by mutual attentiveness: spheres spanning between different interacting parties, each enabling the other to live by mutually participating in spherical zones of creative intersubjectivity. To affirm intimacy is the fundamental condition for creative communication. By referring to the experience of tasting sweets, Sloterdijk illustrates what it means to be in intimate relations. In order to enjoy an ice cream, I must indeed let my own subjective center be invaded by an outside force, letting me dictate its own theme – the indescribable flavor of frozen strawberries, melting slowly and inexorably on my tongue, which is incessantly trying to hold it back and at the same time tremendously enjoying the intensity of the transitory flavor.

The enjoyment of taste is a minor overwhelming of the subject's autonomy and control – in order to enjoy, the subject must give up absolute control, and must instead give in to being possessed by what in fact, and simultaneously, it incorporates in the very act of eating it. Intimate, situational invasions of self by others, through the mutual willingness to communicate: to being passively taken while being actively taking, in one and the same instant. Experiences of this sort, experiences of *interested submission to (in) formative invaders*, as Sloterdijk calls them,[17] are the very means by which human subjectivity can form at all. The question of who we are, which has traditionally been asking for essences, in this light turns into the fundamental question of where we are, for interactivity is only possible within topological proximity. Sloterdijk's conception of media events, viewed as inspiratory moments of creative communication, implies an intense criticism of contemporary individualism which transcends the postmodern idea that we are all functioning as our own interior designers, furnishing and arranging the world(s)

16 Peter Sloterdijk. *"Einleitung"*. In: *Blasen. Sphären I*. Suhrkamp Verlag 1998. p. 14: *Ich werde platonischen Hinweisen nur insofern auf der Spur bleiben, als ich im folgenden hartnäckiger als üblich die These entwickle, dass Liebesgeschichten Formgeschichten sind und dass jede Solidarisierung eine Sphärenbildung, das heisst eine Innenraumschöpfung ist.*

17 Peter Sloterdijk. *"Innenraum denken"*. In: *Blasen. Sphären I*. Suhrkamp Verlag 1998. p. 96: *Setzt nicht jede Subjektwerdung vielfältige geglückte Durchdringungen, formative Invasionen und interessierte Hingabe an bereichernde Eindringlinge voraus? Und ist nicht in jede Regung offensiver Selbstsetzung ein Zorn über versäumtes Genommenwerden eingeschlossen?*

we live in, each insurmountably isolated from the other. What such a notion of topological psychology as introduced by Sloterdijk reveals, instead, is the radical centrality of interested interactivity, as an intimate act of risk in the joyous pursuit of new, evolving forms.

To pursue the emergence of new forms of collaborating, of exhibiting, of fostering student work and of communicating the proper vivid field of research and work through transdisciplinary interactivity has indeed also been the core interest of MetaWorx as a whole – which has found an experiential symbolism in the very form/expression the 2003 exhibition is going to take place, with the nomadic and mobile Airstream-trailers between which an intersubjective sphere, an inflatable tent filled figuratively and literally by the mutual inspirations of all the involved parties, can take form, adapting to the different stations the exhibition will pass through.

Design and art as transformation loops

As Mischa Schaub writes in his portrait of MetaWorx as a project, the unifying bond relating all the involved parties to this common interest in interactivity is their self-understanding as designers and artists engaged in forming and developing future cultural environments. The driving force for scientific investigation enlightened to complexity is no longer the search for truth, but the search for new styles of life: *every innovation is a new way of being in the world, an invention that then redisposes that world according to entirely new rhythmic values. It changes the underlying music of a given world and in so doing changes the very notion of what will become possible in it.* [18] Style is often dismissed as mere effect of surface – and yet, as we have seen from our detour into geological history, reality essentially forms and re-disposes as a surface. To give style to life is to free life of routine, so that new, entirely unexpected patterns of unfolding can develop. All improvisation is life in search of style – a continuous interrogation of 'what is possible'?

The world consists of volatile milieus. The question of the 21st century is not the problem of speed anymore, but the problem of growth. Of transformative growth – growth as a time-based event, beyond movements of accumulation and reproduction. Growth is characterized by breaking points and moments of rupture that generate entirely new conditions. Growth is nonlinear and unpredictable – not the uninterrupted telos of progress, characterized by Newton's actio-reactio, not changing speed and direction unless the particle collides

and transfers energy. Such an universe would never have come into existence, never ever would anything have been able to grow. Growth must be approached in terms of eventuality, of transformation – it is about quality much more than about quantity. Volatile identities in a topological sense, that is, relational identities, cannot be examined in terms of analysis – they ask for an integral mathematics, for a logic of complexity. The event is active and integral, bringing about transformation. The whole is other than the sum of its components. Engaging interactively with our surroundings means incorporating the encountered other, very much in the intimate sense that I have introduced with regards to Sloterdijk's experience of tasting sweets: as an integration of a new flow into the yet existing flows. Interactive encounters are transformative: information is not passive and external, but always already contained, as an intensive potential. Within such terms, designing and artistic engagement means tenacity – it is in this sense that we can speak of design and art as being transformational loops within (cultural) reality, as being part within an organic system, as Bruce Mau has formulated this self-understanding for his own studio: *The studio functions as a transformation loop. Information flows through the studio as liberated particles of matter belonging to various other systems, triggering – in an attempt to resolve conflict – the emergence of new form. A residual flow is captured, and that captured flow in turn triggers an almost chemical transformation of the studio. (With each event, the studio is changed; try as we might we can no longer return to a previous state.) Like a self-sustaining composition, there are several of these loops running simultaneously. The studio becomes a turbulence amplifier.* [19]

Is life, then, a pattern in time? Or a bouquet of times? And is design the practice of evoking patterns into things, of finding new and unexpected patterns of unfolding? All improvisation may be viewed as life in search of a style. Implicated therein lies a responsibility for designers. The familiar concept of design as submitting to the client's imagined need to conform to a market becomes more than suspicious, it becomes intolerable. Design, so MetaWorx is convinced, is a deep commitment to the *cultivation of life*. And to evoke this responsibility and awareness is the vivid interest of the idea of interactivity.

19 Bruce Mau (Ed.). *Life Style*. Phaidon Press 2002. p.143.

18 Sanford Kwinter. *"The Gay Science (What is Life?)"*. In: Bruce Mau (Ed.). *Life Style*. Phaidon Press 2002. p.35.

References

Bachelard, Gaston. *The Poetics of Space.* Beacon Press 1994.

de Landa, Manuel. *A Thousand Years of Non-linear History.* Zone Books 2000.

Deleuze, Gilles. *Foucault.* University of Minnesota Press, 1998.

Deleuze, Gilles and Felix Guattari. *Tausend Plateaus. Kapitalismus und Schizophrenie.* Merve Verlag 1992.

Deleuze, Gilles. *Was ist Philosophie?* Suhrkamp Verlag 2000.

Gleick, James. *Chaos.* Minerva Press 1997.

Grosz, Elizabeth. *Architecture from the Outside. Essays on Virtual and Real Space.* MIT Press 2002.

Haraway, Donna. *Simians, Cyborgs and Women: The Reinvention of Nature.* Routledge 1991.

Kristeva, Julia. *Revolution der poetischen Sprache.* Suhrkamp Verlag 1978.

Lynn, Greg. *Animate Form.* Princeton Architectural Press 1999.

Manovich, Lev. *The Language of New Media.* MIT Press 2001.

Massumi, Brian (Ed.). *A shock to thought. Expressions after Deleuze and Guattari.* Routledge 2002.

Massumi, Brian. *Parables of the virtual.* Duke University Press 2002.

Mau, Bruce. *Life Style.* Phaidon Press 2002.

Pearson, Keith Ansell. *Philosophy and the Adventure of the Virtual. Bergson and the Time of Life.* Routledge 2002.

Peirce, C.S. *Naturordnung und Zeichenprozess. Schriften über Semiotik und Naturphilosophie.* Suhrkamp 1991.

Rosen, Robert. *Essays on Life Itself. Complexity in Ecological Systems.* Columbia University Press 2000.

Serres, Michel. *The Birth of Physics.* Clinamen Press 2000.

Sloterdijk, Peter. *Tau von den Bermudas.* Edition Suhrkamp 2001.

Sloterdijk, Peter. *Sphären I + II.* Suhrkamp Verlag 1998 and 1999.

Maria Stergiou
Art Historian
Head of Sitemapping.ch

University of Applied Sciences Aargau FHA

Department of Design and Art

...in medias res!

Interactive media art – Works by students in the Media Art program at the University of Applied Sciences Aargau.

La suprématie de l'oeil dans l'organisation du visible est défiée. Le regard délègue une part de son pouvoir au bon vouloir et à la virtuosité des doigts, à la pertinence et à la précision des gestes, à la force du souffle, à l'intonation de la voix, à la vitesse des mouvements du spectateur-opérateur. [1]

In her article *L'interactivité entraîne-t-elle des redéfinitions dans le champ de l'art?* the art critic Anne-Marie Duguet describes in minute detail the process of reception when encountering interactive artworks, and thereby she addresses one of the predominant issues within the theoretical discourse on media art.

At the core of this discussion is the interaction between the recipient, who in the context of media art becomes an user (opérateur), as well as the artistic design of the interface between human and machine. The question if and how interactive art may be described and categorized has not yet been answered by this theoretical discourse. For the

still little researched realm of digital media art, however, interactivity is indisputably one of the main features.

What this new aesthetic dimension opened up by interactivity in media art might look like is demonstrated by the following six media art works done by students of the University of Applied Sciences Aargau. Within the exhibition *MetaWorx*, these installation works represent one of the most important areas in current media art. They were especially conceived for the context of this travelling exhibition and can be easily presented in a variety of surroundings. Some of the works even make this aspect of mobility part of their thematic issue. Interaction, as described by Duguet among others, mainly takes place within these works through their integration of sound into their respective interfaces.

The students not only focus on the production of extraordinary images in their works, but also on the invention of new interactive parameters. They are concerned with aesthetic strategies and communication processes. They question cultural technologies and processes of learning. They also create new interfaces and models of perception with the help of new technologies. Depending on the artistic intention and formulation thereof, each of the works puts different weight on technical, aesthetic or communicative aspects, as well as on issues of perception and playfulness. During the course of their education and training, the students learn the mechanisms of staging media productions.

Works in the exhibition

In **FlugiFlüg (fly! fly! fly!)**, a performance by Priska Ryffel and Stephan Haltiner, participants imitate an airplane by moving their own bodies. With covered eyes, they hear the sound of the wind displayed through a helmet with earphones. The sound of the wind is influenced by the participant's own body movements. This component adds an experiential dimension which evokes the experience of flying.

The audio installation **En passant (passing)** by Ursula Meyer-König and Simone Vogel invites participants to play the Swiss board game Carambole as a means of going on a journey of discovery. Winning is not so much the goal of the game as is letting the players explore a sound structure of several channels, creating associations to borders and their respective blurring. Players initiate sounds and voice fragments through their own moves – in a playful discovery process.

In her audio installation **_okay√** Manou Vonwiller was inspired by the work of the Korean media artist Lee Bul. They present a Karaoke station where the familiar code of kitschy images is set against the alienating context of media news casting, Stock market prices and reports from political crisis areas, for example, are mixed in with the song lyrics.

1 In: Anne-Marie Duguet, Déjouer l'image, *Créations électroniques et numériques*, Jacqueline Chambon (Ed.), 2002, Nîmes, S. 113.

The interactive sound sculpture **voice-trans-it** by Philippe Lehmann gives visitors the opportunity to create a sound pattern by making a recording in an audio guest book. The sculpture addresses the issues of mobility and nomadism. These two aspects are not only a focal point of the MetaWorx exhibition and media art in general, but they are also defining characteristics for the way many people live in the information society.

Michael Aschwandens interactive audio-video installation **Lebens-raum (living space)** invites visitors to reflect on the element of water as a part of our ecological system. Image and sound recordings of a stream near Rosenlaui, in the Bernese Oberland (in the highlands near Bern), are transmitted via monitor and speakers. A rock from the stream serves as the interface between the viewers and the installation. Every movement of the rock influences the water flow and the corresponding sound of rushing water, which is displayed via the speaker system.

Media Art studies in Aarau at the
University of Applied Sciences Aargau

The intertwining of electronic media, locations, authorship, and interactivity is the main feature of content in the Media Art program in Aarau at the University of Applied Sciences Aargau. The university thereby consciously makes its mark in the discussion of the definition of media art. In the foundational level of interdisciplinary studies in media art and industrial design, students receive an orientation in practicing media art. Next to concrete project experience, they gain technical, practical, theoretical, and artistic knowledge. Through this interdisciplinary approach, the university takes an initial step toward revising the traditional idea of the artist. In media art, the borders between art and design are fluid. This aspect is accounted for by letting students, from the very beginning of their studies, develop new artistic forms that may also be applied within industry.

Media art as a contribution to cultural innovation

Graduates of the Media Art program acquire professional skills in dealing with new media technologies at the same time that they gain creative and innovative competence in establishing new aesthetic parameters in art. Their works are both artistic experiments and critical visions of the future. They essentially contribute to the design of cultural changes within the information society.

By working with the same technology that our information society and industry depends on, artists continue to affect the designing of our everyday world and influence tomorrow's communication processes and cultural technologies.

All texts translated by Michelle Miles.

Title	Findus
	Please don't feed the animals
Author	Rachel Bühlmann
Project type	Installation
Year	2003
Advisors	Prof.Dr.Jill Scott
	Stephan Athanas
Hardware/Software/	Aquarium, 2 goldfish,
Material:	8 photoelectric sensors, contact
	to midi converter, Sampler,
	audio mixer, audio amplifier,
	4 speakers
Technical support	Christian Kuntner
Contact	raitschel@hotmail.com

MetaWorx	☐ dvd
	☐ webplatform
	☒ exhibition

Findus is an interactive media art project with technical and organic elements. Spectators may observe two fish swimming in an aquarium. Visitors cannot predict much of what will happen in this installation. Their initial ideas are not likely to be confirmed. Fish1 and Fish2 appear to swim more or less accidentally and without deliberation in their element of water. Photoelectric beams are set up in a pattern, initiating various sounds each time they are crossed by a fish. The displayed audio sequences are decontextualized story-fragments recorded from *one day in the life of ...* They are always besides the point, too descriptive, and sometimes predictable.

These oddly descriptive elements unfold into a narrative story, initiated and controlled by the movements of Fish1 and Fish2. Their motivation has its own body of rules which is hardly comprehensible for spectators, whose desire to control, to try to make the fish do what they want, can never be satisfied. Ultimately unable to influence, the spectators are forced to leave the events up to chance.

Findus opens up and punctuates free spaces for the look on improvisation. Stories develop out of loud silences and quiet sounds.

outline of the cybernetic control

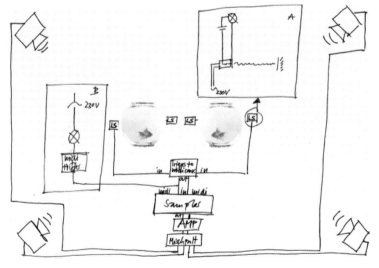

sound sketch

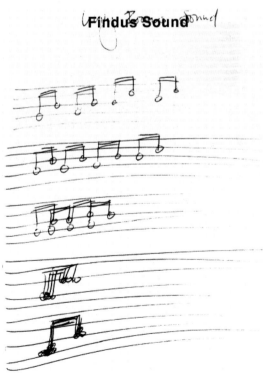

Findus

implementing a light barrier

scaffold: interior mechanism

final object

defining inputs for the sampler
channels

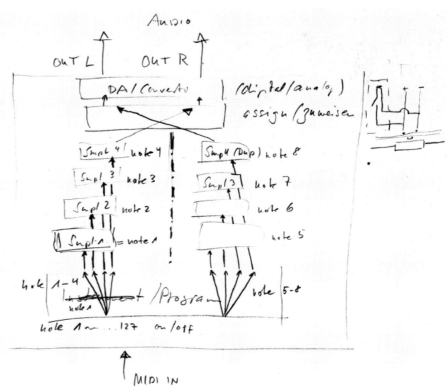

Title	FlugiFlüg (fly! fly! fly!)
Authors	Stephan Haltiner, Priska Ryffel
Project type	Performance
Year	2003
Advisors	Prof.Félix Stampfli,
	Stephan Athanas
Assistance	Mischa Leber
Contact	prisigna@bluemail.ch
	snirp@bluewin.ch
MetaWorx	☐ dvd
	☐ webplatform
	☒ exhibition

Adventure | Wind in your hair | Butterflies in your stomach | Longing | Weightlessness | Letting yourself go | Being a child again
Sometimes we are afraid of losing the firm ground beneath our feet. Sometimes we take off without noticing. Sometimes we free fall into endless depths, and sometimes we rise to the highest heights. If we only awaken the child in us, we can fly. In our minds, we are carried by the wind, free from pressure and from the outside world: fly! fly! fly! Our performance generates two opposing worlds that allow visitors to become artists. In one world, participants are invited to dive into a soundscape of wind, changing with every one of their bodily movements. Giving in to the rhythms of the windy sounds, we can fly through an inner universe, forgetting all about the world outside. In the other scenario, viewers see a poetically absurd pantomime theater of flying, reflecting and evoking images belonging to their own inner worlds.

This sensual experience opens new perspectives onto the many facetedness of our reality. *Text: Jvo Cukas*

FlugiFlüg

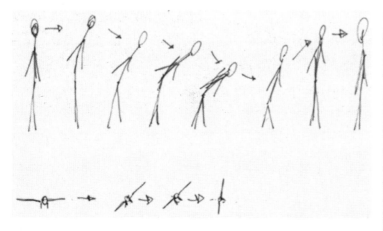

sketched ideas

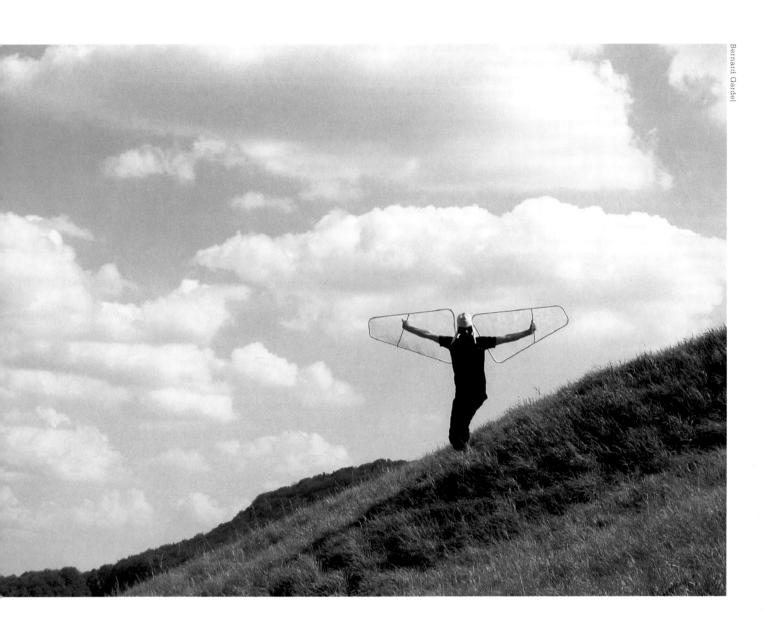

Faites-vos jeux… (make your play) we hear a voice say. A Swiss board game of Carambole is in front of us. Here we go. We hear steps, voices, sounds, music. Is this real or is it a dream? What do these words *mean*? The random mixture of sound fragments initiated by the player's moves across the board results in entertaining, dreamy, or absurd moments.

The installation is about the blurring of borders: borders between fiction and reality, between the past and the present, between countries, languages and cultures. It is also about our own personal borders and limits.

We live in a moment, where the world sees itself as a network that joins points and transverses the confusion, as Michel Foucault once said. Our interactive installation is a loose network of audio references to borders. Borders may only be blurred when they are moving and are being moved.

So – faites-vos jeux!

We are interested in giving a new dimension to a board game that is both well known and yet newly displaced through the Play Station generation. Ursula Meyer-König and Simone Vogel

Title	En passant (passing)
Authors	Ursula Meyer-König, Simone Vogel
Project type	Audio installation
Year	2003
Advisors	Prof.Félix Stampfli,
	Stephan Athanas
Assistance	Mischa Leber
Contact	ursulamk@bluewin.ch
	simone379@gmx.net

MetaWorx	
☐	dvd
☐	webplatform
☒	exhibition

the horizon nearby ...

are you taking the right lane ...

En passant

circuit board I

initial attempts

electrical engineering in action

circuit board II

do you hear the murmur
of the waves ...

USB plugged

the core of the installation

Sakura, kamikaze. Samurai geisha sake hokusai harakiri sushi suzuki tokio fujiyama *Kamikaze misomishimatempurakimono. Tamagochi Karaoke.* Karaoke, that word is the best sounding of all.

I can remember exactly when I saw a jukebox *the usa and* great britain have *closed their dimplomatic offices in saudia arabia* for the first time. But not the first time I was in a Karaoke bar. It's as if they always existed.

Instead I remember *platinum (FR/kilo) 671+1.23%, gold ($/ounze) 369+1.73 coffee ($/t) 730−0.2%* Nao's look. I tried to catch his eye between the blue reflections of the neon lights on the marble block bar. Maybe I could impress him if I could sing *apparently abused his step-daughter sexually over a period of two years,* attacking *her in the shower and on the hood of their car* a song really well. The song catalog is lying next to him. It's so big, there must be something in it. He must have sensed my thoughts. He is writing down a number, he orders a song from the VJ. He gives me a short signal.

Cherry blossoms open, the sun doesn't stop going down, the lights reflect off the disco ball onto rubber palm trees and *stream of cool, humid air off the Atlantic* smiling sea nymphs are moving in time in the tourqoise colored water.

The movement of color over the letters is a sure indicator. My voice is wandering around up there, and in case we *a bus plummeted off a mountain road, falling 30 meters* don't hit a note, we simply glide weightlessly on to the next one, carried along by our listeners.

Maybe we need an orchestra, but the only thing that counts is us.

Title	_okay✓
Authors	Manou Vonwiller
Project type	Audio-video installation
Year	2003
Advisors	Prof.Félix Stampfli
	Stephan Athanas
Assistance	Mischa Leber
Contact	m.vonwiller@stud.fh-aargau.ch,

MetaWorx
- ☐ dvd
- ☐ webplatform
- ☒ exhibition

_____okay✓

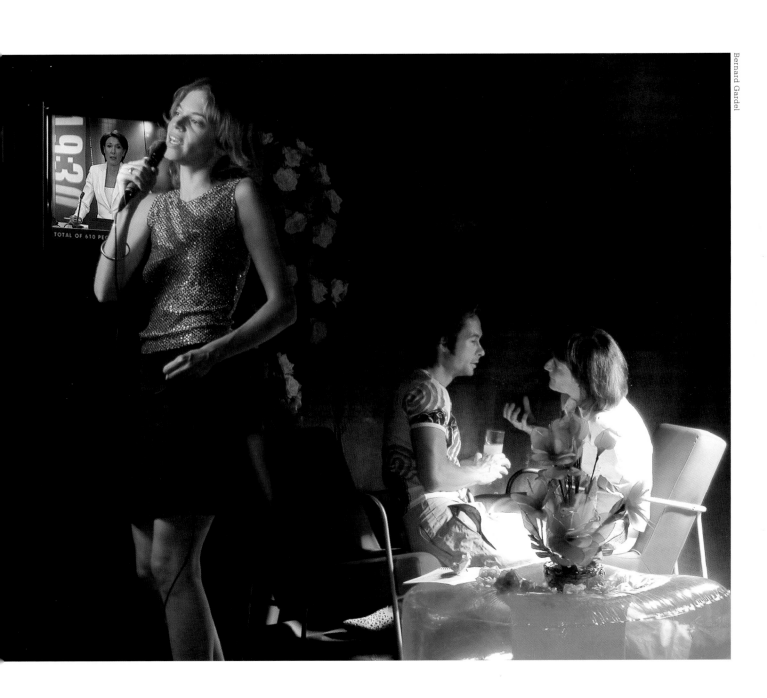

distinct animated letters from
the news sequences

voice-trans-it is an interactive audio sculpture, narrating the past, confronting us with our own presence and challenging us to take part in the future. The installation is interested in what influence we have as individuals with regard to transitoriness. To what extent can we affect what we will forget and what we will retain in our memory?

voice-trans-it is an audio vessel, recording, saving, interpreting and playing back sounds that circulate, disappear and reappear again. The sounds and voices follow their ways, collect experiences, change over time and leave traces for us to detect – always hinting to a distant, yet ever present, origin.

For the installation, this origin is made up of the voices of the participants. There is an exposed and highly visible microphone recording and preserving them in an audio data bank. At first, visitors will hear and recognize their own voices. Then the initially pure recording slowly fades into an echo while continuing to wander through various stages of synthetic transformation. The voices slowly start blending with the sound patterns of earlier recordings. Each new recording, while maintaining a proper character, adds a further note to the continous weaving of sound traces.

Six different speakers are arranged in a circular form. The brain of the installation, the computer itself, is hidden so that only the recording and playback devices are visible. The sculpture as a whole is of an organic form, like a single over-dimensional neuron that receives data and spins it off again.

Title	voice-trans-it
Author	Philippe Lehmann
Project type	Audio installation
Year	2003
Advisors	Prof. Félix Stampfli,
	Stephan Athanas
Collaboration	Yves Rosenthaler
Consultant	Roland Unterweger
Assistance	Mischa Leber
Contact	p.lehmann@stud.fh-aargau.ch
MetaWorx	☒ dvd
	☒ webplatform
	☒ exhibition

voice-trans-it

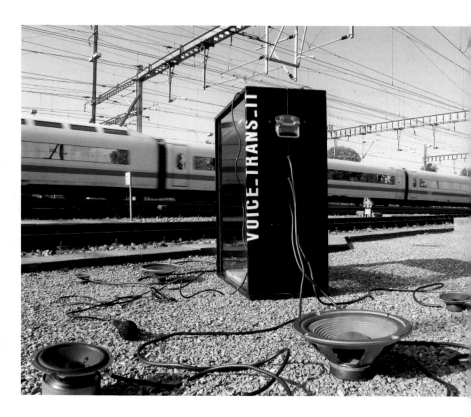

While studying media art, I continually came across the subject of artificial intelligence. What fascinates me about AI is, among other things, how quickly electronic devices are seen as individuals and how they appear to be intelligent when looked at in this way. This is exactly the feeling visitors should get when looking at **voice-trans-it** – as if they were looking at a living technical being, with which they can interact.

microphone

audio exits

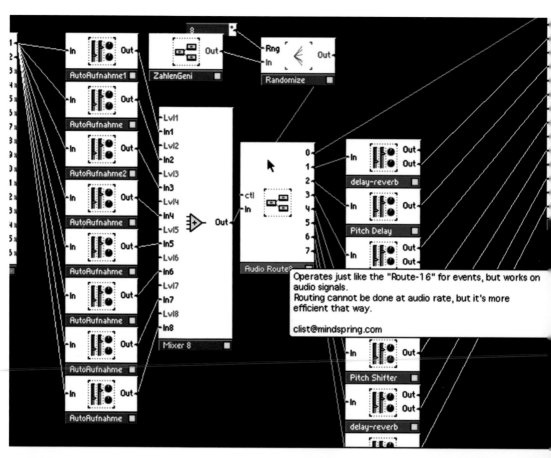

Operates just like the "Route-16" for events, but works on audio signals.
Routing cannot be done at audio rate, but it's more efficient that way.

clist@mindspring.com

first prototype

core of the machine

speakers

Motu

The secrets of water fascinate us and evoke questions. Where does our biological life originate from? Where is our life story leading us to, who is merely part of a complex ecological system? In our relation to water, are we floating freely on, or are we swimming in our first resource? Where do life forces come from – our origin – where are we living – what traces are we leaving – what examples are we setting?

Diving | merging | in the world of sound | the medium | the living space. This audio-video installation allows visitors to dive into water's various worlds of sound, inspiring visitors to reflect on the element of water. A stone serves as interface between visitor and installation. At the same time it influences the amount of water and the intensity of sound. The visitor is invited to dive into water's worlds of sound through a surround file of carefully mixed original recordings. The expressive power of these sounds is enhanced by a visual transmission of the stream on a monitor. Visitors are immersed into sounds of water dripping from a spring, vividly winding its way through small, carved rivulets, until it becomes a roaring raging stream, following its course.

The film footage was shot in the smallest village in Switzerland, in Rosenlaui, located 1328 m above sea level in the Bernese Oberland (the highlands near Bern). It departs from the spring of a branch of the Weissen stream and flows into the wild Rosenaui gorge which was carved out millions of years ago by the Rosenlaui glacier.

Title	Lebensraum (Living Space)
Author	Michael Aschwanden
Project type	Audio-video installation
Year	2003
Advisors	Prof. Dr. Jill Scott,
	Stephan Athanas
Assistance	Mischa Leber
Contact	m.aschwanden@blockschmelzer.ch
Reference	www.blockschmelzer.ch

MetaWorx
- ☐ dvd
- ☐ webplatform
- ☒ exhibition

**recording location Rosenlaui
(Bernese Oberland CH)**

recording sound

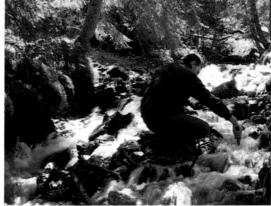

Lebensraum

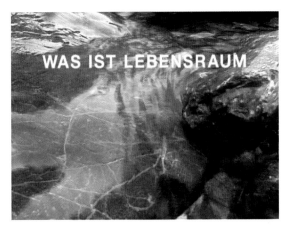

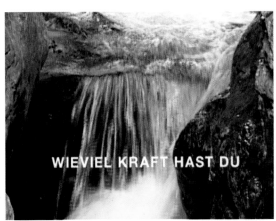
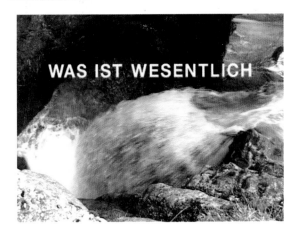

Reinhard Storz _____

University of Applied Sciences Basel FHBB
School of Art and Design Basel HGK

Department of
Visual Art / Media Art

Thinking within the media

Interactive media art falls within a mechanized world where forms of man-machine-interaction have taken on a significant quality with regard to work and leisure time. Already in 1948, Norbert Wiener pointed out this perspective. Because art does not serve anti-auto-nomous purposes and can take its time where issues of form and sig-nificance are concerned, its task is to reflect upon the tendencies of social development and to analyze its own work ideas in their context. However, within the public cultural discourse, the competence of art schools to develop socially relevant models of interactive cultural work is already being questioned. This became evident, for instance, during the discussion at the Ars Electronica 2001 led under the heading *Takeover. Who's Doing the Art of Tomorrow?* Reproaches have been made that classical art education, in the end, still plants the rituals of art into the unstoppable media evolution (Gerfried Stocker). It is said that new impulses come from the net activists' scene and independent game factories, while the classical art system has halted in the face of philosophical laziness (Jon Ippolito).

Having said this, maybe, it nowadays just makes sense in art educa-tion to be beyond the commercially motivated acceleration of media culture. The avant-garde's claim is being superseded by the art of critical sidelong glances; the deconstruction and transformation of existing media techniques within art can lead to significant insights. Even if one would like to have it otherwise, art schools cannot keep up with the resources of commercial art producers and technical uni-versities. Instead of high-tech research into *artificial intelligence*, the card of artistic intelligence still remains for them to play.

The demands on theory and studies in today's art colleges have changed over the last years. For work with new media and art con-cepts aiming at the interactive participation of the viewer in the work, the following demands can be formulated: students are to become self-critical individual authors at the same time that they acquire the social ability to participate in collective authorship, since art work with new media often involves working collectively. Students are meant to do the intellectual work of the conceptual artist, since media art is conceptual art. At the same time they are to become media craftsmen, since the new media have revitalized an almost pre-industrial degree of technical skills. Finally, students are to have a profound knowledge of art and media theory at their disposal, since the ideas behind interactive media art are often reliant upon art and media reflection.

The basis of our practical media theory at the University of Art and Design Basel is the fact that, here in Switzerland, one of the oldest and most thorough art educations in the field of video is offered. Moreover, Basel has experienced a significant enrichment in courses of study and institutions which are concerned with different aspects of production, and presentation or reflection of new media (art). These unique opportunities include *Plug in,* a media art enterprise; *Viper,* an annual media festival; media-scientific courses at the University Basel; and *HyperWerk,* a sister department of the University of Applied Sciences Basel. Exchange and collaboration with these institutions support the department of Visual Art / Media Art at the University of Art and Design Basel's media work in which useful forms of coopera-tion are still being developed among the parties concerned.

What is noticeable about our student's work is the presence of the body as a primary instance of their multimedia work ideas, whether as drawn body that can be viewer-animated in the work of Bruno Steiner, as unconscious *organ of control* in the work of Jan Torpus, or as bodily convergence in the contribution of Marc Mouci and his co-sleep action, for which the monitor just serves as a distant bedroom window. Technique is always being used to ask questions concerning the body on this side of the human-computer interface. Our school's most recent project, the *Video Orchestra,* integrates the manipula-tion of technical interfaces directly into physical stage action. Here, strategies of immersion of virtual art are being carefreely transformed into a low-tech mix of bodies, sensors, and computers. Our society's machine fixation is made a living spectacle as technical fetishism.

John Cage's demand for a work of art which should react to patrons instead of staying fixated and static, and British artist and theorist Roy Ascott's 1966 idea that art within future telematic culture should be diffuse, immanent, and variable, as well as multifaceted and in constant motion, are unifyingly crucial elements for such art work.

The department Visual Art / Media Art of the University of Art and Design Basel tries to further artistic thought before any media decisions with its students. In a next step, a way of thinking *within* the media and out of the media, be it painting or video, spatial installation, Internet application or performance, takes place. This reflection before and between the media often requires watering down a classical media fixation with first-year students. In that respect, art theory starts before every lesson in C++ or Lingo programming as an act of deprogramming obsolete art ideas. The museum script: onVisitMuseum {goto theWall (left, right); slowly walk along theWall; if (image) {stop (+ − 45 sec);} else (stroll (on);} if (image = already seen) {goto NextRoom ();}} should no longer be understood as the sole possible model for the reception of art.

The interaction and technique euphoria of the nineties has long since vanished. The assertion that techno art will overturn the parameters of classic art and inevitably lead to the emancipation of the viewer via interaction (Peter Weibel) no longer appears credible in its absolute formulation. Net art's *interaction fetish* (Roberto Simanowski) also must be judged by artistic quality standards. Here, some media utopia pales want to recognize the computer and Internet as tools of an emancipated political participation, and qualify interactive work of art per se as politically and ethically valuable, because it enables participation and participatory behavior.

While working in art schools, these overheated media theories must not lead to resignation, but to an old, and prolific art-immanent discourse. Actually, the role of the art viewer never has been really passive. As an admirer, as a lover, and as a thinker, the viewer has also been, through all phases of art history, an *user,* an active element within the relationship system of artist-work-viewer. However, in the modern age the issue of interdependences within this system was considerably expanded. From Dada and surrealism through action and conceptual art to today's computer-based art, artists and art theorists occupy themselves with the role of the viewer as work participant – a problem which is being formulated as the actual central issue of today's art work. Since it is about re-assessment and redefinition of authorship and authority, it concerns a delayed process. A lot seems to be at stake – aside from the properties of museums and collectors, the actual *copyleft* discussion also questions the creative property of artists themselves. What is being declared as theoretic and practical open-heart surgery in the domain of art, actually is, above all, a bypass operation on the constricted appreciation of art pitted against philosophical laziness.

All texts translated by Udo Breger.
The contributions are conceptualized by René Pulfer.

Moveables

Title	Moveables
Author	Bruno Steiner
Project type	Internet Installation
Year	2001
Reference	www.xcult.org/moveables

MetaWorx	
☐	dvd
☒	webplatform
☐	exhibition

I sketch figures on a white background. While doing so I examine the relationship of posture and state of mind. The balance between stature and moving picture in this work is extremely unstable. What's only possible in one's mind with a conventional drawing, here also happens on the monitor screen: the lines made begin to move, the figures take new positions. The drawing becomes interactive animation.

In his thesis work **Moveables,** Bruno Steiner goes into the issue of how on the one hand, in the process of flash programming, the body of the draftsman is written into the skill of drawing. On the other hand he explores how in the techno aesthetics of object-oriented graphics, the *soft* symbol of the body can be depicted and widened by the moment of animation. For the animation, the body of the viewer comes into play. By means of the mouse, he sets the figures into motion. The movement concept of animation not only permits a cinematic-linear course from A to B, but each and every inter-image permits a picture moving back and forth. Instead of discrete values like Yes or No, A or B, the picture movement follows the maybe's, the not-the-way-you-do-things, and the it-is-a-little-bit-extreme idea. This hesitation also embodies itself in the form and line of the drawings. Weak, inhibited figures perform childlike silly acts under the hand of the mouse arrow – they hide in a sack or exercise a little. They do all this only when our hand urges them to. We stroke these strange little people with the mouse, and we smile (a little). As revenge, they conjure a little emotional magic into our faces.

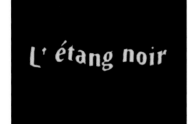

2Screens / l'étang noir

Title	2Screens
Authors	Daniel Brefin, Regula Burri, Simone Fuchs, Andreas Hagenbach, Regula Hurter, Gabriele Rérat
Project type	Workshop, development of a navigation interface
Year	1998
Teachers	Catherine Lutz-Walthard, Philipp Gasser

Title	l'étang noir
Authors	Clara Borbely, Charlotte Greber, Rebecca Mori, Marc Mouci, Peter Spiellmann, Bruno Steiner
Project type	Workshop, development of a computer game
Year	1999
Teachers	Catherine Lutz-Walthard, Philipp Gasser

MetaWorx	
	☒ dvd
	☐ webplatform
	☐ exhibition

In 1998 and 1999, two workshops were held at the department Visual Art of the University of Art and Design Basel within the context of its video education. The objectives of the two workshops were the application of multimedia software, in terms of content and technical aspects. During a four-week period, the students in **2Screens** studied the application of Quicktime and non-linear video editing, and realized an interface in Director to control their movie clips. During the second workshop **l'étang noir,** the applied software's range was expanded by Final Cut, Flash, Cinema4D, and SoundEdit. Both workshops were based on the idea of picking up the necessary techniques through learning by doing, and were therefore designed specifically for the realization of multimedia ideas of one's own. With **l'étang noir,** the project's guideline in terms of content was derived from the production of an artistic computer game. A *multimedia tale* whose individual constituents are connected by means of coherent navigation were to be developed collectively. For this project, new forms of teaching had to be explored. Working as a team, teachers Philipp Gasser and Catherine Lutz-Walthard supported students in their different formulations of questions in terms of content and technical aspects; a survey of commercial games and amusement arcades supported the workshops collective *groove,* as did the shared dinners. At the students' request, the realization of l'étang noir was extended into their own studio work, and finally took one year.

Getting to grips with media specific, conceptual, and structural ideas was crucial for both projects. The acquisition of the necessary soft-

ware knowledge in the course of realization involved the process of trial, error, and starting anew. With the great variety of the programs used, the time spent by the teachers in looking after their students was enormous, but the student's persistence and enthusiam were even greater. The innovative work with short video and sound loops, with new techniques of animation, Lingo script, interface and link concepts also promoted, apart from technical knowledge, the analysis of issues of interaction and media aesthetics.

L'étang noir (citations from the accompanying booklet)
Effervescing bubbles lead down to the pond's bottom. A wrong click, and the whole pond will be poised ... A can pops up from nowhere. By the right click one gets into the inside of the can ... A flying object allows bubbles to well up and merge into a sparkling little man. The little man is being followed by projectiles and has to get over obstacles. Once the hurdle race is successfully finished, poisonous fungus appear ... The three-dimensional creatures let themselves be observed. Creatures no human eye has ever seen ... The story of the goat and the cow is especially touching ... The right pieces take the player further, the wrong ones sound good ... In the pond's depth animals appear and ask the players for help. With the right xy-letters one can turn the animals into fishes again. If one uses the wrong combination, the fish will die, and a skeleton appears. If one uses the right letters, however, the animal turns into a fish again. In the end, the number of fishes saved or killed is displayed.

In Bed With Me

Title	In Bed With Me
Author	Marc Mouci
Project type	Internet performance
Year	2000
Reference	www.centreimage.ch/inbedwithme
MetaWorx	☐ dvd
	☐ webplatform
	☐ exhibition

I'm offering you to spend a night with me in my bed. You enroll yourself at contact, and we arrange an appointment. Then you come to see me; you bring a bottle of wine, and I do some good cooking for us. If my closeness and my bed appeal to you, we proceed into my bedroom and lay down. Next to the bed there will be a camera installed which takes snapshots throughout the night. The images will be used for the documentation on the Internet. As a thank-you for your assistance, you'll receive a certificate from me that you have spent a night with me.

Marc Mouci's work **In Bed With Me** (2000) used the Internet as a medium for making contact and for creating a pictorial documentation. The co-sleep action lasted five months; his bed stood in the *Stadtgalerie Berne* for a while. According to regulations, sexual interaction was out of the question.

In the contour and body-less communication space of the Internet, Marc Mouci's performance tells the story of an unusual convergence of humans and bodies. The artist lures the stranger beyond the monitor towards himself. He zooms in close from that far-away reality of light planes and pixels as it were, and into the dark cramped space of the bed. Pores, and not pixels become the measure of approach. But at once, the journey from the close bodies goes on, moving into one's own strange beyond of sleep. Marc Mouci invites the adventure to cross borders; and he finally experiences with himself, as he notes online in his *nightbook*, how strongly we have internalized our own individualization.

Affective Cinema

Affective Cinema II

Title	Affective Cinema I + II
Author	Jan Torpus
Project type	Interactive Video Installation
Year	2001 + 2003
Reference	www.affectivecinema.net
MetaWorx	☒ dvd
	☐ webplatform
	☐ exhibition

During his studies, Jan Torpus occupied himself with the issue of how personal and intuitively combined pictures can be fit into well-conceived narrative structures. For his thesis project *Velazquez*, a CD-Rom structured for interaction, he applied the principle of hyper-text to the nonlinear sequence of video sequences. According to an associative logic from the given film and text material, the viewer produces a *narrative* of her / his own.

The construction of such non-linear fields of navigation is demanding, the danger of randomness is great. Therefore, Jan Torpus started to understand his work with the interactive film assemblies as actual research work, as development in the field between art, play, and science. Together with the Dutch psychologist and media artist Michel Durieux, and in collaboration with actors, he subsequently realized the interactive installations **Affective Cinema I** (2001) and **Affective Cinema II** (2003). Here, navigation detaches itself from any conscious decision of the viewer. Via skin resistance, a sensor measures the intensity of his feelings and influences via Max (MSP/Jitter) programmation combined with the video and sound sequences structured on emotional effect. Images and sounds react to the incontrollable micro emotions of the active viewer: film and viewer have a reactive relationship to each other. The highly complex development of **Affective Cinema** serves as an example for today's apperance of interdisciplinary and intemedial research work under artistic supervision.

The Video Orchestra

Title	The Video Orchestra
Authors	Silvia Bergmann, Katja Loher
	and guests
Project type	Performance
Year	2003
MetaWorx	☒ dvd
	☐ webplatform
	☒ exhibition

Some artists enjoy themselves in the machine park. They enact the breathing MulitEgo-Cyborg in the tangle of cables. Feverish hard and wetware, live prothesis theory performed as interactive soulwork is hip. Hearts in processor time: bioheart next to Megahertz, electronstorm along nerves and wires.

The Video Orchestra does what its name implies. Women & men play musical and picture instruments in front of a public, playing them with and against each other, in front of and together with the viewers. They stage a happening. Starting from their prefabricated sound and picture material, they take off into free improvisation, interacting, and performing. The video pilots steer the energy flow diagonally through the room, stealing pictures and sounds from the audience, and mixing them with their own data flow. A live act is given, a concert for bodies, pupils, and auricles is staged.

The Video Orchestra is a collective consisting of individuals. It works chaotically with a dramaturgical structure. Like musicians, visual artists play live with the products of technical instruments. Within the audiovisual event area, they follow an open score. Strategy and synchronization of effects are notated there, the room for solo entries and for joint improvization.

The Video Orchestra's concept is based on the interaction among the protagonists and with the audience. During the half-hour entrance, the video activists act at the interface between man and technique, image and sound, stage and auditorium. Their media mix is the varied range of analogous & digital devices, subversive performance

interludes, their corporeal presence staged within a tangled installation of equipment.

laurenzbau basel, art historian's party, may 2003
2-3-1 calls \times^2 2.0 | 1.1 reports the rhythm in a visual loop | hey, 7.7, do you hear me? | the keyboard informs the RGB a symphony | heights race through the magnetic ring | basses move in the shibaden | the colour corrector snatches the singing | the dancing mixer creates inspection, sometimes in a transparent form, also in a satiated or negative way | hidden harmonic colours hide themselves behind locked safe doors | the coordinated pushing buttons frees musical images | the search for compositions which move in more complex systems | than just in the realm of ones & zeros | let us listen images & see sounds

weimar, bauhaus-universität, design department party, july 2003
i am beautiful, cut diagonally through the tape. am a material girl, scratch and destroy images, and a lover of cables. maybe i play lego, stick visuals together with music. am for more ideas per video minute (IPV), and venture to tackle compositions. lupe monitor sings in the shower: it's a sad and beautiful world! | distorted melody! | i am most interactively active, since punk's not dead, and my belly button sparkles. | i find a picture and move the report towards the invalid moment. cut up perfection and piece it together again, and in the meantime observe the beautiful little cuts, and am crazy about picture

stories, which move about between time – and have nothing to do with telephone invoices. | ultrasound funerals, exemplary. | i scream! you scream! | ¡hasta la victoria siempre!

perspectives
with jack and chinch hand in hand diagonally through the cable wood, practical video story against the evil eye. without video conductor confused in the RGB, VTW-100 songs for the chart show. number 1.// 3-5 calls 7.72 we operate on the documentation morte in the concert hall. | preferably in goethe's garden as anarchist simultaneous swimmers visible in the water level between going underground and submerging. surfacing as mixture of siamese video brains brought into line. expanded intercom. | at full throttle like on german autobahns in direction video apocalypse, english logic turned around again in delay. list of devices for customs like a menu plan. | immobilité vivante | we, a megapulpo, put out our arms, grab what we catch … cosmic plan. somewhere on the air magnetic vibrations fight against the aceton. dead nature moved as far as the style de vie. we, opponents of all mtv effects, still remain unrepairable, in spite of genlock and cotton buds. memento mori and entertain me tightly, please. we, les yeux bleues vertes, cut a video-cubist gesamtevent live, just for you. tied to buttons and levers we present you with passion. rhythmized harmonic colours in the image flow. | ahora mismo, belmondo.

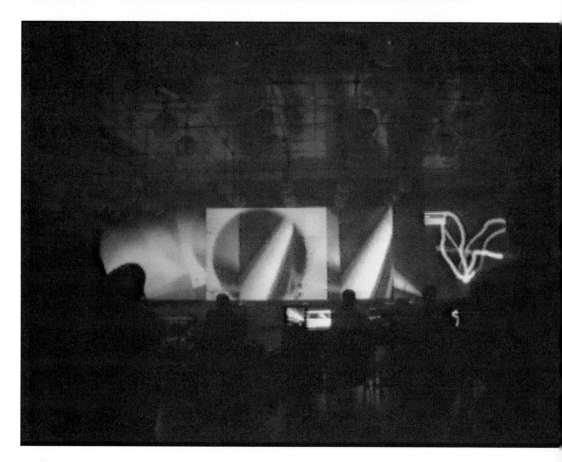

Prof. Andreas Wenger

Dipl. Architect ETH SIA

Head of the Department of

Interior Design

University of Applied Sciences Basel FHBB
School of Art and Design Basel HGK

Department
of Interior Design

Interactive rooms?
An interplay of architecture, design and scenography

According to Bernard Tschumi, the architectural room is *"not a passive room, but rather a room in expectation."*[1] In order to activate it, it has to be discovered by those entering it. This spatial notion – based on the assumption that there is *"no architecture without action, with-out a programme and without a result"*[1] – elucidates the decisive role that utility assumes in today's design realm. If the (objective) function was the focal point of interest in the modern era, today it seems to be perception – an instrument that could not be more subjective.

Actually, our spatial perception has changed fundamentally with the rapid development in technology and science. In particular, the natural sciences produced a new definition of reality through the development of phenomenological theories[2] which also provided the impetus to new approaches in architecture and profoundly characterized our present-day understanding of space. Through the introduction of the space-time continuum, the aspect of motion, the room

(space) has experienced a semantic change; and, detached from a merely formal and thereby *static* claim, it has subsequently retained a strong dynamic component.

Various approaches are perceptible in the current architectural debate, especially with regard to documenting the dealings with space.

The significance of spatial limits has become established as one of the pivotal creative tasks. When Bernard Tschumi speaks about the activation of space, he does not incidentally anticipate the forbearance that *"orientation and therefore also motion are independent of the physical limits of space, simply because one no longer perceives the limits. Suddenly the bodies move in dependence of light sources."*[1] Through the specific utilization of light, projection, acoustics and new media, the interaction between space and people generates an image which is completely different from the actual, constructive spatial form, or can even contradict this. It no longer concerns how a room is, but rather how it is perceived, which perceptions it generates, and finally, what results it produces.

Jeffrey Kipnis, architect and architecture critic, introduced two terms for this purpose[3], which illustrate the different approaches in spatial design. With the strategy of *InFormation,* he describes projects which are derived from the *event rooms of new technologies,* and which focus mainly on the emphasis of the programmatic. On the one hand, by means of various technical effects, visual superposition and settings, one attempts to activate the rooms with events. On the other hand, Kipnis describes the *event rooms of new geometries,* whereby the visual element – the search for new aesthetic forms – is in the foreground with the strategy of *DeFormation.* These projects are based solely on function as the architectural program.

It is not astounding that the new technologies play a leading role in the case of *InFormation.* The event as a designable *entity* elucidates the present-day non-committal manner of the concept of reality which has emerged with the increasing influence of media. Peter Eisenman is convinced: *"In a media-augmented world there is no longer any locality in the former sense. Today, architecture has to grapple with the problem of events."*[4] Concrete experiences – as was customary and possible in traditional architecture – begin to sway in activated rooms. The statically-characterized terms room (space) and location have been long since inadequate to define the *phenomenon* in its entire complexity. In the search for a new type of literary vintage, through which *other conditions could come to light that perhaps have always been immanent or suppressed out of hand in the urbane web,*

3 Jeffrey Kipnis: *InFormation / DeFormation.* ARCH+ No. 131, April 1996
4 Peter Eisenman: *Die Entfaltung des Ereignisses (The Evolution of the Event).*
ARCH+ No. 119/120, Dec. 1993

1 Bernard Tschumi: *Die Aktivierung des Raumes (The Activation of Space).*
ARCH+ No. 119 / 120, Dec. 1993
2 Catastrophe theory, chaos theory, i.e. theories of non-linear dynamics.
Peter Eisenhardt, Dan Kurth, Horst Stiehl: *Emergenz: Die Entstehung von Radikal Neuem
(Emergence: The Origin of Radical New Things).* ARCH+ No. 119 / 120, Dec. 1993

Eisenman encountered the notion of the *V-unit*. This term, which has already been the subject of discussion, especially assumes a form relevant for architecture in the treatises by Gilles Deleuze. In his definition of the V-unit, the form is not a clearly outlined, static object, but rather a continuously fluctuating condition, which has much more to do with expansion. Deleuze therefore describes it as an *object event*.

Another definition of room types also stems from Deleuze. Together with Félix Guattari, he speaks about *smooth and notched rooms* in his *Thousand Plateaus*. Whereas the binding static aspect with fixed hierarchical rules is of immediate importance within the notched room, the smooth room describes more oscillatory connections which are distinguished through a complex simultaneity. *The smooth room is occupied much more from events (...) than from formed or perceived things. It is more of an emotional room than a room of possessions. It is more of a haptic than an optical perception. Whereas in the notched room the forms organise a matter, in the smooth room the materials refer to forces or serve as symptoms. It is more of an intensive than an extensive room – a room of distance and not the unit of measurement. Intensive Spatium (interstitial spacing) instead of Extensio (extension). Therefore the smooth room is occupied by intensities, winds, and sounds, from tactile and tonal forces and qualities.*[5]

It is based on the background of this new conceptual model that the change of educational emphasis within the realm of spatial design is to be understood. The task of designers is no longer restricted to the forming and furnishing of rooms. On the contrary, it concerns comprehending interactive connections, discovering real and virtual spaces. They are expected to design, construct, and reinvigorate with objects without forgetting utility and function. In other words, they are to create localities which are ready to be discovered and to include the factor *mankind* within the appurtenant perceptive faculty. With an interdisciplinary collaboration between architecture, design, and scenography they attempt to link the heretofore clearly separated special fields. The subsequently expanded range of possibilities makes it possible to react more effectively to the altered requirements.

For instance, the project from Steffen Blunk in Senones illustrates how intensively the room and human perception can be affected, and what an impressive result this interaction creates in juxtaposition. The small, economically plagued town in the Vogesen region is part of the *Salm2* revitalization project that was called into being by Mischa Schaub, the director of HyperWerk FHBB in Basel. The objective of *Salm2* is to set up a semi-virtual campus in Senones that is supported by a network of international colleges. The city of Senones provided a vacant Benedictine cloister for the work on this project. Both of the following illustrated projects are now part of an initial, carefully-conceived, temporary occupation phase called *Jungle2*. Separate working units are to be created in the former cloister library, which can be utilized within the scope of a semi-virtual study for workshops lasting several weeks.

To do this, Steffen Blunk installed room-high crosswalls which bear the *obstructed visibility* as a graphically produced image. When those entering are standing exactly at the entrance site, the room appears in its entire vacant enormity. The impression is that there is no project – as if there were no latent temporal inconsistency, which confuses and draws the utility functions into the room. With the entry into the halls, the levels actually begin to shift and the perspectives gradually disperse with every step. An interaction between room and people is created, which is even stronger than in the room. Other than that, no furnishings or other objects whatsoever are visible. This type of room activation exhibits a frame of mind in which *InFormation* is to be understood as defined by Kipnis. In this case, however, there is no need to fall back on the help of new media. Instead solely graphic interventions are needed.

The four works on the theme *future building* are also featured as an example of *InFormation*. For this special exhibit, which was conducted on the occasion of the *Ineltec 2003* in Basel, the students were given the task of staging the possibilities of light management as well as intelligent spaces for living and working in a loft-like building (arranged according to the latest state of technology). This did not entail the exhibition of specific products, but rather the creation of event rooms. With the help of interactive technologies, various approaches to *activating* rooms and blurring or forming virtual limits allowed the designers enormous potential for working with this theme.

In this sense, the selected student works provide a small insight into the *topology of diversity*[6] as characterized by mathematics[7] and discussed by Deleuze and Guattari, which is of major importance for our institute's research concerning *the room of events*.

6 Gilles Deleuze / Félix Guattari: *Mille Plateaux*. Les Editions de Minuit, Paris 1980
7 In their *Mille Plateaux*, Deleuze and Guattari refer to the mathematician Riemann, who rendered the substantive of diversity from the multiple, and thus demonstrated the onset of a typology and topology of diversity.

5 Gilles Deleuze / Félix Guattari: *Mille Plateaux*. Les Editions de Minuit, Paris 1980

The project is focused on producing initial images of the new campus, which make the potential of the *Salm2* idea visible and communicable. With this depicted image, there is an attempt made to generate inter-est and recruit other colleges for the project and to integrate them into the collegiate network. This is based on the statement by Rémy Zaugg regarding the context of the art museum: *"...White is unaffected by colour. In comparison with a wall of some other colour, the white wall is the least loaded with expression, but most strongly present, because it is the most detached and liberated from subjective intentions ..."* [1]. The **(No) Logo** project perceives the strongest of all images to be in the existing, empty room of the former cloister library. The room itself becomes the image, stage set as the image-room.

Room-high walls juxtaposed next to one another obstruct the view into the depth of the real room. Graphically produced images of these obstructed room fragments supersede the perspective and compliment an image room. A zoning of the overall room emerges – a division of the points of view into front and rear, left and right. The perspective defines a frontal, pivotal point of view, from which the room retains its consistency (0-coordinate). When seen from all other points of view, the perspective of the room becomes fragmented in contradictory, opposing sectors from the central perspective. The room becomes

1 Rémy Zaugg: *Das Kunstmuseum, das ich mit erträume oder der Ort des Werkes und des Menschen (The art museum that I dream of, or the locality of the work and the people)*, Publishing House for Modern Art, Nuremberg 1998

Title	(No) Logo
	Install yourself:Temporary
	utilization of the cloister
	library from Senones (F)
Author	Steffen Blunk
Project type	Interior design installation
Year	2002/2003
Exhibition	Jungle2 exhibition, cloister
	Senones (F) 2003. Afterwards
	gifted to the Senones general
	public and the students.
MetaWorx	☐ dvd
	☐ webplatform
	☐ exhibition

groundplan: conception of the room

(No) Logo

an image of itself. What emerges is a collage comprised of room, a two-dimensional image with individuals in motion, who are irritated by their own perception and therefore constantly scrutinize this collage for its accuracy. The second, back-wall side offers free space for flexible working. For this purpose, the crosswalls provide only the most necessary basic supply of electricity and light. The room is perceived as an empty, white sheet of paper, which is without restrictions and can be freely sketched. The performance and alteration of this free space lies within the sphere of responsibility of the users, their requirements, and their visions regarding their work.

Requirement
Install yourself!

Message
There's free space here!
There's free space here which wants to be occupied / altered!
There's free space here to realize ideas / visions!

model photograph: coordinate
(0 / 0 / 0 / 0)

model photograph: coordinate
(x / y / z / zeit)

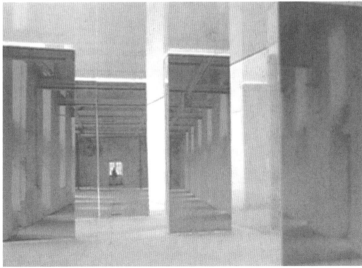

The project demonstrates in an exemplary manner how a piece of furniture emerges from the spatial context, and thereby becomes a room furnishing or a type of furnished room. The focal point is the arrangement of an interface between the existing room situation and the working people. A minimal individual working cell is constructed so that, on the one hand, it enables an individually adaptable working atmosphere; and, on the other hand, it allows different types of congruency to emerge between the people and the cell. There is an ergonomic congruence (an adaptation of room objects to physical proportions), a cognitive congruence (environmental readability), an emotional congruence (emotional reaction to the environment), and a motivational congruence which is provided *"if the environment includes action scopes, if it is suitable, and if it can be personalized."*[1]

The psychological study by Fritz Riemann, *Grundformen der Angst*[2], offered important insights with regard to the utilization of the difficult to gauge congruence theory. Riemann acts on the assumption that with everything which we experience and decide upon, we are influenced by four basic fears in varying degrees of intensity, and from which four personality structures can be derived. Accordingly, he speaks about schizoid, depressive, compulsive or hysterical people, and analyzes their behavior patterns as well as histories. Based

Title	Interfaces
	Adaptive Cells: Temporary
	utilization of the cloister
	library from Senones (F)
Author	Matthias Gerber
Project type	Adaptive furniture installation
Year	2002/2003
Exhibition	Jungle2 exhibition, cloister
	Senones (F) 2003

MetaWorx
☐ dvd
☐ webplatform
☐ exhibition

1 U. Fuhrer: *Person-Umwelt-Kongruenz (Individual-Environment Congruence)*. In: L. Kruse: *Ökologische Psychologie*. Ein Handbuch mit Schlüsselbegriffen (*Ecological Psychology*, A Manual with Key Concepts). Weinheim 1990

2 F. Riemann: *Grundformen der Angst (Basic Forms of Fear)*. Munich 1990

Interfaces

on spatial perception, two different types are able to be deduced from these personalities. On the one hand, there is the extrovert, whose emotional sejunction of his / her social environment represents his / her greatest fear. On the other hand, there is the introvert, whose typical basic fear lies in the fact that he/she is afraid of self-devotion – which he / she experiences as self-loss and dependency – and which is why he / she preferably seeks a secluded situation.

Acting on these findings, the minimal individual working cells should offer the users with the possibility to adapt their surroundings to their individual entitlements and personal moods. And this not merely through complicated and time-consuming alterations, but solely through the physical positioning and alignment in the room. The visual perspective and subsequently the room properties are altered through a rotational motion on the central work seat. A normal, everyday motion is loaded with a second level of significance, whereby a rotational regulator is created for the room atmosphere.

The cells were installed by Matthias Gerber within the scope of a semester project for the Winter Semester 2002 / 2003. They were placed in a window niche, and thereby defined the interface between inside and outside. Visitors to the site had the opportunity to test the object and determine, depending on introverted or extroverted mood, whether they would like to turn towards the countryside or the interior. The back of the chair then respectively compartmentalizes the cells from the exterior or the interior. The various event rooms were able to be individually explored in this manner.

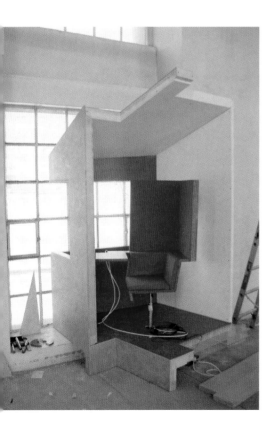

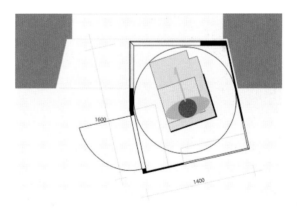

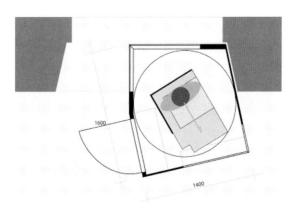

Title	Renderzone
	Future Building: Lighting and
	interior design for Ineltec '03
	in Basel
Author	Hans-Jörg Sauter
Project type	Lighting and interior design
	mockup
Year	2002/2003
Exhibition	Ineltec 2003 in Basel,
	Switzerland
MetaWorx	☐ dvd
	☐ webplatform
	☐ exhibition

The trade fair booth deals with the theme of facades, which it breaks down into various material fragments. Presented in individual wire frames, they constitute a virtual landscape which primarily concerns materialization, virtualization, and the presentation of fluid space respective of the freezing of a time lapse. The virtual landscape takes the form of a group of erratic blocks. The wire frames are covered against those entering with a foil, on which an image of the material piece respectively located therein is projected. And so, visitors are initially shown a virtual view of reality. While entering, however, the real object appears from the side due to the transparency of the foil on which the virtual image is being projected. Behind it, the material begins to liquify as a form of shadow, and thus defines the path to a suspended, translucent platform.

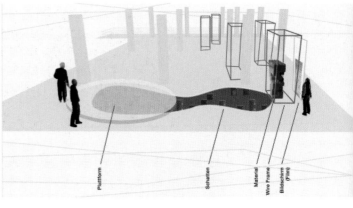

Renderzone

Title	Follow me / Lighting
	Space formation through light
	Future Building: Lighting and
	interior design for Ineltec '03
	in Basel
Author	Oliver Betschart
Project type	Lighting and interior design
	mockup
Year	2003
Exhibition	Ineltec 2003 in Basel,
	Switzerland
MetaWorx	☐ dvd
	☐ webplatform
	☐ exhibition

The limits of developed space are to be solved by means of targeted utilization of light, and flowing rooms are to be subsequently created. The building is presented in the form of spherical bulbs in which those entering are always accompanied by cones of light. The room is defined not through its physical structure, but through the light that moves with the visitors, and through the light islands which surround the exhibition objects. Alternating in their illumination, these appear independent of the people within the room in a determined rhythm, and are always explained by actors. Thanks to the partially transparent building shell, the stream of visitors guided by the light can be perceived from outside. The animated facade lights draw the public's attention to the exhibition inside, where the significance of the play of lights is then understandable.

Follow me / Lighting

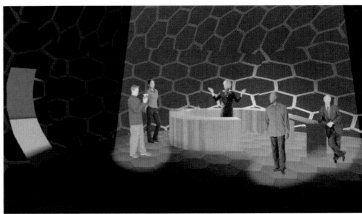

Title	Netz_Raum
	From invisible expedient to
	space-forming element
	Future Building: Lighting and
	interior design for Ineltec '03
	in Basel
Author	Patrick Rothmund
Project type	Lighting and interior design
	mockup
Year	2003
Exhibition	Ineltec 2003 in Basel,
	Switzerland
MetaWorx	☐ dvd
	☐ webplatform
	☐ exhibition

The electronic networking of our working and living environment is becoming more and more complex, and at the same time it is hardly ever perceived by the users. The project **Netz_Raum (net_space)** takes this development as its basis, and provides an addition *stage setting* within the framework of the Ineltec '03. The networked office workplace as well as the requirements which the users address are the focus of attention in this context: communication is ensured by means of an open conference room, whereas *retreat zones* offer space for concentration and relaxation. These fundamental changes are orchestrated by dramatic protagonists on abstract working platforms. The arranged workplace features a high degree of flexibility, whereby it automatically adjusts to the respectively present workforce and is individually furnished for the individuals. The network utilized in this connection is transformed from an invisible medium into an atmospheric, space-forming element.

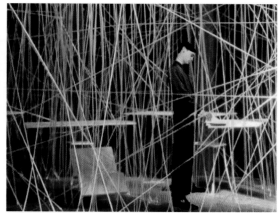

Netz_Raum

An initial zone consists of a band which produces space by means of convolutions, a typical example of *DeFormation*[1]. However, at the same time the concept also comprises the strategy of *InFormation*, whereby the band functions as an information carrier. Both sides are manifest as an LED display and recorded on film. Along the band the theme complex *Building* is compressed and abstractly introduced in the form of three theme ribbons: 1) Live-Your Home is your Office; 2) Work-Your Work is your Life; and 3) Live-Private Atmosphere.

In the second zone, the convolutions in the transverse direction, the overlapping themes of the *Future* are examined: 1) Time and Space; 2) Individual Society and Data Body; and 3) Virtual Construction and Digital Code.

The themes of the first zone are produced in more detail and put into concrete terms in the pavilion in the back.

The band's nodal points and recesses link themes that are actually depicted in other contexts along the theme ribbons. A superposition and overlapping of the combined themes *Future* and *Building* emerges. The visitors interact with the larger-than-life information offer, whereby they repeatedly select, make decisions, extract information, adopt a course (of action), and thus control their personal level of information and knowledge. This pre-information is construed from various fragments into an individual overall idea – **Future Building**.

1 Compare introduction. Jeffrey Kipnis: *InFormation / DeFormation*.
ARCH+ No. 131, April 1996

Title	Future Building:
	Information > Network
	Future Building: Lighting and
	interior design for Ineltec '03
	in Basel
Author	Steffen Blunk
Project type	Lighting and interior design
	mockup
Year	2003
Exhibition	Ineltec 2003 in Basel,
	Switzerland
MetaWorx	☐ dvd
	☐ webplatform
	☐ exhibition

Future Building

Prof. Michael Renner
Head of the Department of
Visual Communication

University of Applied Sciences Basel FHBB
School of Art and Design Basel HGK

Department of Visual Communication

Interactivity from a visual perspective

The Department of Visual Communication: Interaction | Imagery | Typography, at the HGK Basel has radically repositioned its influential tradition at the renowned Basel School of Design. Today, the confrontation with new technology and the subsequent exploration from a visual perspective form an important area of the curriculum and of research and development. In combination with traditional disciplines like typography, imagery, and film animation, new areas of visual communication have arisen which are in between communication, art, technology, and 3-dimensional space.

If one uses the definition of communication as a starting point and conceives this as the exchange of signs for transmitting messages, then visual communication is the exchange of optical signs for transmitting messages. Thus, we find ourselves in the center of the knowledge and experience arena of visual communication. The production of signs, their interpretation, their placement in a context, and their structure is the basic capability of the visual designer. Also included within this context is the competence of organizing and structuring signs. Through this competence, based on the empirical experience of typography, data is being transformed into universally accessible information. Whether we start from interactive media, video, or print graphics, the ability to generate signs, to read signs, and to use them

is important in the context of traditional media as well as in new media. This point should always be considered when we talk about interactive media.

The exploration of interactive media in the Department of Visual Communication developed from the assumption that designers shape how we perceive our world, formulate emotionally compelling messages, and structure information, thus making it generally accessible. Pure technological know-how, as we have seen excessively celebrated throughout the last few years, has thereby never obscured our interest in exploring the medium itself, simply as a means to convey communication.

The term *interaction* can be interpreted in many different ways. Interaction is possible between people, between other organisms, and even between substances. Contrary to many interpretations of the term interaction, the Department of Visual Communication bases its definition on the idea that interactivity originally designates an interrelation between two individuals. Since computer programs were guided by Graphical User Interfaces (GUI), the term interaction in the area of visual communication has been established for the recursive relationship between humans (the user) and the machine (computer). Interaction design refers to the design of the interface between humans and machine, which in turn enables the exchange between the machine and the user. It is obvious that interactive design, by including moving images and designing the form of human / computer communication along with the known design elements, extends beyond the traditional design area of static communication products. Alongside this, the adjacent fields of psychology, computer sciences, 3-D space, and software engineering, run tangent.

In the beginning of the integration of interaction design in the Department of Visual Communication, we chose a method of comparing static and moving images. It was soon realized that the formidable presence of standard software interfaces and the stagnation of the development of innovative User Interfaces was drastically influencing the work of the designer. Most of the results in the area of interactive communication, which were realized up to the middle of the 90's, did not go beyond the area of established functionality and its visualization. Buttons became brighter by Roll Over and were displayed as a word with a one pixel frame. The feedback to the user was celebrated as a great innovation. The HCI (Human Computer Interface) Associations booked record memberships. Soon, the worldwide use of the same software packages and the respective effect on visual design and interaction design was recognized.

In reaction to this, the course of study in the Visual Communication Department focuses since then on a balanced relationship between a wide design experience and specific technological know-how. This

combination contains the potential to escape the dictate of standardization, and to break through the leveling process which has occurred through worldwide use of the same software tools. The basis for an innovative form of interaction design is the communication of the designer with the computer through a computer language. Next to the creative, conceptual, and planning ability, the understanding for the functioning of the medium is a central factor for innovative developments in the area of interaction design and for the development of an appropriate aesthetic of the medium.

The projects on the following pages are successful examples in which the described combination of design and technological know-how can be perceived. It becomes obvious that interaction design not only conveys information and makes it accessible, but also designs a framework in which communication, information, and content can be developed, processed and published. Starting out from a clearly defined introductory exercise (Roman Schnyders' project **Interacting Squares**), with which the basics of programming are introduced, a visual theme becomes the focus of an experimental exploration on the screen. How can the human/computer interaction generate images through a program, make possible the design of animation and the manipulation of video sequences, generate harmonious color compositions or write visual programs? Such questions and their answers interest visually oriented students, and that is why we call these works *Tools for Visual People*. The projects are conducted in experimental environments outside of a strict communication context. They are attempts to explore the computer and to overcome its original meaning as a calculator.

We could have also presented a selection of on-and-off line applications in which the interface design shows clear traces of the experimental exploration. These applied products can be judged like traditional design products under the aspect of the relation between form and content, and become interesting where large amounts of information can be accessed through an appropriate form of interaction design.

A second section of projects that is presented here goes beyond the interaction on the screen with mouse and keyboard and is summarized under the title *Beyond the Screen*. Interactive projects are based today mainly on the interaction between humans and the computer, with the interface of the computer screen (output), the mouse, and the keyboard (input). These known input and output devices neglect many aspects of human scale and 3-dimensional space. The projects *Beyond the Screen* concentrate on the relationship of the human body to its surroundings, and question how information can be visualized without converting the data into pixels or how the computer can be used as an actor in a staged setting rather than as a calculator that merely modifies the screen.

Where does the journey of interactive media lead to after it has come through the disenchantment of the dot-com crisis, and after the events on September 11, 2001 have made us aware of how vulnerable our highly technologized system has become?

The innovation curve of digital technology has leveled off. We have acquired distance which allows us to reflect on the latest developments. What we have experienced in the last decade was the quick adaptation of many areas of life to new technological processes and methods. They have established themselves purely out of economic reasons. It is no longer possible to imagine being without the digitalization of print production, video, audio, and telecommunication. Communication per e-mail has established itself, because messages can be exchanged faster and cheaper and because sending and receiving a message does not have to happen at the same time. In the meantime, nuanced levels of communication, at play in the telephone exchange and transmitted through pitch of voice and accentuation for example, are lost. The disposition of the sender of an e-mail is in no other way present than in the meaning of the text, because personalized factors like handwriting are missing. The introduction of Emoticons is a reaction to this phenomenon, yet they offer at best an amusing compensation. Nevertheless we cannot imagine, irrespective of the amount of pessimism we have towards technology, that we would turn back to communication before e-mail. The challenge for the future is to develop communication systems that work with a more direct notation than the input per keyboard and which show a smaller loss of the periphery of the sent message.

Generally it can be ascertained that: To further develop and establish the use of technology in order to truly fit the needs of the user and not the other way around, will gain in meaning after the first phase of digitalization. In order to forge ahead with advancements, the cooperation between the visual designer, communication expert and technological expert is of growing importance. The works on the following pages point into this direction.

Interacting Squares

Title	Interacting Squares
Author	Roman Schnyder
Project type	Interactive design
Year	2000
Mentor	Michael Renner
Contact	rschnyder@datacomm.ch

MetaWorx	☒ dvd
	☐ webplatform
	☒ exhibition

Two black squares on a white field create the starting point for an interactive exploration between user and computer. Through programming, the squares are assigned different entities and behavior patterns. The squares mutually influence each other, pull towards one another, crash or turn around each other, or simply stay stuck to one another. The possibility to read the interactive process is conveyed by the severe reduction of the design to the most necessary elements.

The user can intervene in what occurs on the screen with the mouse. Yet he or she can only influence one of the two squares at a time, while the other one is controlled by the computer. The different behavior patterns of the squares can only be known through playful testing, in other words through the interaction of the user with the program. The same movement of the mouse can have different results. This leads to unexpected events and provides an alternative way of interacting with the program.

Drawing Machine

Title	Drawing Machine
Author	Roman Schnyder
Project type	Design Software
Year	2001
Mentor	Michael Renner
Contact	rschnyder@datacomm.ch
MetaWorx	☒ dvd
	☒ webplatform
	☒ exhibition

Drawing is the most direct and most basic form of design. While today's current computer drawing programs are limited to the simulation of classic drawing tools like the pencil or brush, **Drawing Machine** explores new, computer specific aspects and principles of drawing. These drawing possibilities are oriented on the collaboration between human beings and computer.

Images generated by **Drawing Machine** always move within the boundaries between a free human gesture and formalized, mathematical constraints. The emerging images are always the product of human drawing as well as of programming processes. Because typical computer processes like cutting and copying help to design the image, we can speak of a computer-true imagery language.

While the prevailing program is specified by the rules of a respective imagery language, the user can learn to speak it and eventually move freely within these constraints – even able to explore a poetic way of speaking. This *restricted openness* allows for ever different images to emerge, in an interactive design process that can be actively experienced as an open collaboration.

The images emerging from the **Drawing Machine** do not design themselves automatically, rather they require the initiative of the user. Once initiated, the designing process self-organizes and develops without the intervention of the user, although he is still free to give new impulses at any point in the interactive process. However, once the process is initiated by the user, the elements are set in motion. The user's decision not to give further drawing inputs is also

processed as information which influences the designing process.
Whether the human-computer interaction is active or passive, the
designed image will always be the product of a mutual collaboration.

Visual Programming

Title	Visual Programming
Author	Roman Schnyder
Project type	Design Software
Year	2002
Mentors	Michael Renner, Angelo Lüdin, Viola Diehl
Contact	rschnyder@datacomm.ch
MetaWorx	☒ dvd
	☒ webplatform
	☒ exhibition

Visual Programming explores how the abstract process of the programmer can be visually experienced, and how simple programs can be designed by pure visual means. The visual content of the project conveys that an image always arises through the development of a program structure. In **Visual Programming,** the programmer becomes a painter, and the program becomes an image.

Within **Visual Programming**, a program structure is not made from text commands but with command symbols. The functional objects are available at the left edge of the screen and are divided into four different groups: the generating objects, the manipulating objects, the visualizing objects, and the transforming objects. In this way, the basic functions of programming languages that generate, manipulate, and interpret values are represented.

The fifteen different functions become active as soon as they are placed on the screen. Here, by means of these functional objects, variable inputs (numbers, or colors) can be created, manipulated, visualized, or transformed. Such input-objects can visually be made to interact with each other through mutual encounters, during which their distinct values are changed. For example, the input-objects can be enlarged, shrunk, duplicated or transformed from numbers into colors and vice versa.

Simple program structures can thus be created through the intentional placement of the functional objects processing variable inputs. This process is not hidden within abstract code, but is fully visualized on the screen. It is also possible to place the object playfully or

chaotically on the surface and to observe what happens. Such experimental arrangements often develop into surprising images, allowing interesting programming structures to emerge that one might not have been able to imagine beforehand.

Once a program structure is designed, the style can be easily changed. The elements of the data currents leave traces behind and in this way generate an image. Depending on the dataflow, the image changes itself dynamically and can be further modified at any time.

Technical Flower

Title	Technical Flower
Author	Roman Schnyder
Project type	Interactive sculpture
Year	2002
Mentor	Elise Co
Reference	www.fhbb.ch / vis_com / beyond
Contact	rschnyder@datacomm.ch

MetaWorx

- ☒ dvd
- ☒ webplatform
- ☐ exhibition

The **Technical Flower** combines all kinds of sensors and output devices into an organic sculpture. The flower needs water to be activated. It reacts to wind, light and sound and responds with lights and movements.

All sensors and output devices are integrated into a single system, in which all of the parts are interdependent. For example, if the flower is not placed in water, all of the functions of the plant gradually weaken until the plant finally dies – that is, gets turned off. The flower consists only of those electronic parts that are essential for its functioning. The function determines the form.

The heart of the flower is a BasicX-microcontroller to which all the sensors are connected. If the water sensor at the root of the flower detects water, the flower is slowly activated. The leaves of the flower are sound input devices that measure the wind and sound level. At the top of the flower, three motors respond to the wind by spinning and illuminating LEDs. An abstract animation on a liquid crystal display shows the level of the flower's activity. At the top, a light sensor measures the surrounding light. If it gets dark, it can even illuminate the water from green to blue.

Bildautomaten

Title	Bildautomaten
	(Automated Imagery)
Author	Andres Wanner
Project type	Installation
Year	2001
Mentor	Michael Renner
Reference	www.pixelstorm.ch/portfolio
Contact	andres_wanner@yahoo.de
MetaWorx	☒ dvd
	☒ webplatform
	☒ exhibition

The **Bildautomaten** – images that paint themselves. Original static Swiss postcard images are continually growing into areas of colorful animation, out of which new compositions keep arising and decaying. The images invent and recycle themselves again and again, allowing for wonderful disorder within the static, tidy, and familiar world.

The project redefines the borders between the image-producer, the image itself, and its spectator: the image becomes its own image-producer over time, forcing the spectator to obey its rhythms. By the slow speed of the changes, the project attempts to contrast the hectic play of instantaneous action and reaction that we know from computer interfaces. Within **Bildautomaten** there is no possibility to interact through direct-control-clicking. They are interactive in a very peculiar sense: the spectator is supposed to interact passively, so to speak, by letting himself be drawn into the image which forces him to continually and actively adapt to the visually perceived changes. The spectator's interactivity consists of submitting and adapting to the animated imagery evolving over time, allowing his constructive interactive contribution only in how he interprets the ongoing happenings.

The animation process takes place in a random way, controlled by very strict constraints. Yet the spectator will never see the same image twice.

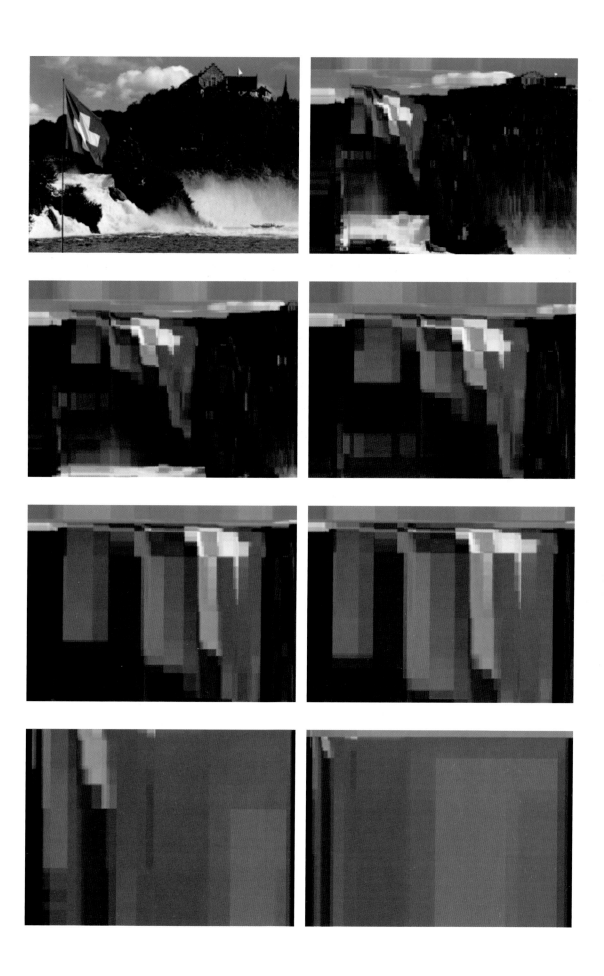

**Lightning – One out of
seven screen-visualizations of
body movements (the picture
was taken by the very camera that
was used for the installation).**

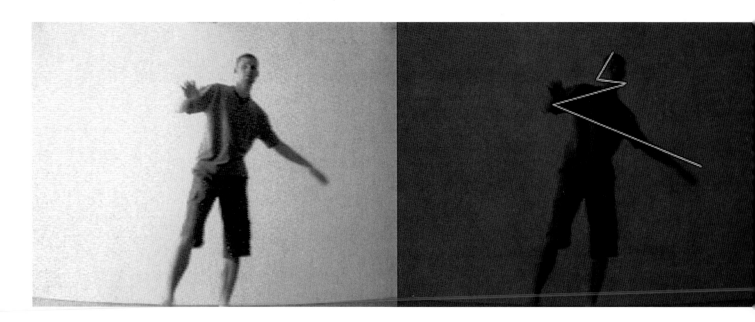

move

Title	move - let your body	
	control the beat	
Author	Andres Wanner	
Project type	Interactive computer-video	
	installation	
Year	2001	
Mentors	Gregory Vines, Peter Olpe,	
	Angelo Lüdin	
Reference	www.pixelstorm.ch/move	
Contact	andres_wanner@yahoo.de	
MetaWorx	☐ dvd	
	☒ webplatform	
	☒ exhibition	

An increasing number of our bodily capabilities are being replaced and extended by technological facilities, threatening to render the human body superfluous not only in the context of work, but also in everyday life. **move** is an interactive computer-video installation that seeks to make our bodies matter, by allowing the user to playfully enjoy his own body's activity.

The installation visually interprets performed movements and immediately displays them, thus encouraging the performing participant to interact with the screened images of his own actions: he can paint compositions, touch and deform virtual objects, and thereby trigger animations.

Different ways of interacting with screen-images are explored within seven surroundings, each allowing the interactive participant to see his own motions – with which he can interact – at the same time that he can see the produced effects corresponding to his own interactions on the other screen. The performing participant can thus develop and discover new body images for himself.

Through the use of a common web cam (80 × 60 pixels) and a regular G4 Macintosh, the installation obtains a low tech character.

Spectator's reactions at the
Diploma exhibition of HGK, 2001,
Kunsthalle Baselland.

Animation Machine

Title	Animation Machine
Author	Dirk Koy
Project type	Interactive design tool
Year	2002
Mentor	Michael Renner
Reference	www.dirkkoy.com
Contact	info@dirkkoy.com

MetaWorx
- ☒ dvd
- ☒ webplatform
- ☒ exhibition

The **Animation Machine** is a tool which allows animations to be experienced. The animation process is a continuous event in which different behavior patterns can be applied to a static object, which in turn transforms accordingly. This event can be directly observed in this project.

The **Animation Machine** consists of seven fundamental objects, property windows, and a navigation bar. The fundamental objects are visualized in the form of points, which, through the navigation bar, can be attributed to a mouse-dependent or computer guided random movement. The property windows can be divided into two main groups: form and movement. The form group contains the properties of line, triangle square, circle, transparency, stroke style, and space. The movement group contains the properties of spirals, rotation, pulse, and stop.

If a fundamental object moves through a certain property window, the specific behavior will be applied to it. The property windows can change in size, allowing for an easier application of their property. They can also be layered, which leads to the addition of the behavior patterns, resulting in a new, more complicated property. Further possibilities exist for dissolving the window frames so that the form and movement expirations can be better observed.

☐ reset 0 ▭▭▭▭▭▭▭▭▭🖃 100 frameview ☐ mouse controlled ☐ random controlled

Light Object Generator

Title	Light Object Generator
Author	Dirk Koy
Project type	Interactive Object
Year	2002
Mentor	Elise Co
Reference	www.dirkkoy.com
Contact	info@dirkkoy.com
MetaWorx	☒ dvd
	☒ webplatform
	☒ exhibition

The **Light Object Generator** is an interactive model construction, producing two dimensional and three dimensional, dynamic light objects.

The generator consists of a foam rubber sheet on which 15 LEDs are placed. The light behavior is navigated by a micro controller, which functions according to different interactive programs. A sensor placed between the LEDs measures the distance between viewer and object, and feeds this variable into the different programs which guide the pulsating rhythms of the light. This means that the light-patterns displayed by the LEDs are sensitive to how far or how close the viewer is to the light object. The foam rubber sheet sticks to a motor regulating the speed and rotation of the entire set of LEDs.

The displayed light patterns, influenced by the position of the viewer and in interplay with the speed and rotation of the set, makes dynamic light objects appear. These objects can either be stationary or in motion. They are sensitive to the complex interplay between the generating machine and the interacting viewer.

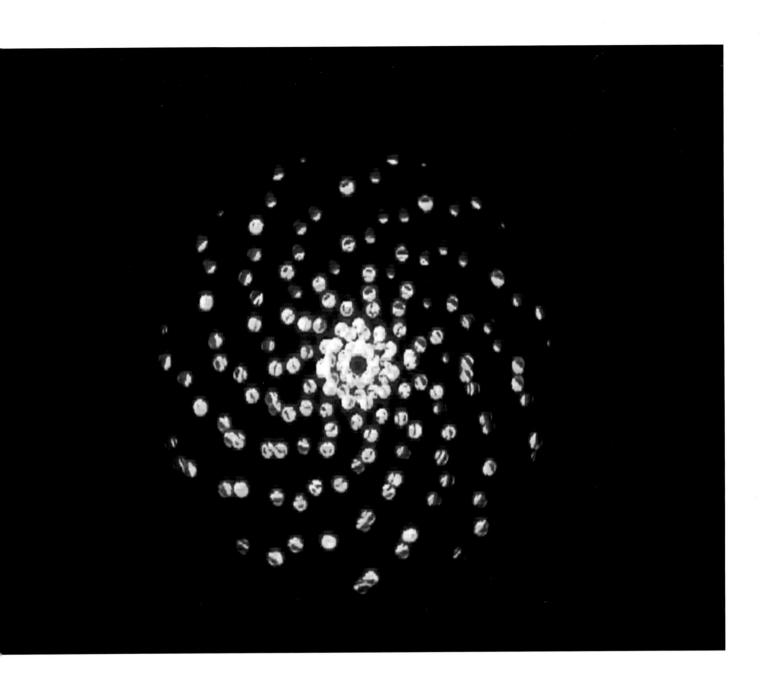

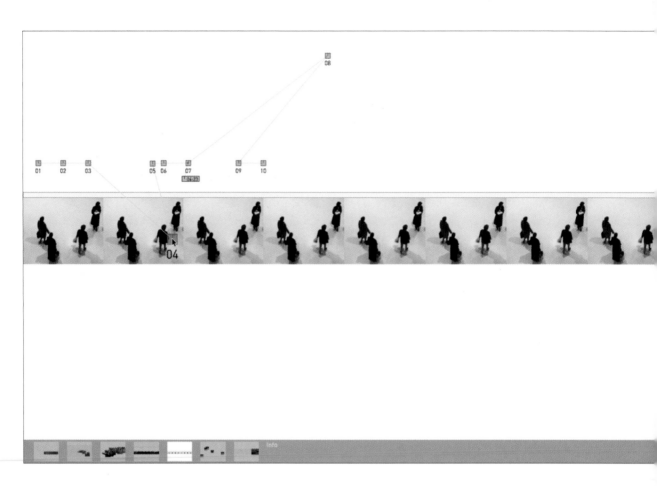

In search of time

Title	In search of time
Author	Nathan Aebi
Project type	Interactive tool
Year	2001
Mentor	Michael Renner
MetaWorx	☒ dvd
	☒ webplatform
	☒ exhibition

In search of time is a conceptual project that explores the phenomenon of passing time as a basis for visual experience.

There are seven short thematic films, each examining a specific aspect of time passing. Time as a continuous movement, or time as spin, are displayed in an attempt to consider time as a force independent from motion. In all seven films, the passing of time can be described in vectors. Each film can be influenced interactively by the viewer. Together with the viewer's movement in space, completely singular definitions of elapsed time can be experienced.

One of the main goals of **In search of time** is to discover a fresh and unusual approach to the way the medium time is represented in our fast moving culture.

Interactive Landscapes

Title	Interactive Landscapes
Author	Thomas Bircher
Project type	Interaction exploration
Year	2001
Mentors	Michael Renner, Roland John
Contact	Thomas.bircher@claudiabasel.ch

MetaWorx	
☐	dvd
☐	webplatform
☒	exhibition

This project plays with the aesthetics of the computer generated representation of reality and shows different ways in which interaction can change or influence the perceived impression of an image. Through the manipulation of photographies, I create representations of real und virtual landscapes which the user can explore interactively.

Like in real landscapes, there are no buttons in the displayed imagery indicating where and how the user can trigger certain actions. Exploring each new scene, the user has to discover for himself how and where the environment is responsive to his interactions. Groping through the landscapes with simple mouse moves or mousedown events, the user will develop a feeling not only for the peculiar materiality, but also for the time and dimension in which the image exists.

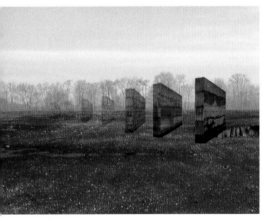

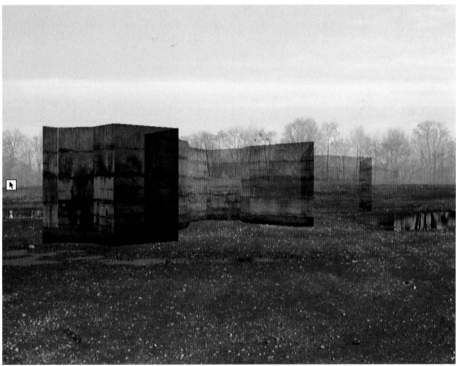

Mischa Schaub ————————————
Head of the Department —————————
HyperWerk FHBB ———————————

University of Applied Sciences FHBB

Department HyperWerk

Interaction as a universal principle

In the debate surrounding interactive media, HyperWerk belongs to the first generation, at least in Switzerland. It all started in 1992, when a financially independent media workshop was founded at the engineering school in Basel for the purpose of pursuing further education, research, and production. Fundamental aspects of how we understand interaction in real life can be seen in the economic models we chose at the time. We chose to operate our joint stock company – which despite the fact that it was not profit-oriented was still operating quite profitably – as an economically and legally independent structure, yet with ties to an engineering school. This basis still exists today. We wanted to hire as few employees as possible. Instead we supported our inquisitive, enthusiastic students with work scholarships. We wanted to work professionally without becoming a commercial agency. We wanted to research in peace and quiet without isolating ourselves. This means that we have experienced interaction intensely from the beginning. We have deliberately become involved in content-related, economic, social areas of tension and have used these experiences as impulses for our work.

We soon recognized at HyperStudio the need to re-educate most of our team workers for the open experience with and the handling of the potential of interactive media. We proposed the creation of a new course of study at the University of Applied Sciences in Basel, and this led to the founding of HyperWerk in 1999. This is also the moment that marks an important shift for us: the shift from designing interactive media products to the design of comprehensive interactive processes.

Interaction in the student team

HyperWerk is set up to be completely interdisciplinary; it was not a regular course of study that was expanded to become interdisciplinary, which is something that has become common today in reaction to the increasingly distinct borders between specialized fields of knowledge.

It was obvious to us from the beginning that we did not want to lay any claims to economy, design, or technology, but that we wanted to look for the mediating qualities in between, that open ground between the pre-existing camps. However, HyperWerk doesn't see itself as being without a clear stand of its own. Instead, it gathers the classical disciplines around itself as a source of enrichment. We are the solid core, the center that combines the rest. But we are not just a turntable or hub; we have our own unique position. We are the only course of study in Switzerland that regards its students as the most diverse team possible and chooses new students with this in mind. This team grows out of diverse yet complementary cultures, areas of experience, and disciplines that are as different from each other as possible. All of these differences come together to create a whole that is both productive and capable.

Interaction as a core competence

In our opinion, design is only useful if it is also economically and technologically valid. Economy is only justified if it does not pursue certain interests that may distort or even damage the general interest. It must always keep an eye on the design of the whole structure. Solutions for the future cannot be established without an integrative design for technology and economy as a whole. An institute of higher education does not make sense if it does not strive to integrate different forms of knowledge and points of view and thereby dare to achieve what is unimaginable today. HyperWerk provides the ideal framework for such a comprehensive approach. Its assessment of the overall point of view as a form of knowledge in its own right diametrically opposes the usual model of specialized knowledge, and this opposition is liberating.

Interaction in the context of social development

Salm2 is the name of HyperWerk's largest project. It started two years ago and is to continue at least until 2015. The project started

with building a long-term, functional reality lab in an abbey, which is 15,000 square meters large, in the town of Senones located in the Vosges Mountains in France. The integration of the many areas of expertise found in the surrounding institutes of higher education allows us to demonstrate how a region can wake up after the postindustrial shock and reposition and reorient itself.

Global interaction

We are participating in a type of globalization that no longer wants to establish the generic world village but that seeks to create concrete, tangible, and distinct spaces of experience through the new streams of information. Furthermore, we want to show how it is possible to live globalization, examine it, and report on it. This is what we are doing in our projects Global Campus and SpiderWerk, for which we are setting up a network of institutional partners in each of the continents around the world.

Interaction between college and society

A college shouldn't be content with just supporting people in their work abilities. In today's world, it should also strive to become a vital counter society, to become a field of experimentation for innovative forms of knowledge work. Such an institute of higher education needs people, departments, and institutes that want to represent, arouse, and support the connections between the many fields of specialization and who have the ability to recognize, formulate, convey, and produce the unfamiliar context that generates innovation.

Interaction with the nature of our task

HyperWerk is increasingly shifting its field of work from interactive media toward the far-reaching transformation process in society. Through the current major project Salm2, Hyperwerk is participating in the outlining of a diverse model for the future for a region in which institutes of higher education should play a fundamental role. The logistic highpoint of this developmental process should be the interaction with the research landscape as such, which we will approach as its own individual set of design problems. We feel the most important pre-requisite for useful research work is the designing of its basic conditions, the formulation of questions to be clarified, and the selection of forms and rituals for gaining and transferring knowledge. Many fundamental questions must be addressed here, especially in the context of design and art.

Bruno Latour from the Center for the Sociology of Innovation at the Ecole des Mines de Paris writes: *The 20th century was the golden age of the laboratory. ... Call it the era of trickle-down science: Knowledge emerged from a confined center of rational enlightenment, then slow-ly diffused out to the rest of society. Today, all this is changing. Indeed, it would be an understatement to say that soon nothing, absolutely nothing, will be left of this top-down model of scientific influence. ... The sharp divide between a scientific inside, where experts are formulating theories, and a political outside, where non-experts are getting by with human values, is evaporating. And the more it does, the more the fate of humans is linked to that of things, the more a scientific statement (The Earth is warming) resembles a political one (The Earth is warming!). The matters of fact of science become matters of concern of politics. As a result, contemporary scientific controversies are emerging in what have been called hybrid forums.*
The World Wide Lab, *Wired Magazine,* issue June 11, 2003)

Interaction with the world of things

Besides our role of bringing together academic skills in new, logical combinations, we see another tempting role heading our way.

Medical technology is far enough advanced that it can now move from its monitor blue obstetric station back to the world of the tangible. In the next few years, it will emerge in our real world, merging with it into smart materials, changing the world in a drastic way. The still unknown forms of this breakthrough will produce an even greater change than the wave of virtualization which is now rolling behind us. This time, it will not be about replacing the world with artificiality; it will be about enhancing the real world through media technology. This is where we will step over the next threshold for designing the future.

Translated by Michelle Miles.

The **deif chair** is a console playing station that explores the potential for consoles to address a wider public through enhancement with interactive elements, which in turn allow for a more inclusive emotional experience.

Console playing today is an activity that focuses mainly on male single-players as a target public. Within the scope of this project, I am interested in how consoles can address different target groups. The **deif chair** is a first step towards the development of new marketing strategies for console terminals.

The interactive chair is being developed for exhibitions and/or events, as a new terminal to present products in an experiential way and as an attractive eye catching design object. The **deif chair** is equipped with different interactive functionalities (vibration, light, sound etc.) and other attention grabbing effects, which are activated independently from the game-action. By situating the **deif chair** in the contexts of exhibition and event, target groups are addressed that had not been attracted to console experiences before.

Even though the console will stay the most important interface, the experience of game and adventure will be extended to new dimensions of product presentation. The **deif chair** will create a sustained experience for any presentation in this terminal. This form of emotionalizing is theorized to motivate visitors to interact with the product in a much more intensive way.

I am fascinated by new technologies, and their possibilities for consoles. This exciting mix promises a great potential yet to be explored.

Title	deif chair (direct emotion interactive feedback chair)
Author	Christian Schefer
Project type	An interactive console terminal
Year	2003
Mentor	Bettina Lehmann
Event	Playstation Experience, 12./13.September 2003 Maag MusicHall Zürich
Support	Sony Computer Entertainment Switzerland
Contact	info@deif-chair.com
Reference	www.deif-chair.com
MetaWorx	☐ dvd ☒ webplatform ☐ exhibition

deif chair

Title	don't beat - TALK! A preventive, interactive video installation
Author	Matt Inauen
Project type	Interactive Video-Installation
Year	2003
Mentors	Bettina Lehmann, Markus Würgler
Collaboration	Matt Inauen, Mike Egle, Christof Seiler, Markus Würgler, Aernschd Born
Exhibitions	Theaterfalle, Jugend Kultur Festival Basel
Support	BAG, SGG, AJFP, Christof Merian Stiftung, IngenoData AG, Sylon Hosting, Theaterfalle Basel
Contact	inauen@dontbeat-TALK.com
MetaWorx	☒ dvd
	☒ webplatform
	☐ exhibition

Anna is sitting at the bar having a drink, waiting excitedly for Andy to join her. Next to her there are Bea and Bela, who are chatting and having a drink. Andy appears out of the restroom door, wearing an artistically made cloth of white silk. Nervously he walks over to Anna. In just a few minutes, a fashion contest will take place where Anna presents her cloth, modeled by Andy. They are sure to win the first prize – a two week internship with an haute couture fashion designer in Paris. Anna places a cigarette between her lips and asks Andy to give her a light. Bela, listening to their conversation and trying to flirt with Anna, hastily pulls his lighter and thereby spills Andy's drink, leaving a dark spot on the white silk cloth. What is Anna's reaction? What is going on in her mind? Today's statistics prove that a lot of young people choose to react violently rather than attempting to resolve conflicts through communication. Unfortunately.

The interactive video installation explores different ways of responding in such situations. Four viewers participate at a time, each identifying with one of the characters in the movie. The viewers decide on the development of the interaction at several points throughout the story by considering what action their characters should take. Through their interactive involvement, the viewers' perspectives are broadened. The goal of **don't beat – TALK!** is to make us more conscious about our own conflict behavior and to increase our conflict competence.

Eye for eye, tooth for tooth – will leave the whole world blind and indigestible …

don't beat - TALK!

Title	Instant Gain in Grace
	An interactive tool fusing dance
	performance and visual media
Author	Dr.Irena Kulka
Project type	Interactive performance
	installation
Year	2003
Coaching	Prof.Mischa Schaub, Dr.Regine
	Halter, Gabriele Fackler
Collaboration	Katherine Batliner
	Nadja Tarnutzer
Exhibitions	[plug.in] Basel 2003
Technical conception	ETH Zürich Dr.Paul Lukowicz,
and development	Prof.Dr.Jürg Gutknecht,
	Martin Gernss, Thomas Frey,
	Dr.Emil Zeller, Holger Junker
Contact	irena.kulka@gmx.net
Reference	www.hyperwerk.ch/ikudoku

MetaWorx ☒ dvd
☒ webplatform
☒ exhibition

A dancer reacting to her own codified movement creates a dynamic *aesthetic emotion space*. The installation, coupling the performing dancer and visual media, returning her own encoded emotional movements to her, drives the dancer – and is navigated by her improvisations – through instantaneously and intuitively created clouds of visual signs.

Wearable sensors as parts of a high-tech chain of innovative real time system components (Bluebottle/Aos with Bluetooth) track the dancer's movements. Whirling up a fragmented imagery for visual feedback, this creation and representation of a codified improvisation establishes codes of interpretation and emotional composition.

The dancer creates her own self-reflexive participatory visual space of backgrounds and approaching pictures, constantly choosing or avoiding certain landings in that abstract space, which are proposed by the image composition system.The dancer's expressiveness is mediated through a system of body sensors, real time movement analysis, semantic movement interpretation and real time graphic composition. This allows for the production of an instantaneous choreography intuitively composed, exceeding the mere tracking and visual articulation. Each performance within this installation transcends the dancer's own codes, gaining grace on the fly.

Dance – a matter of interpreted code and context? It is an ant-hill. Born into a nest of backgrounds, pictures meet from afar. When 'interpretation' is a contemplative experience and memory, we find a relevant kind of trace through the pricking fir needles over obscure corridors. Our medium grows from here.

Instant Gain in Grace

Draussen is an interactive video installation exploring the border-lines between inside and outside, between inner and outer world perception, between the stance of the distant viewer and the involved participator.

Children play hide and seek on a wide green meadow. The landscape's width expands into a little boy's own subjective way of orienting himself while hiding. He loosens his hold and dives into an inner world of utmost intensity, to a place where the viewer accompanies him.

A complex interplay of seduction and conduction starts – the breathing of the viewer has subtle but direct effects on what the boy experiences. Once realizing his own interactions, the viewer can no longer occupy the detached stance of an observer, and is instead involved in a very physical and immediate sense. The flow of the cinematic narrative shifts slightly with the viewer's breathing rhythm: the length of pauses are varied as is the pace of certain events. Narrative time becomes strictly relational, in a manner reminiscent of Bergson's concept of duration as opposed to the objective and linear time of classical physics.

Draussen questions any stable frame of reference by performing how the mutual interplay between time, identity, narration, and play structures our sense of reality in a very complex sense.

Zeit ist kein Rätsel, Alypius. Vergiss es. (Time is not a riddle, Alypius. Forget it.) Durs Grünbein, Aporie Augustinus

Title	Draussen (Outside)
Author	Patrick Juchli
Project type	Interactive video installation
Year	2003
Mentor	René Pulfer (HGK Basel)
Collaboration	Katherine Batliner, Božena Civic
	Uli Franke, Tomek Kolczynski
Support	MAP Bern, Aargauer Ideentopf
Contact	patrick@resurfacet.net

MetaWorx
- ☒ dvd
- ☒ webplatform
- ☐ exhibition

Draussen

Title	Betarhythmica - loop fiction &
	sample remix
	An internet installation
	devoted to the dynamic rhythms
	of everyday life
Author	Anja Kaufmann
Project type	Internet project
Year	2003
Mentors	Maria Dundakova, Peter Philipp
	Weiss, Volker Grassmuck
Collaboration	Constanze Kirmis, Denis Grütze,
	Marc Champion, Marco Jann,
	Thomas Bach and others
Exhibition	[plug.in] Basel, September 2003
Contact	b@betarhythmica.net
Reference	www.betarhythmica.net
MetaWorx	☒ dvd
	☒ webplatform
	☒ exhibition

Betarhythmica is an internet sound environment based on autonomous architecture. The visitor is allowed to dive into an atmosphere of displaced (or rather a-placed or inter-placed) audible fragments, representing envelops of real time and space, which the visitor can remix to create an own looping sound fiction.

The sound fragments are the sound objects of **Betarhythmica**, they consist of situational recordings of acoustic physical environments, audiostreams, and beats. Musical interpretation can be achieved through iterative placement of these objects within different situations in the playground area. Various users can simultaneously meet in **Betarhythmica**, bringing the soundobjects of their choice to be displayed. Once within the playground area, however, the sound objects encounter each other through resonance – that means, they mutually transform each other, depending on the spatial proximity between them. In this way, a dynamic sound environment emerges out of the mutual attraction and communication among visitor and the resonating objects of other visitors.

The playground of **Betarhythmica** is a cyberarea for avatar-gaming: while composing and experiencing your own SoundStorySpace you may be audible to others. You may test your telematic skills by navigating together – or by playing hide and seek.

The sound environment of **Betarhythmica** is in contact with physical environment conditions (wind force, solar energy), which influence the sound objects in their longevity and behavior.

There exists a suggestive parallelism between the emergence of the mathematical concept of function and the awakening of psychology to the concept of relationship. Paul Watzlawick

Betarhythmica

Title	Enter Propaganda
	An interactive spatial
	documentation
Author	Michael Huber
Project type	Interactive spatial
	documentation, CD Rom
Year	2003
Coaching	Miriam Zehnder
Collaboration	Daniel Meier, Marc Champion,
	Urs Suter
Sponsors	ABB Manufacturing & Robotics AG
	Mechan. works Urs Bitterli
Exhibition	[plug.in] Basel,
	2.-9.Oktober 2003
Reference	www.enter-propaganda.ch
Contact	m.huber@hyperwerk.ch
MetaWorx	☐ dvd
	☒ webplatform
	☐ exhibition

Enter Propaganda is an interactive documentation based on the diaries of Victor Klemperer, focusing on the correlation between an individual, political propaganda and its mechanisms. The main intention of the project is to direct one's attention towards the act of story-telling and away from the accumulation and presentation of historical facts.

In his diaries, Victor Klemperer (Victor Klemperer: *I Will Bear Witness*, diaries 1933–1945. The citations are courtesy of the Aufbau Verlag, Berlin represented by the Kiepenheuer Bühnenvertriebs GmbH, Berlin.) accumulated a vast documentation of observations he made during the Nazi regime. **Enter Propaganda** is an interactive, architectural environment built around these observations. It asks the user to find his own way through the documentation space while constantly being exposed to deception, manipulation, propaganda, and censorship.

Based on my interest in oral history – story-telling has a long tradition as a means of revealing and transporting information – I am exploring the potential of interactivity in the context of documentation. **Enter Propaganda** is an interactive environment developed in an editor normally used for 3-dimensional computer games. The user interacts via a special navigation interface.

I am greatly fascinated by the possibilities of real-time interaction in spatial environments that is offered by game engines. With the help of this technology, I have tried to make hypertextuality more sensitive and immersive.

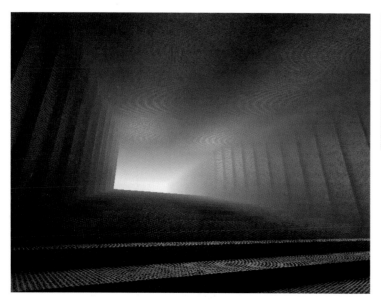

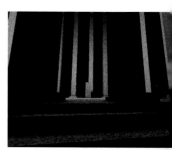

Enter Propaganda

Title	Mahlzeit
Author	Marc Dietrich
Project type	Prototype development
Year	2003
Coaching	Jürg Landert
	(gastro-conceptioner)
Collaboration	Paolo Donnicola, Eliana Favini,
	Tobias Gsell, Stefan Meile,
	Tammo Trantow
Exhibitions	igeho, The World of Inspiration,
	Basel
	foroom.willisau
Contact	m.dietrich@hyperwerk.ch
Reference	www.hyperwerk.ch/mahlzeit
MetaWorx	☐ dvd
	☒ webplatform
	☐ exhibition

Imagine enjoying a wonderfully prepared *Berner Rösti* in a restaurant. Despite the excellence of the food, you feel slightly uneasy. You might not be entirely comfortable with the overall ambience of the place. This is what **Mahlzeit** is interested in – the exploration of the possibilities of interactive systems to please the customer's individual well being at the same time that varying requests are responded to.

Mahlzeit seeks to respect the complex and personal nuances which are at play within public spaces by investigating the possible ways that gastronomy can be enhanced through interactive media. For example, guests might be welcomed warmly by a light turning on, indicating which table has been prepared for them, or decorative paintings might be replaced by lyrical fragments which appear, depending on the dishes that have been ordered.

With a network of designers from the fields of interior design, light design, and industrial design, the collective interest here is interactivity. **Mahlzeit** develops prototypical elements which are presented in the context of the International Trade Fair for Gastronomy, taking place in the fall 2003. A specific target public is to be addressed through a small fair-within-the-fair called *The World of Inspiration*, where innovative solutions within this field are sought and discussed.

By combining architecture / design and interactive systems, I have discovered a new field of exciting possibilities. The permanently new perception of interiors and objects as well as the possibilities of influencing them, is what interests me. However, human beings not technique are always the focus of my true attention.

Mahlzeit

The contemporary global development in work and education, the opening market conditions and the trend towards worldwide networking of production sites has led to an increasing need in mobility in the day-to-day life of our society. Our mobility is supported by telematic products such as cell-phones, laptops, and the World Wide Web. However, in our personal lifes, we remain limited in our flexibility by the generally static focus of architecture and city planning.

Living space is rare in many larger cities. At the same time, there is a great amount of land lying fallow which, in principle, is available for temporary usage. **JayWalker** organizes an event devoted to *New Living Style and Society* in the summer 2003 where questions of mobile space design are to be addressed. In collaboration with architects, **JayWalker** will present a prototype of city furniture. In the form of flexible modules, conceptualized as standardized space-skins, they are intended for limited time spans only. Accordingly, they are easy to transport, build, and deconstruct. They can also cheaply be reproduced.

With our event, we wish to increase people's curiosity about and awareness of new forms and styles of living.

We are talking about major restructurings of our everyday lives, about further growth and condensation of our cities – and at the same time, we still plan living-spaces for the next hundred years, even though we know very well today, that the requirements and conditions are constantly changing.

Title	JayWalker City Furniture
	Jaywalking through fallow lying land
Author	Daniel Pfister
Project type	Assistence in the development and realization of a prototype for mobile city furnishing organization of an event
Year	2003
Mentors	Zai etoy, Bettina Lehmann
Collaboration	NRS Team, Schilliger Holzbau, Blumer-Lehmann
Sponsors	Schilliger Holzbau, Blumer-Lehmann
Exhibition	Tonimolkerei Zürich, Sept. 2003
Contact	dpf@hyperwerk.ch
Reference	www.jaywalker.ch
MetaWorx	☐ dvd
	☒ webplatform
	☐ exhibition

JayWalker City Furniture

Title	SchappeLan
Author	Hanspeter Portmann
Project type	Field research and
	conceptualization of a model for
	an intranet for housing estates
Year	2003
Mentor	Gunnar Krüger
Collaboration	Christoph Bütler, Christian
	Schumacher, Fabian Schweizer,
	Mathis Meyer, Nelly Riggenbach,
	Simon Hänggi
Support	Prof. Marco Della Chiesa,
	Thomas Bruhin, Armon Ruben,
	Max Spielmann, Johannes Vetsch,
	Felix Diem
Contact	kontakt@schappelan.ch
Reference	www.schappelan.ch
MetaWorx	☒ dvd
	☒ webplatform
	☒ exhibition

An exploration into the potential of computer networks to enhance social interactivity and ecological sustainability.

New media (Internet/Intranet) and their tools (computer/pda/mobile phone) allow networks to be constantly accessible irrespective of the place and time. **SchappeLan** conducts a field research in the housing estate *Obere Widen* in Arlesheim BL. On the basis of this work, a conceptual model is being developed for virtual networking among medium size housing estates (approximately 30 to 300 housholds). **SchappeLan** works out the possibilities of virtual community-building for the support, improvement, and extension of informal, organizational, and social processes.

It enhances the individual awareness of the community and its actions as an entity.

The project's main focus lies on the pragmatic aspects of networking for everyday matters like child service, bulk buying, holiday absences, carsharing, bartering, as well as for the exchange of administrative, cultural or personal information services. It is a tool for organizing social events like celebrations, meetings, or other events.

SchappeLan *allows people in housing estates to create new forms of social interaction.*

SchappeLan

FragWerk initiates an interactive dialog. By means of combining new technologies with conventional media, FragWerk is a complex machine that entices people to ask questions – for, as Erich Kästner explained, it is from questions that, what will remain, can develop. (*Die Fragen sind es, aus denen das, was bleibt, entsteht.* Erich Kästner).

FragWerk is an exemplary happening taking place in the summer 2003. The population of the *Appenzellerland* congratulates the canton St. Gallen for their bicentennial. **FragWerk** collects questions from the geographically encircled middle, and offers them to the celebratory St. Gallen.

The local daily papers promote the public dialog between the three cantons. Over five weeks, questions are collected and initiated responses are published. As a second way of exchange, each question is printed and attached to a balloon, carrying the questions across the borders. Some may be found, and even provoke a response, which might find its way back to the initiator by way of post – thus opening a personal dialog between individual persons.

Dialog is initiated in yet another way: the collected questions are radio-broadcast and so initiate responses that are just as volatile as the medium itself, as they will stimulate attention for just a short moment.

To conclude the project, **FragWerk** produces a postcard series from selected questions. This gift will remain after the project and the celebrations end, as it is from questions that, what will remain, can develop.

Title	FragWerk - a project for man and machine
Author	Peter Olibet
Project type	Cultural event
Year	2003
Mentor	Matthias Weishaupt
Collaboration	Daniel Meier, Martin Kappenthuler
Support	Appenzeller Zeitung, St.Galler Tagblatt
Contact	p.olibet@hyperwerk.ch
Reference	www.fragwerk.ch
MetaWorx	☐ dvd
	☐ webplatform
	☐ exhibition

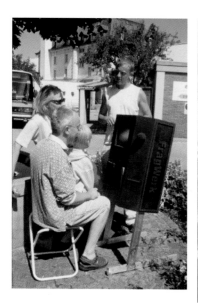

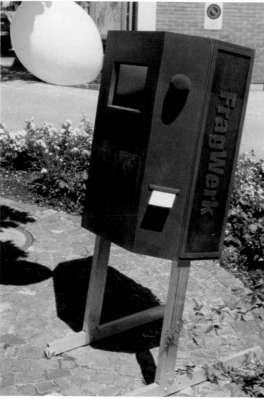

FragWerk

winomat is a modified, digitally enhanced vending machine, placed in a multi-ethnic neighborhood in Basel. In a creative and sensual manner, it guides attention towards questions of cultural diversity, integration, and ecological concerns. How can an intervention in socially problematic circumstances be achieved in a significant, and yet affirmative and pleasurable manner? **winomat** appropriates the seductive moment of consumer mentality with an individual, fundamentally different interest.

Driven by a latent desire to consume pleasure, passively examining what the machine has to offer, the citizen of the respective neighborhood will be surprised to encounter the works and statements of artist, delicious dishes from foreign countries, flea-market curiosities and information on the relevance of ecological sustainability presented in an everyday and accessible way.

winomat is a playful platform for cultural exchange, seeking to overcome social barriers through a low access threshold. It draws on the universally human characteristics of curiosity and desire to be seduced. This moment of encoding the cultural object of a vending machine while at the same time taking advantage of its seductive characteristics, **winomat** performs a gesture of ideological criticism that invites people to get involved.

I see the vending machine as an important wheel in our profit oriented and consumer-driven system. **winomat** *applies its mechanisms to foster awareness to create a broader social and ecological concern.*

Title	winomat - The First Automated Digital Goods & Information Centre
Author	Glenn Hürzeler
Project type	Installation
Year	2003
Collaboration	Artur Jorge Gomes De Carvalho, Lucas Gross, Thomas Martin, Cristina Mösch, Corinne Petitjean, Nelly Riggenbach, Pascal Treuthardt
Exhibition	Gundeldinger Quartier Basel, fall 2003
Contact	g.hurzeler@hyperwerk.ch
Reference	www.winomat.ch

MetaWorx
- ☒ dvd
- ☐ webplatform
- ☒ exhibition

winomat

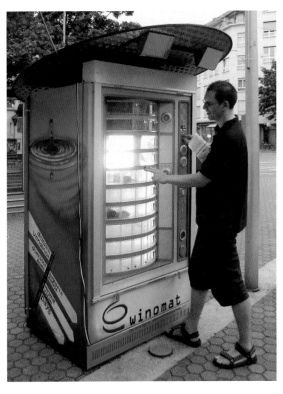

The project explores the potential for intranets to automatically and continually adapt to changing user needs and behavior.

The intranet has become an important means of communication for companies today. For the success of such complex systems as an efficient working tool, it is crucial to know about the user's needs and behavior. The patterns of user behavior, however, are likely to change over time, which reduces the significance of usability tests.

Since it is impossible for companies to afford usability tests every other month, additional solutions have to be found to preserve the efficiency of intranets on the one hand, and reduce the costs for introducing it to new employees on the other hand. Usually, the interactions of users with the intranet are recorded by conventional logging tools. Can certain usability problems be solved by an automatic analysis of generic server or browser logging that would allow the system to adapt automatically?

For whom and under what conditions could automated adaptation improve usability? What would the consequences be? The project consists of broad research. It is an exemplary case study and involves the development of a conceptual prototype.

With the gained experiences I wish to contribute to a bridge between technology experts and novices. Consider usability their mutual language. I am learning to speak it.

Title	Adaptive Intranets?
Author	Angie S.Born
Project type	Research, case study, development of a conceptual prototype
Year	2003
Collaborator	Beat Raeber
Support	Kieran Fagan (Novartis Pharma AG)
Contact	info@tripelle.ch
MetaWorx	☐ dvd
	☒ webplatform
	☒ exhibition

Adaptive Intranets?

As a result of its linear usage, the medium 'exercise book' confronts its limits by trying to link information associatively. **Scribit** offers an extension of the exercise book's functionality by taking it to a more complex, interactive level.

The exercise book as a pedagocical tool for work and storage is very flexible in its usage and has its own peculiar charm. Personal expression through handwriting and intuitive organization of the page offer valuable context information. Can these peculiarities be re-engineered to meet the demands of today's knowledge society?

Scribit is a prototype system that links miscellaneous components of the analog and the digital world to add a digital and functionally extensible dimension to the analog exercise-book. The data written by an analog-digital pen on digitalized paper is stored in the pen's memory and transferred to the Scribit-Server. From there it can be accessed and displayed in a specifically developed web interface. This allows students to combine handwritten contents of the school lessons – be it their own or that of their fellow students – with material of their individual research or personal knowledge. It also allows students to extend, filter and reorganize the contents online. **Scribit** is a powerful solution for schools to integrate content management skills in their curriculums.

As a former teacher, I am well aware of students' difficulty in keeping their exercice books organized and up to date. Knowledge management is also my interest today, and **Scribit** *is a feasible contribution to the current discussions revolving around these topics.*

Title	Scribit
	an idea for guiding the exercise book into the future
Author	Matthias Käser
Project type	Media Integration & Prototype Development
Year	2003
Consultancy	Mischa Schaub (Hyperwerk, Basel), Thomas Bruhin (media sonics, Pfeffingen)
Collaborators	Arne Schöllhorn, Luca Vicente, Michel Pfirter, Roman Borer, Simon Hänggi, Tamara Staub
Support	Hanspeter Meier (ICT-Büro, Basel)
Contact	m.kaeser@hyperwerk.ch
Reference	www.scribit.ch
MetaWorx	☒ dvd
	☒ webplatform
	☒ exhibition

Scribit

A professional, reliable platform is conceived for network visualization for Internet Service Providers (ISP), which may be used by ISPs in any area. This project seeks to ease, accelerate, and qualitatively improve their work.

NETinfo bundles and visualizes all relevant network information for middle and large-scale Internet Service Providers (ISP). Complex data is arranged on different scales, so that different user groups can directly obtain individual information.

In a central database, all of the available data about a network is collected and put into one context. It contains inventory, measurements, accounting, utilization to capacity and marketing data. With the help of a geographical information system (GIS), this data, depending on the intended application, is visualized in 2D or 3D, or made available in a tabular form.

NETinfo is also a concept for the transmission and visualization of data. It allows complete information procurement and network configurations to be made available over one platform only.

NETinfo has been brought to life in cooperation with ESRI Geoinformatik AG at cablecom. Thereby, the latest web-based prototypes of ESRI GIS applications, as well as their own individual developments have been used at cablecom. These circumstances have permitted the developed concepts to be actively acquired, tested, and studied.

Title	NETinfo
	Network visualization for
	Internet Service Providers (ISP)
Author	Armon Ruben
Project type	Software
Year	2003
Mentors	Max Spielmann, Ivo Abrach
Collaboration	cablecom/ESRI-Suisse
Support	cablecom
Contact	info@buendner.ch
Reference	www.buendner.ch

MetaWorx	
☐	dvd
☐	webplatform
☒	exhibition

NETinfo

Title	Dendron - dynamic media collaborations
	Virtual cooperations: a guiding model for the future or the utopia of non-hierarchical organization?
Author	Sam Sherbini
Project type	Development of a semi virtual platform for networking (web tool)
Year	2003
Coaching	Thomas Bruhin
Collaboration	Florian Landolt, Luca Vicente, Thomas Martin
Contact	s.sherbini@hyperwerk.ch
Reference	www.hyperwerk.ch/dendron
MetaWorx	☐ dvd
	☐ webplatform
	☒ exhibition

Dendron

Imagine the productivity, the creativity, and the efficiency that could be released if all small and medium enterprises and all freelancers working in multimedia were to team up. Inconceivable synergies would emerge from such a collaboration.

Due to rapid developments in technology, the working world is undergoing massive changes. These changes have direct effects on the society as a whole, which means, new questions and problems are arising which need to be explored.

Under the assumption that today's markets are defined by an increasing demand of extensive services and a decreasing time allowed to react, the only possibility for small and medium enterprises seems to be the concentration of their efforts on their core competences. By comparison, larger companies can meet this increasing demand by merging or employing lacing capacities. As an alternative, the technical and systematical union of cooperating small and medium entreprises would offer the participants the opportunity to reach the efficiency and diversity demanded by today's markets. In order to exploit the synergies which emerge from such co-operations, **Dendron** is developing a semi-virtual platform for networking, paying respect to the essential relevance of trust and personal exchange which is necessary for collaborations in general.

The goal of this tool is to increase the small enterprise's, freelancer's and student's capacity to act. The main question, though, does not concern developing such a tool, but the means by which the users can be made to recognize the advantages of such a tool, as well as how these advantages can be used successfully.

Title	BarrioCom - Commerce and
	Communication
	Strengthening micro businesses
	with interactive new media for
	real life communities.
Author	Andreas Springer
Project type	Research, Prototype, Management,
	Software
Year	2003
Consultancy	Dr.Walter Egli NADEL ETHZ
Collaborators	Geovanna Muñoz, Beat Muttenzer,
	Marco Klingmann
Taking place in	Ecuador, Argentina, Panama,
	Mexico
Support	Fundación ChasquiNet, World Bank
Reference	www.barriocom.net
Contact	a.springer@hyperwerk.ch

MetaWorx	☐ dvd
	☒ webplatform
	☒ exhibition

BarrioCom introduces a platform for commerce and employment in Latin America, meeting the challenges of creating awareness of e-business opportunities in poor communities and of promoting the virtual marketplace in a region where local content is nearly unavailable on the internet.

The project focuses on the cultural, economic, and governmental circumstances of Ecuador that demand individual entrepreneurial initiative. The unemployment rate is very high in Ecuador, and informal and micro business sectors are growing. Access to ICT is mainly provided by commercial cybercafes or community-based telecenters. Promoting the creation of local content about products, services, and employment in a virtual market while leveraging the existing social and infrastructure networks of telecenters, the platform is being implemented in different pilot networks in Latin America, beginning in Ecuador. This effort follows principles of sustainability and reproducibility.

The project is not meant to offer a new market product but rather to introduce a four-phase process that begins with a collaborative conception of the **BarrioCom** idea. This extends to initial contacts with telecenter operators, the pilot implementation phase and an evaluation phase, during which a manual and training materials are produced to secure reproducibility.

I specialize in content generation platforms for education and commerce. I do not see a solution in the technology of interactive platforms in itself, but as dependent upon accompanying processes that lead to a productive application for generating effective outcomes.

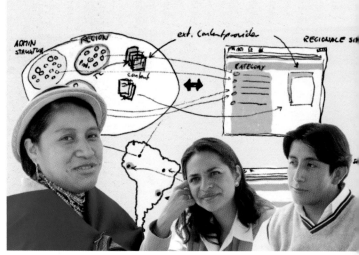

BarrioCom

Title	V.O.N.S. numériques
	New Media for North-South
	research partnerships with
	developing countries
Author	Anja Gilgen
Project type	Field research and
	conceptualization of a
	communication tool
Year	2003
Mentors	Dr.Thomas Lehmann,
	Dr.Ralf Peveling
Collaboration	Beat Muttenzer, Dana
	Wojciechowski, Dieter Berger,
	Martin Matt, Martin Schaffner
	Roland Hunziker
Sponsors	KFPE Commission for research
	partnerships with developing
	countries
	SDC Swiss agency for
	development and cooperation
MetaWorx	☐ dvd
	☒ webplatform
	☐ exhibition

V.O.N.S. numériques explores how New Media can be used to support and facilitate collaboration and communication between intercultural teams involved in North-South research partnerships. Focusing on a concrete research partnership between Switzerland and Benin as a case study, the project is interested in both the interactive conceptualization process of a communication tool and the functions of the tool itself. The main goal of **V.O.N.S. numériques** is to initiate an exemplary learning and working process, with special attention given to how both partners can equally participate and contribute to the process. By recognizing and respecting the different sociocultural contexts, interests, and opinions, ways of avoiding a traditional, hegemonial approach of North-South technology and knowledge transfer are being sought.

Special emphasis is placed on how initial conditions can be designed to foster a conceptualization process which allows new, truly dialogic strategies of interactive technology development to be found and on how the gained insights can be shared.

In order to achieve these goals, the specific needs and working conditions of both partners are being intensely examined. The difficulties, challenges, and opportunities encountered throughout this process are being video-documented and – along with the sketched methods of resolution – arranged into a documentary cd-rom.

Technologies are not mere exterior aids but also interior transformations of consciousness, and never more than when they affect the world. Walter J.Ong

V.O.N.S. numériques

dot:in is interested in photography, in the complex meaning and relevance that visual representations of the world have for our society today. The project initiates an interactively enhanced symposium to the implications of the iconic turn.

Since its invention about 200 years ago, photography has profoundly influenced our way of approaching and investigating the world. Science, art, forms of communication and entertainment could not have progressed as they actually did; key insights could not have been achieved without photography. Despite the impact of photography on our society, there remains an uneasiness concerning how to read and understand visual information. Is there a visual language that we can become competent in?

What are the impacts of new media to photography? Digital ways of producing and publishing images have been developed that tremendously simplify and enhance the production and transport/distribution of photographs.

Light information is no longer transformed into a static chemical structure, but into dynamic zeros and ones, requiring a silicon based life form to be actualized and interpreted.

Many questions arise for our information-based society through the iconic turn. **dot:in** approaches these matters in the form of a symposium taking place in September 2003 in Basel, Switzerland. The symposium is complemented by a cross-media internet forum, allowing for a greater audience involvement by providing a platform where the topics can be elaborated and publicly discussed. The audience is asked to interact and contribute before, during, and after the symposium.

CNN, for example, made up the 1991 gulf war piece by piece and sold us a 'truth' that never occurred in the way it was communicated.

Title	dot:in
Author	Benjamin Füglister
Year	2003
Project type	Webplatform/Symposium
Mentor	Bettina Lehmann
Exhibition	dot:in Symposium 2003
Partners	pepnoname.ch, mkb-group.com
Contact	info@dotin.info
Reference	www.dotin.info
MetaWorx	☐ dvd
	☒ webplatform
	☒ exhibition

_ _ _ _ dot:in
- - - - - - - - - - - -

StatementStation-Trailer

Basic concept Mischa Schaub
Interior design André Haarscheidt, Andreas
 Wenger, Martin Wiedmer
Customization Martin Fehrenbach
Technology Thomas Bach, Andreas Schiffler
Interaction design Christian Zuleger, Marco Jann
Renderings Vladimir Iandovka
Politics Dorothée Schiesser, Catherine
 Ledig, Jean-François Deblock

HyperWerk-Trailer

Art direction Doris Traubenzucker
Production Florian Kutzli, Tian Lutz,
 Christoph Bütler, Christian
 Zuleger, Fabian Schweizer,
 Christina Hagmann, Lukas Meier
Customization Arno Stöckli, Rudolf Wenger

HyperWerk exhibits

Image editing Sabine Kachel
Text editing Vera Bühlmann
Coaching Sabine Fischer
Assistance Tammo Trantow

StatementStation: the StatementStation is an innovative instrument serving direct democracy in times of interactive media. The installation provides the possibility for individuals to create convincing and professional media outputs of their own attitude towards any framework of questions by simple means in a nearly fully-automated way. Statements are video-documented and then directly published on the internet, using the principle of structured discussion as it is known from Internet-newsgroups. Furthermore, it is possible to automatically generate a DVD via recourse to the underlying database. The potential of gaining professional and structured recordings will be of high value for the purposes of marketing (feedback and advertising), citizen action groups, research interests (oral history) and the growing fields of corporate identity as well as for the purposes of institutional quality and knowledge management.

HyperTrailer: the contributions of HyperWerk to MetaWorx are exhibited in a specifically designed Airstream trailer. The peculiar look and feel of this exhibition space hints at the original function of the trailer as living space. With this intermingling of living and exhibition space, we wish to express that our projects are paying respect to the profound challenge for creative work to reflect on the various facets of everyday life.

More than meets the eye

with traditional art practices such as installation art, soundworks, and performances.

For the participation of their students in MetaWorx, *zero1* has decided, conjointly with the departments for media art of Aargau and Basel, to consider interactivity in relation to sound. At a time when the many productions in electronic music have become a major object of consumption and the source of diverse cultural debates, it seemed interesting to prompt students to elaborate upon interactive soundworks while bearing their respective critical and aesthetic stances.

Not surprisingly, most of the projects selected clearly show a complete lack of fascination for technology. Adopting mainly a low-tech approach, the works proposed by the *zero1* students prefer to raise such questions as the evolving roles attributed to art audiences by the increasing use of new media, rather than simply offering comforting game-like displays.

All texts by Pedro Jimenez Morras.

Pedro Jimenez Morras

University of Applied Sciences Geneva HES-GE
School of Fine Arts ESBA

atelier zero1

zero1 – plastic research and multimedia

Atelier zero1 is a second stage interdisciplinary workshop proposed at Geneva's ESBA by Enrique Fontanilles and Hervé Graumann. Most of the dozen students attending it are involved in extracurricular cultural projects.

zero1 is a somewhat informal thinktank devoted to new approaches to computer art. Indeed, similarly to social and economic upheavals, the continuous development of audiovisual technologies constitutes a challenge for artists. These new tools, by ceaselessly questioning the current techniques and know-hows, favor both the research in and the critique of emerging aesthetic possibilities.

It has thus become increasingly important for artists to always be in a position to situate themselves vis-à-vis the upgrading of their tools and to find an approach both playful and critical of the so-called new media. Today, computers and software constitute hyper-tools accessible to almost everyone. These tools indiscriminately combine the most varied media (text, video, sound, still pictures, colour) and permit us to edit them in an equally wide variety of forms.

From word-processing to artificial intelligence, from virtual spaces to robotics, *zero1* strives to be a study and work place connecting the physical and binary worlds. *zero1* focuses its research on the confrontation of new technologies such as the internet or dvd production

Call Me

Title	Call Me
Authors	Alex Muller, Filippo Vanini
Project type	Interactive installation
Year	2003
Medium	Three mobile phones, sound-system, sound effects. Size variable.
MetaWorx	☐ dvd
	☐ webplatform
	☒ exhibition

Mobile phones have probably become the most familiar elements of the technobilia surrounding us in our everyday life. There is hardly a context, by now, where we aren't exposed to their presence. No matter how controversial they may be, even the most reluctant individuals seem to have succumbed to their handiness, not to mention their smartly marketed usefulness.

The imposing presence in the public space of these extensions of our private or professional lives, has also brought a multiplicity of new social practices and attitudes. Cultural etiquette, for instance, has had to incorporate specific rules about minimizing the annoyance produced by the abrupt *ringing* of mobile phones in theaters and other areas of public performance. In a similar mode, school regulations have also adapted to the presence of these devices in the classroom, while the street and the café seem to have remained deregulated free zones for mobile users. The industry has increasingly responded to the annoyance of untimely soundbursts by turning ringtones into buzzes and thus transferring the target of the stimulus from the ear to the surface of the body.

The installation **Call me** intends to take advantage of all the sound possibilities offered by mobile phones, including their vibrations. By simply calling one of the numbers communicated, the audience will trigger a peculiar soundscape. Indeed, the absence of an interlocutor will allow the amplified ringing or buzz to become the source of a specific soundpiece that will last for as long as you keep waiting for an answer. By jeopardizing the communicative function of the

telephone, Muller and Vanini turn it into an electronic instrument
played at distance and question some of the limits of our communi-
cative social patterns.

TinyTin

Title	TinyTin
Authors	Alfred Orla, Théo Quiriconi
Project type	Interactive installation
Year	2003
Media	Tin cans, string, photocopy
	on cardboard, display unit
MetaWorx	☐ dvd
	☐ webplatform
	☐ exhibition

Bringing the people together, as a recent advertisement phrased it, could be a suitable motto for the joyful information society we are all supposed to belong to. But the bright image of a happy global community, gathered amidst the flux of telecommunications, may actually overexpose the individual who is increasingly estranged by an ever-expanding technological environment.

In an attempt to wittily problematize our daily interaction with talking machines, Alfred Orla & Théo Quiriconi have reinterpreted a classic handcrafted toy. Though obviously referring to the primary function of a telephone, the two empty tin cans linked by a simple piece of string also stress the relativity of its communicative possibilities. Packaged as a mass produced article, including a marketing blurb modelled on the one praising mobile phones, **TinyTin** is presented as a newly commercialized product, which questions our upgrade oriented consumerism. The form of this *back to basics* work challenges any overly predictable approach to both sound and interactivity, for it forces the audience into a radical reinscription of the body. Indeed, the ergonomics of the object not only stress the materiality of sound transmission, they also reiterate the necessity of a collaborative effort to successfully produce a one-to-one information exchange.

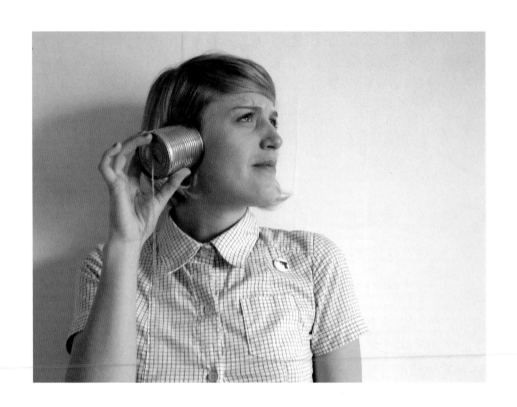

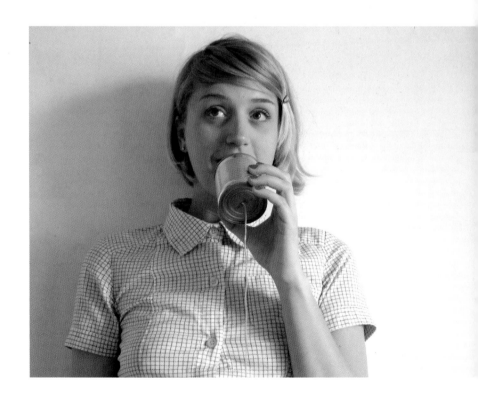

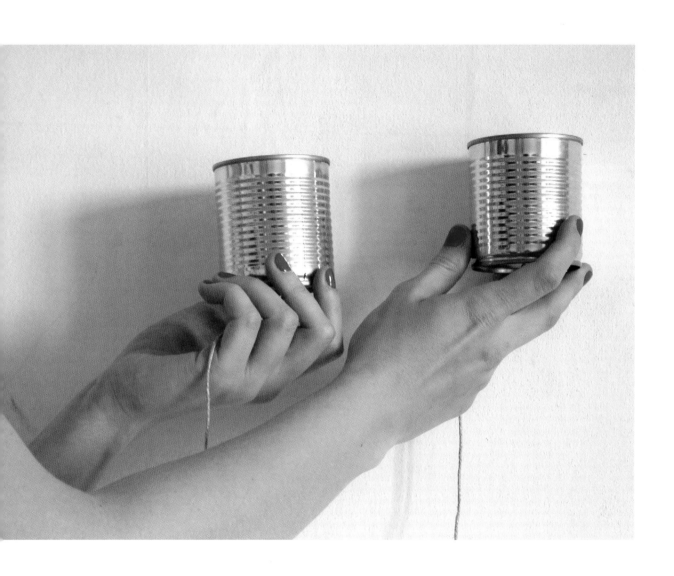

Echo

Auf der Alp

Ausstellungsort

Verbindung ISDN-Anschl.

Compi mit
Telekommunikations-Kit
Desktoplösung

Compi mit
Telekommunikations-Kit
Desktoplösung

Title	Echo
Authors	Martina Loher, Pascal Robert,
	Fabian Stalder
Project type	Interactive Video/
	TV installation
Year	2003
Media	Telephone conference equipment,
	computers, Olympus Eye Trek
	FMD-700 glasses with earplugs,
	microphones, speakers,
	ISDN connection
MetaWorx	☐ dvd
	☐ webplatform
	☒ exhibition

Is there any real difference between someone watching TV in the privacy of a living room and another individual confronting an art video in an exhibition? Is the aesthetic relation attributed to the latter a matter of less passivity? In order to find answers to such questions, the installation **Echo** seeks to challenge the inescapable one-sidedness of our relationship to television.

The moving images we are invited to see as well as the sounds brought to our ears through the headphones, have not been previously recorded. They are the live broadcasts of a mountain landscape. But since nothing, in the image, can certify the veracity of its immediacy, we are given the opportunity to orally interact with that distant location. When talking into the microphone, our voice is transmitted to a speaker located up in a pasture land. We then hear our voice return as part of the ambient sound. Animals and hikers may also react to our words or even answer back.

This acoustic intervention not only momentarily shortens the spatial distance, it also stresses the circularity of the broadcasting system by turning the electronic images into the source of our own echo.

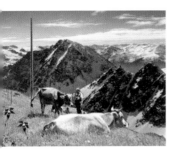

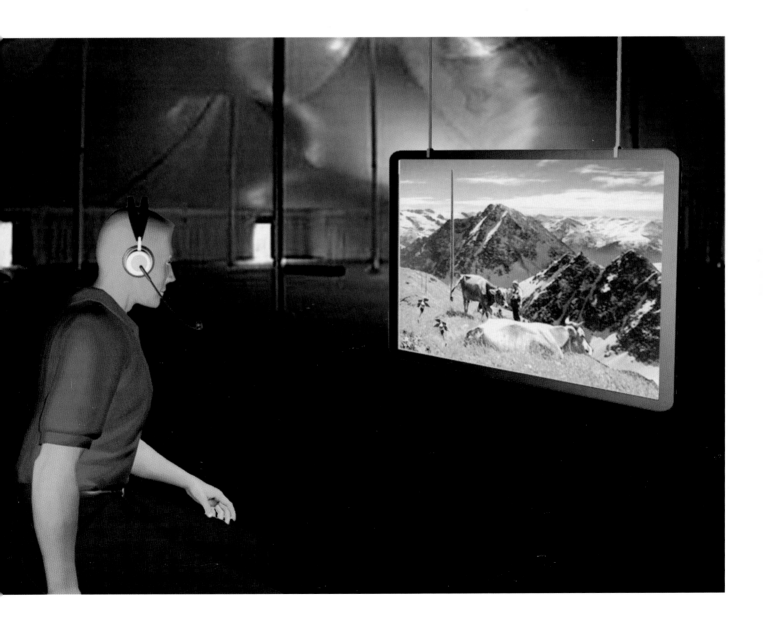

Trauma Zone

Title	Trauma Zone
Author	Stephan Perrinjaquet
Project type	Interactive installation
Year	2003
Media	A battery-operated low voltage electric power release, conductive wire, hooks, poles. Size variable.

MetaWorx

- ☐ dvd
- ☐ webplatform
- ☒ exhibition

The **Trauma Zone** has no stable borders. It can either frame a given territory or channel the entrance to another. Its light materiality gives it a harmless appearance and can almost make it invisible. When confronted with the outer limit of this fenced area, waiting for instance to enter the exhibition space, you may feel some sense of familiarity with this long thin wire, coated in translucent plastic, hardly thicker than a piece of yarn. This structure seems to almost neutralize its holding function and its appealing colourfulness invites you to touch it.

Led to physically interact with the **Trauma Zone**, your interaction will almost certainly produce sound, since you will probably noisily exclaim by coming in contact with this exhibit. You might then remember the familiar context you had been trying to figure out. Grazing cattle are kept away by use of the same device: a low voltage electric wire fence.

The realization of the **Trauma Zone** at MetaWorx will be site specific and variable in shape and size. Up to 50 kilometers can be delimitated and the battery-operated device has an autonomy of 5000 hours.

ONYX.0+33

Title	ONYX.0+33
Author	Manuel Schmalstieg
Project type	Interactive sonic adventure
Year	2003
Media	Cordless stereo FM
	headphones, sound recordings,
	sound transmitter

MetaWorx	
	☒ dvd
	☐ webplatform
	☒ exhibition

A monopolistic national telephone company, a foreign integrated satellite service company with unclear connections to the ministry of defence for a North-Atlantic superpower, gigantic parabolic antennas in the Swiss Alps, an international electronic communications surveillance system.

Ideas for a conspiracy theory thriller? The background of a forthcoming episode of James Bond's adventures? No, only some of the key components in the Satos 3 project, a Swiss surveillance-system that could be used to monitor all satellite-based communications in the country, including mobile phones, and internet traffic. As such, this system is suspected by several observers of being a new element of the global Echelon spy network.

Manuel Schmalstieg's interactive sonic adventure gives everyone the possibility to become a novice spy just by pricking the ears. Equipped with cordless stereo FM headphones, the visitor wanders through the multitrack recordings constituting the dematerialized body of the work. By changing reception channels and by manipulating the tuning button while moving around the exhibition space, the visitor can intercept some of the sounds and voices constituting the aural archive of **ONYX.0+33.** This archive includes press coverage of the debate around this secret intelligence co-operation between Switzerland and the United States.

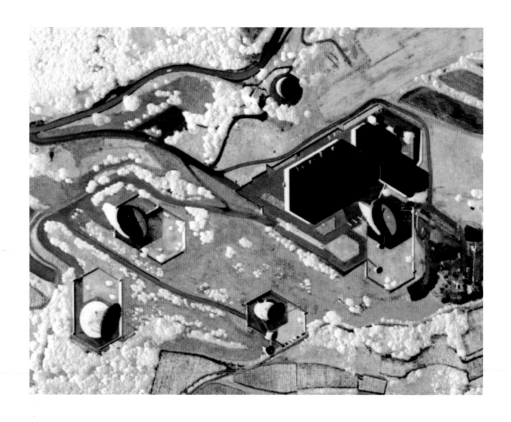

My own rock and roll show

Title	My own rock and roll show
Author	Benoit Guignat
Project type	Performative, interactive sound installation
Year	2003
Media	Speakers, microphone, tripod, cabling, CD player, silkscreen banner. Size variable.
MetaWorx	☒ dvd ☐ webplatform ☒ exhibition

What time does the gig start? One might ask when confronted with this installation, a part of a series of works related to Guignat's *rock and roll project.*

My own rock and roll show is a partial replica of a show stage, reduced to few of its representative elements. The silent status of the potential performance evoked here is permanently challenged by a soundtrack made of a sample of the whistles and shouts from a virtual audience that enhances the feeling of anticipation. As a spectator trapped in the peculiar temporality of something about to happen, you are the beholder of interactivity, by deciding to occupy (or not) the empty position of the leading vocalist, by becoming an act(ivat)or of the installation.

All of the other works in this project address different aspects of the iconicity attached to rock and roll stars, by manipulating fragments of peripheral elements of show business such as stage displays, logos, video clips, posters, etc ... while at the same time carefully avoiding to represent the performance itself.

For Benoit Guignat, the contribution to MetaWorx is a first opportunity to become involved in interactivity as a part of his research and interestingly enough, to participate with this project in a travelling exhibition offers the possibility of a *European tour* for this *rock and roll show.*

MY OWN ROCK N'RALL SHOW

Prof. Giaco Schiesser
Head of the Department of
Media & Art

University of Applied Sciences and Arts Zurich
School of Art and Design HGKZ

Department of New Media SNM

Autumn 1998: classes begin in the *Studienbereich Neue Medien SNM*, Department of New Media at the *Hochschule für Gestaltung und Kunst Zürich, HGKZ* (University of Applied Sciences and Arts Zurich, School of Art and Design Zurich). Educational opportunities in Switzerland in the field of new media are limited: indeed, there are a number of Swiss schools of design and art offering training in the *old* new medium of video as an artform, as well as introductory courses in screen design in the field of visual communications. Nevertheless, with the exception of the Hyperstudio / Hyperwerk – significantly, a department at a technical college in Muttenz (near Basel) – there is no other institution offering training that deals with computers and networks as media in their own right.

Summer 2003: what a change in available educational opportunities! Two new developments are evident:

1. In the meantime, an extensive network of institutions of higher education has been set up throughout Switzerland to offer instruction in the field of digital media.

2. Swiss academies of design and art are prepared, on the one hand, to compete by offering a variety of educational curricula and majors, and, on the other hand, to collaborate with one another as well. *MetaWorx 2003* marks an important stage in this process of development.

From the Beginnings of the SNM...

The point of departure in developing the curriculum put together by technologist Walter Stulzer (faculty associate until 2000), media artists Yvonne Wilhelm, Christian Hübler (known collectively as Knowbotic Research) and Margarete Jahrmann, as well as Giaco Schiesser, a scientist of cultural and media studies, was the conviction that computers and networks are not only tools with which we all work nowadays but also media (like film, photography and literature) with their own special, inherent creative and expressive potential that is an appropriate subject of study. As our publication for prospective students put it in early 2002:

You are all familiar with works of literature, the fine arts, photography, music, film and video. From your everyday experience – whether as specialists or laymen – you are aware that each one of these media has something about it that is essentially its own. What can be written in literature is something different than what can be shown on film. What a photograph captures differs from what a piece of music expresses.

All these media possess different possibilities and limitations that make them unique and inimitable by any other. In technical terminology, this is referred to as the Eigensinn *(literally: willful obstinacy) of a medium. And for each of these media, there is a series of specific aesthetics that have emerged over the course of centuries in some cases, over several decades in others.*

In light of these experiences with media and the history of the various aesthetics, the Department of New Media set up in 1998 has attempted to accomplish something unique in Europe: to educate students who are working in and with computers and networks as media, who are seeking the Eigensinn *of the computerized medium, and who want to find out what can be done with this new medium. After all, despite all the uncertainties of contemporary society, one thing is absolutely clear: the society of the future will be an Information Society or a Knowledge Society, and its foundation will be the digital culture that is, in turn, based on digitization, computers and network linkage.*

... to the Present

Needless to say, that curriculum has continually been updated and refined on the basis of experience gained by students and professors. Nevertheless, we have never abandoned our original concept, which, as we see it, has been confirmed by intervening social developments.

Today, the framework, content and objectives of a course of study at the SNM can be formulated in terms of the following three fundamental precepts:

1. Training in individual and collective media authorship.
2. Working at and with the *Eigensinn* of computers and networks as media.
3. Art as process, art as method. Due to space limitations, I can only go into these key concepts very briefly here.

Training in individual collective and collaborative media authorship means that students ought to pursue their own themes, interests and issues, which they are then to execute in a way that is appropriate to the medium in which they are working. An advantage of the concept of media authorship is that it avoids establishing a fruitless distinction between artistic and applied works. Whether students go on to careers as artists or in private enterprises – either as employees or entrepreneurs – is their decision. The key factor here is that students do not assume the role of an operator who executes prescribed assignments; rather, they act as producers who, with independence and media competence, process content and realize it as a finished project or product.

Working at and with the Eigensinn of computers and networks *as media* proceeds under the assumption that computers and networks have their own individually specific potentials, structures and limitations. Without working on and with this *Eigensinn*, it is impossible to attain media authorship that exhibits originality, radicality and promise.

Art as process, art as method refers to the fact that it is only by means of project-oriented education and ongoing artistic experimentation – the process of incessantly going deeper into a subject, of going against the grain and of subverting or getting away from conventional, commonplace uses of media – that new and innovative artistic and design projects, and thus new possibilities of perception and insight, can be conceived, executed and experienced.

On the Eigensinn of Computers and Networks as Media

What does the *Eigensinn* of computerized and networked media actually consist of? That which is subsumed by the terms *digital spheres of agency, connective interfaces* and *collaborative environments*. If one takes the human-machine relationship to be of seminal significance for work with computers and networks as media, then there are three conceivable approaches: the primacy of the human being, the primacy of the machine, or no primacy at all.

If one proceeds on the basis of the primacy of the human being, then the consequence of this is that the machine is of interest only as a tool. Accordingly, the author sits before his computer and utilizes his ThinkPad as a device to compose the text you are reading just now. This human-machine relationship plays an essential, indispensable role in our society.

If one proceeds on the basis of the primacy of the machine – for which we can take Artificial Intelligence research of the first and second order as a proxy here – primary interest shifts to the development of (neuronal) networks that can evolve on their own. Interaction with human beings is limited to their initial input at best.

There is, finally, the third position: seeking to ascribe absolute determinacy to neither element in the interactive relationship, and focusing on the reciprocal inputs and outputs and their processual nature. This point is the essence of the SNM's educational concept.

Spheres of digital agency means that the interaction between human beings and machines is of interest as a domain in which activity (i.e. inputs from human beings, activities of machines, output to machines and human beings) takes place. Data are processed, modified, reassembled, etc.

Collaborative environments refers to the fact that human beings collaborate in such interactive relationships – human beings who may be dispersed at different locations and do not necessarily work together simultaneously, human beings who use computers that are likewise employed trans-locally, trans-temporally and linked together in networks.

Connective interfaces are those that make it possible for these dispersed human beings to work together with one another. In going about this, these interfaces are not mere technologically determined navigational tools, as is widely assumed, but rather cultural artifacts that can be opened and modified through individual and group usage. They pervade and exert a lasting effect upon our being as subjects and our existence in this world – through the collective generation of knowledge, for instance.

Concept: This project's point of departure was the wish to collaboratively create electronic music and to do so via network link-up of multiple locations. In going about this, we aimed to work with the smallest possible quantities of data (trigger inputs) in order to achieve high-speed sound control at geographically dispersed sites (WAN). And the operation of the entire set-up was to be kept as simple as possible (narrow data bandwidth).

Objective: The objective is to build a production infrastructure making it possible to collaboratively play electronic music as well as enabling the ensemble members themselves to create in a multi-user environment a sound performance that takes place simultaneously at more than one venue / live presentation. The prime concern here is to achieve a balance between the control possibilities of each individual and the interaction of all the performers. Top priority in this regard is to bring across the character of each individual venue / live presentation, whereby the set of samples used in any particular instance can represent any one of a wide range of musical styles. Second of all, the musician on site ought to possess the capability of reacting to the input of the other members of the ensemble, in that he determines how the trigger inputs (which initiate a certain sample at a particular point in time) are utilized. He can fade individual samples in and out and apply additional effects, too. Thirdly, however, there's the essential interaction of the musicians: after all, it's the impulses from the other locations that trigger the samples and make them audible.

Realization: Each individual venue / live presentation features, first

Title	Noisaikk
Authors	Roland Roos, Valentina Vuksic
Project type	Interactive On-site and Network Installation
Year	2002
Contact	noisaikk@unisex.ch

MetaWorx
☐ dvd
☐ webplatform
☐ exhibition

Noisaikk
- - - - - - - - - - -

of all, one *tool / musician* to make the set of electronic samples available (step sequencer in MAX / MSP) and, secondly, *additional tools / musicians* to control the samples of the other musicians – i.e. when which samples are triggered there (shockwave interface). The tools have already been developed, but have only been employed at a single location up to now (one musician and as many as five additional ensemble members on site).

The *Web interface* displays for every user an overview of the impulse being set down – for example, 25 samples and 32 time units (beats). The activities of the *other members of the combo* are thus visible to all. Built-in chat capabilities allow for text messages to be sent to all ensemble members (e.g. instructions and ideas).

The *Master interface* resembles a mixing console. The individual samples are controlled by virtual faders and potentiometers. Small control lamps indicate current inputs, and the use of an external soundcard makes it possible to listen to individual samples via head-phone (pre-fader listening).

Concept: In a dream, we were playing with our genetically engineered creature. Its very appearance made us want to hold it and pet its soft fur. When it was finally my turn and I could hold and cuddle it, I wouldn't let it go. I hugged it harder and harder, and was even more delighted now that it was mine. I was fully aware of the danger to which I was exposing myself – that things would soon reach the breaking point and the incredibly benign energy that emanated from the creature would be transformed into an excruciatingly painful attack in the form of pointy claws that would be driven into my thumb and I, meanwhile, would be bringing my finger closer and closer to the creature's snout. But I paid this no heed and held the creature even more firmly in my hands until it finally set its claw upon my finger and the steel pincer dug into my flesh. Screaming in agony, I tore the creature off me, whereupon it leapt to the next victim and the game began anew.

Objective: An encounter with hate and love in the Infotainment-Tech Age, and the whole thing bundled in a playful application in which feeling simulators and virtual life forms come into use. The execution was to be realized on the basis of simple technology and was intended to make possible some small research results.

Realization: Stuffed animals and rag dolls are by their very nature interfaces with virtual worlds. The **Love Heroes**, cuddly toys equipped with various sensors, are linked to small algorithms that define their psyche. Their mental state changes depending on how they're handled.

Title	Love Heroes
Author	Felix Eggmann
Project type	Interactive Installation
Year	2001-2003
Contact	filitz@gmx.net
Reference	www2.snm-hgkz.ch/~flx/
	loveheroes/
MetaWorx	☐ dvd
	☐ webplatform
	☒ exhibition

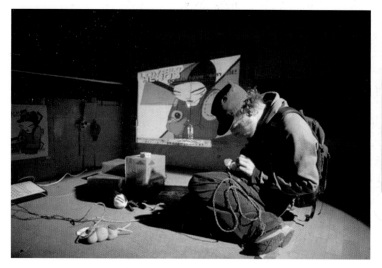

Love Heroes

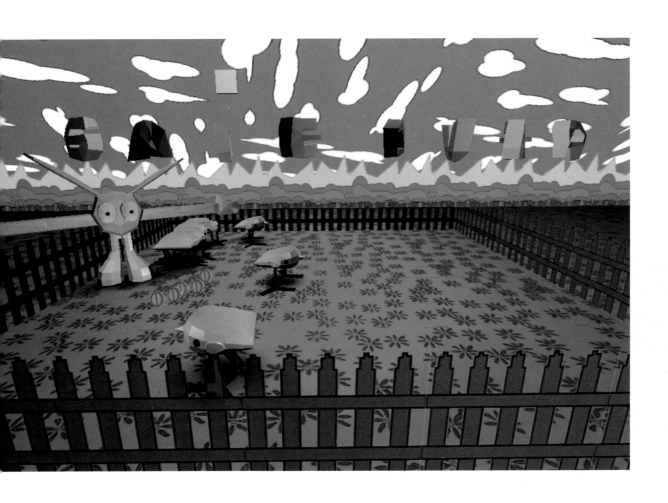

Concept: The radical technological upheavals of the last two decades have made a lasting impact on our lives. We have witnessed the emergence of new worlds that are intruding upon and structurally transforming us and our environment. The space in which we live is increasingly being overlaid with invisible electronic information and is evolving from an analog into a digital data sphere. We go about our lives within an immersive mix of real and virtual worlds.

The city is an outstanding example of these mixed circumstances, changing from a manageable analog data sphere to a complex digital one in which networks of visible and invisible flows and layers of data are superimposed upon the city and engender a condition of permanent tension among physical, virtual and mental realms. This work focuses on this universal process of network linkage and seeks to provide a playful interactive encounter with the productivity of this phenomenon.

Objective: **Re:tour** is an activities setting – that is, a computer program with which the cityscape and the everyday life that goes on within it can be broken down into practical *digital information units* and recombined. This approach makes it possible to generate new urban algorithms that can be printed out as a map and run in the real world. The user can generate individual maps on the visual level in three steps by overlaying geographical locations, activities and spatial filters, and a printer can then print out these maps. A city tour individually designed in this way leads to the fascinating sites of everyday life in the city and, by giving a new spin to familiar everyday

Title	Re:tour
	A journey through the urban
	data sphere
Author	Stefano Vannotti
Project type	Urban Activities Setting
Year	2003
Distribution Medium	CD-Rom
Contact	stefano.vannotti@gmx.net
MetaWorx	☐ dvd
	☐ webplatform
	☐ exhibition

Re:tour

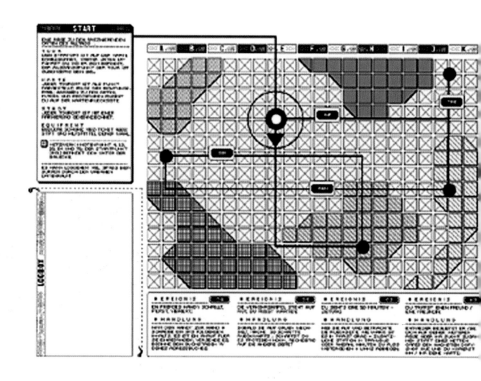

routines, makes it possible to see them from a new perspective. The city can be toured and experienced from completely new points of view. **Re:tour** enables users to cruise and drift through the urban data sphere in the same way that they surf in virtual worlds.

Realization: **Re:tour** consists of three main elements: *software,* the *map and markers in the city.*

The **Re:tour** *software* consists of a graphical interface that gives users online access to the urban data at the **Re:tour** server. A selection of spatial filters is centrally stored in a databank. An additional data set consists of locations and instructions for carrying out activities that typically go on there. A third batch of data consists of a wide variety of procedures and everyday activities, which are themselves, in turn, linked to specific events that are part of everyday life. The **Re:tour** software can be installed on processors running the Windows 2000 or Windows XP operating systems. An additional requirement is a reliable Internet connection since there is a continual exchange of data taking place between the software and the server.

The *map* consists of two DIN A4 sheets. The main element on the front side of the map is the map grid (which the software already recognizes); locations, spatial filters and procedures are graphically recorded on it. On the reverse side, there are instructions for activities and descriptions of spatial filters and routes.

Markers have been set up at the tour locations in the city. These are the first destination at each respective location since they specify the correct spot for properly carrying out the activity instructions.

Concept: In light of the ongoing debates about a *gift economy*, **Luxus4all.org** is being set up as an experimental facility to test a free market for information and its users. Visitors assume the role of co-editors, authors or producers of various media works. This is meant to support the production of public property. **Luxus4all.org** provides a site for a wide variety of information and products available free of charge. Users are able to offer texts, sounds, pictures, photographs, artistic artifacts and all sorts of media both online and offline under various different free licenses as a way to produce public knowledge, products, and property. Publications alone, however, cannot be a strategy to counter the publications industry (including EMI, Nike, Time Warner and others). Additional value must be generated, and this value resides in the free availability of information provided under open license (whereby the right of use is conveyed to the public at large). After all, tools and ideas have always proclaimed a significance all their own in the Internet.

Objective: The motivation to produce goods and services despite the fact that a monetary incentive is totally absent is based on the assumption that one loses nothing when one duplicates property in the Internet. Every producing participant receives in return a yield that is more than fair in the form of the combined contributions of all other participants. Capital is defined here in accordance with Bourdieu as an individual's work that is the product of the investment of social energy and that is accumulated over the course of a social biography (which, within an online community, lasts precisely

Title	Luxus4all.org
	Free of Charge+Anonymous
Author	Mario Purkathofer
Project type	Web Platform and Shop
Year	2003
Reference	www.luxus4all.org
MetaWorx	☐ dvd
	☒ webplatform
	☐ exhibition

Luxus4all.org

as long as the duration of the member's personal activity). In the future, more and more public property will be made available under various different free licenses at **Luxus4all.** With respect to content, the main focus will not be on the reproduction of software but rather on conceptual contributions, small scripts, music, texts and artistic artifacts of all kinds. Anyone who acquires such a product does not obtain ownership of a piece of merchandise but rather assumes shared responsibility for processing it further and for its publication, distribution or commercial exploitation. Even if it might at first seem difficult to give away something one has created, this nevertheless opens up the possibility that others might make something out of it, promote the participant's work or react in some other way.

Realization: **Luxus4all.org** consists of an *online platform* providing open access to free informational products and *physical representations* as well as *facilities* – for example, one in the form of the *Public Net Shelter Zürich* – that attempt to mediate the contents through the use of physical space.

The *online platform* that has been produced for **luxus4all.org** is a mixture of weblog, wiki and *free online system*. Every product is entered into a databank and is assigned its own Web environment (sub-domain at **luxus4all.org**). Here, simple tools are available with which the products can be published, distributed and processed further.

Public Net Shelter was an exemplary facility, a spatial utopia for free information that was open for seven days in March 2003 during the exhibition of diploma thesis projects in *Kunstraum Walcheturm Zürich*. Here, in a simple layout, information could be made available, freely licensed, and offered as open products.

Public Net Shelter is a shop, stage, studio and structure for the production and distribution of public property. It is not merely a shop offering its inventory free of charge; rather, it is a place where material that is not available in this form anywhere else is gathered and made available under open license. Visitors are asked to bring their own ideas, concepts and materials with them in a plastic sack, to write their name and a title on it, and to deposit the whole thing in the library.

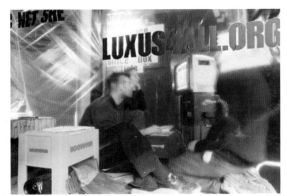

Concept: *Even Flusser, the media theoretician who welcomed the new technologies so enthusiastically, worked with a mechanical typewriter. And one notices that his speeches were also determined by the rhythm of the typewriter on which the author composed the manuscripts.* The dissimultaneity of medial behavior and forms of hybridization are the starting points of this work.

Objective: This small-scale, lighthearted project utilizes interaction to enable users to sensorically experience what the hybridization of an old medium (the typewriter) with a new medium (the computer) can mean. The typewriter as a familiar medium for writing text is combined with a computer to become an input / output interface that dictates to the user his / her own portrait as an **ASCII** image. A new medium combined with an old one transforms a face that has been registered with high-tech equipment into an old low-tech form that makes new aspects of the face visible.

Realization: A Webcam records the user's image, which is dictated via text-to-speech software and visually, typed out on a conventional typewriter in **ASCII** characters, and the result is then printed out on a printer.

Title	ASCII-art: imagewriter
Author	Silvan Leuthold
Project type	Interactive Installation
Year	2002
MetaWorx	☐ dvd
	☐ webplatform
	☐ exhibition

ASCII-art

Title	Slave & Master
	Recombinant Engine
Authors	RAM-Raum Experimente: Anne-Lea
	Werlen/Carmen Weisskopf
	Please Don't Debug:
	Christoph Burgdorfer
	Master Board: Cindy Aebischer
	Free Frequencies:
	Marco Klingmann
	Token Ring: Mascha Leummens
	486 Trash Concert: Roger Wigger
	Packet Radio: Thomas Comiotto/
	Nico Dreher
	Black Box: Andrea del
	Carmen Cruz Gonzales
Media	hardware, software, video:
	interconnected experimental
	array
Contact	slave@hgkz.ch
MetaWorx	☒ dvd
	☐ webplatform
	☐ exhibition

Concept: The basic idea behind the **Slave & Master** Project was to collect and re-adapt old, obsolete hardware. Anything along the lines of techno-junk was to be brought in and re-processed into individual hardware modules. The first step was to check out the various individual student projects to determine – in a re-interpretation of the *hardware handshake* – if they could be compatibly hooked up with each other. Then they were scrutinized with respect to their media-poietic qualities. In other words, they were analyzed with the aim of establishing what can be generated with the material itself without any further input.

Objective: The sole clearly prescribed project goal was to construct an experimental network of arrayed components for all project participants on the topic of the revalorization of outmoded technologies. Everything else was set up in a process-oriented fashion and emerged as the result of permanent experimentation with the hardware and software the participants themselves had gathered. In the human-machine installation – proceeding on the basis of the concept of the *machinic* – the point is to create different kinds of inputs. The machines' structure and architecture provide the first step in the process of constructing this experimental set-up. The experimental modification and reconfiguring of the hardware offers an opportunity to get an introduction into the process of communication among machines and is designed to enable students to acquire practical and theoretical experience with this process.

A certain form of experiential knowledge and an aesthetic experience

Slave & Master

can be generated with the machine itself. The content of this aesthetic is to make the working process, software and hardware structure visible. Furthermore, the machine is interpreted as an array of components that not only produces something but also reproduces its environment. The human being is the essential element in the self-referential machine-like system – first of all as constructor of the set-up, then as observer of the experimental array, and finally as constructor / observer in the process of feeding the results back into the system.

Realization: Separate individual projects generated these experimental arrays, which took the form of a hardware manipulation, old hardware being run with new software, or of an action and an artifact. In a video, in a visual network, in the reflection and application of the machinic as text and as object, the revalorization of techno-junk was carried out and applied in conjunction with a discussion of concepts as to how something old can yield something new and different. The spectrum of the experiments that came out of this idea ranges from an action with a mobile LAN bus in the Zurich metropolitan area, extraction of sound taken directly via microphone from various different hardware components like graphics cards, a war-chalking action via homemade wave LAN antenna modules, and all the way to a pressed computer that can be exhibited in the context of a work of art and thereby newly encoded.

In the *RAM-Raum Experimenten (RAM-Space Experiments)*, tiny components of the computer architecture are tested and discussed in interviews with experts in various technical fields. The paradox of the situation – the fact that even experts are incapable of interpreting certain information such as messages that appear on-screen – becomes apparent, though this is treated in a serious manner. *Please Don't Debug* relocates an ant colony into a machine, the two of which then enter into a symbiotic relationship. *Master Board* ultimately becomes – though worked out only as a concept on paper – the master switch for all other machines. *Free Frequencies* is the basis for all joint actions in the Zurich metropolitan area that are oriented on the war-chalking actions that are establishing themselves in various other cities. They detect wireless networks and hack into them in order to show what can be done where and who's responsible for it. The works on *Video* were shown online with the help of its homemade antenna. *Token Ring* tests obsolete network architectures as an artis-tic concept. *486 Trash Concert* serves as a live performance and a concert sound machine that extracts sound directly from computer components. *Packet Radio* traces the roots of free networks in the early radio networks. *Black Box* discovers its optimal form in a computer pressed into a cube.

MetaWorx – a transdisciplinary project focusing on the
manifold realm of contemporary research on digitally enhanced
interactivity at Swiss institutions of higher education

MetaWorx

Mischa Schaub
President of the association MetaWorx

The forming of an idea

Migros Culture Percentage (a company department managing the
percent of turnover the Swiss retail company Migros donates to cultu-
ral, social and economic causes) has been contributing and fostering
research and art projects within the realm of interactive media since
1998. Meanwhile, an ever-increasing number of projects from conti-
nuously new courses of study developing in the field of new media are
seeking channels of financing. Many of these projects are innovative,
fresh, and relevant, and may be compared to projects found in inter-
national media art festivals. And so it came to be that Dominik Land-
wehr, the head of new media at Migros Culture Percentage, posed the
following question in March 2002: What can we do to convey Swiss
interactive media work to a larger public and vice versa?

One attractive solution soon became apparent: the idea of staging
a supportive framework for productions at institutions of higher
education, where needs and abilities in this area of culture could be
connected with each other in a more efficient, cost-effective, long-
lasting, friendly, and convincing manner.

Mischa Schaub, the head of HyperWerk Basel, developed the first
draft for the project, and this lead to an order from Migros Culture
Percentage to make an attempt at such a supportive framework. This
was successfully carried out after eight months when the associa-
tion MetaWorx was founded. MetaWorx is the result of a balancing
act performed between seven departments at institutions of higher
education, that previously had been competitors within the field of
new media and interactivity and now found themselves eyeing each
other with rather mixed feelings. However, they eventually positio-
ned themselves along one common guideline for the development of
MetaWorx. Of course, since this act of diplomacy had something to
do with interaction, the solution was going to be somewhat obvious:
MetaWorx was given a basic form in the first proposal of important
issues, and this proposal was put together with a wish-list of insti-
tutional partners. Migros Culture Percentage sent this proposal to

potential partners, asking them to first look at the idea, and then together assess whether or not it could be the solution to the initial problem. The idea was accepted, and HyperStudio was awarded the order for planning the project. The promise of the MetaWorx vision convinced several of our busiest partners to climb onboard. After all, who would want to be the only one left behind? One major reason for the project's success was also that every potential partner received a personal visit to discuss points that were unclear, taking as much time as was needed. Then, directly after each visit, Tammo Trantow sent the institutions a copy of the notes kept during the discussions, while realistic suggestions for improvement were incorporated into an updated version of the basic idea, when possible without alteration and to their fullness. In this way, all parties involved were given the opportunity to make the process of forming MetaWorx into their own project.

It was at this time that we located our first exhibition rooms, found a basic concept / metaphor for our exhibits as well as a publisher, finalized our financial plan, organized our work shifts, and harmonized our various responsibilities. The name *MetaWorx* is actually left over from the initial project proposal. Encapsulating our collaborative vision, this name soon stuck and has since been well received.

What is MetaWorx all about?

Is interactivity so important that it warrants the foundation of an entire organization? Haven't people been interacting with one another and with the world for some time now, and this without much problem and without MetaWorx? And as many a clever student has asked his / her instructor, is there really more to interaction than the awkward, unwaveringly boring moment in which you *point and click*?

If this were the case, we would subscribe to these students' contempt. Yet, after a closer look, the depth underlying the phenomenon of interaction is much more impressive than the tip of the mouse pointer first leads us to believe. Because we sensed this depth, we decided to join forces in order to sound it out mutually, systematically, and publicly.

But what does the substance of which interaction is made look like? Who and what does not interact with someone or something? Is this phenomenon not just a rather obvious, basic process about which hardly anything new can be said? It is clear that we had to make our search more precise in order to find land in the sea of banal questions. And because we understand ourselves primarily as artists and designers, we are interested in forms of interaction adhering to a tangible body of rules; namely the interaction system, its structures, interfaces, and rules governing processes below the surface of every single instance of interaction.

What relates many systems of interaction is their digitalization or digital enhancement that has either occurred recently or should occur very soon. We are focusing and limiting our research on this basic fact, and through MetaWorx we address aspects of the production and design of digital, or digitally enhanced systems of interaction, irrespective of whether the system in question is a part of art, design, general discourse, and / or the world of business. Importantly, along our discovery process, we are careful not to overlook the borders. Instead of ignoring restrictions, we acknowledge them as protective barriers which mark the way and keep us from veering to paths which are either irrelevant or misguided.

Feedback: The active agent should be able to realize what he has done. He should be able to see and feel the effects of his own actions (or at least the condensed effects of all previous interactions) in the most direct way possible, without a time delay.

Inertia: The moment of system inertia must be adjusted to the system's purpose. If stock market trading, which can lead to a free fall within its own feedback loop through panicked overheating, needs to be delayed, then something has obviously gone wrong.

These two principles function as a juxtaposition that may be condensed in the short rule: *As direct as possible and as inert as necessary.*

Scalability: The performance of differentiated actions is only possible after an accurate measure has been identified. This principle has long been a basic feature of computer games where it is possible, for example, to personally determine the power of the interstellar atomic bombs – now that is handy!

Identifiability: Albeit not always desirable on an election ballot, it is always very desirable on a purchasing order.

Reversibility: One advantage of digitally enhanced interaction is the possibility of reversing your own actions. Part of the body of rules for a system of interaction should include conditions relating to reversibility.

Transformability: The greater the ease in changing the rules of the game, the greater the variety in the uses available for the system of interaction. However, this not only has its good side; the consistency and reliability of the body of rules are the primary qualities of an attractive system of interaction. Clear documentation of all changes made combine the flexibility wanted with the credibility necessary. This is done in the development of software, for example.

Clarity & Fairness: The rules children use in their games do not come with instructions for application. Their logic is simply grounded in the very soil of society. It is, therefore, no surprise that fun and fairness are so closely interconnected. Each and every system of interaction should honor the principle of fair play. Despite the apparent universality of this principle, it is precisely this supposed solid basis which can become rather fragile when systems interconnect a variety of different cultural spheres.

Positionability: Where do individual action and personal contribution belong within the big picture? Does a single action make an impact? Does it trigger other actions?

Temporality: The values which refer to the current state of a system may be viewed as a dynamically created circumstance. As such they are therefore much easier to understand with the aid of timed notations.

As we have made clear thus far, the creation and design of digital, or digitally enhanced, systems of interaction have much to do with the rules of play. The public test lab of the MetaWorx exhibit should provide us with the opportunity to observe and comprehend not only what the public understands and takes home, but also what it leaves behind. Processing this information into a body of rules should prove to be helpful in creating a subsequent generation of applicable tools and in working with a greater sensitivity to culture. The installation of StatementStation to be used for gathering feedback at the MetaWorx exhibit should serve precisely this function and will accordingly be elaborated upon further below.

MetaWorx as a promise

Throughout this statement of purpose for MetaWorx, it should become obvious that all those responsible for our systems of democracy, marketing, research, mediation, and education have a common challenge on their way to the next generation of these systems. That goal is the creation and design of their own specific digital, or digitally enhanced, system of interaction.

It is not by accident that we have centered MetaWorx exactly as the focal point of this comprehensive project. It is, after all, meant to serve as an exemplary model. However, we do not see our exhibit as a solution per se but as an opportunity to act, to develop new theories, to inspire the public, to coordinate and to serve as a platform for cooperation. We want to express ourselves in the clearest way possible, because we are aware that, in our field of work and investigation, there is a great need to regain public confidence and interest. It is our enthusiasm for popular culture that inspired us to place our exhibit in camping trailers that will be transported to highly visible locations in spaces that are very accessible to the public.

Though the MetaWorx team is interdisciplinary, all those involved share a mutual understanding of themselves as designers and artists. MetaWorx represents a collective search for a new definition of design and its function. For us, design is not about simple adornment or superficial decoration. It is the development and erection of the functional foundation for central social processes. It has emancipated itself to become a force with far-reaching influence.

As it can be seen, MetaWorx incorporates the goal, provides the working platform, and supplies the collaborative representation for the future of design and art in Swiss institutions of higher education.

The goals of MetaWorx

The purpose of MetaWorx is to attract more attention to and gain more acceptance for interactive media work in Switzerland and in surrounding European countries. MetaWorx strives to make the public more aware of and familiar with questions, ideas and interests of digital interactive media work. This work includes the dimensions of design, art and society at large.

MetaWorx supports the solidary partnership between departments at those institutions of higher education which are committed to exemplary research and work in the area of interactive media.
MetaWorx supports the cooperation between departments and is devoted to promoting a fruitful and enriching exchange for all those involved in interactive media.
In order to achieve these goals, we have been instrumental in organizing and publicizing interactive media events, and in promoting platforms and exhibits useful in conveying the importance of interactive media work.

Why we need MetaWorx

After the e-bubble burst, one might be tempted to ask whether or not organizing a traveling exhibit for digitally enhanced interaction could actually meet the demands of careful marketing policy. Clearly, after this rather spectacular flop, there is an obvious risk in so publicly voicing our position in the debate over interactivity. However, we feel that raising the amount of public awareness is precisely where our social responsibility lies. Everyday, we see the digital weather clouds gather with amazing speed, despite the evaporating speculations. It does not matter what name is chosen to label the post-industrial society. Be it the information society, the network society, the knowledge society or even high-tech capitalism – the fact is, this society is inextricably grounded in digitalization. This being the case, it is imperative that a post dot.com crisis be avoided. By this, we mean the profound lack of interest which underlies the allergic reaction which can be triggered whenever to topic of interactive media is raised.

We are committed to our field. We are convinced that, without making systematic progress towards addressing the questions raised in the context of new forms of communication, our society will degenerate into an assembly of paralyzed victims of technology, as it slides precipitously down the slippery slope of pernicious passivity. MetaWorx can be seen then as a symbolic counter model to this danger. It is important to us to gather the courage not only to try, but to try and try again. In order to do this, it only makes sense to work with intelligence and innovation, resolutely avoiding the temptation of following old paths already taken and failed. It is our desire to carry out this process of progress in public as an event where we can present our results within the context of MetaWorx.

It is important to us that we maintain our solidarity as we face the demands of putting MetaWorx to the test, for these are difficult times for our art. It is our aim to sustain and improve all that which we have gained in the Bubble Age. The resilience of networked structures and alliances is to be treasured in the quality of life.

MetaWorx as a prototypical form of collaboration

Never has a media exhibit united and excited so much expertise as the collaboration that is MetaWorx. Our partners can really stretch out and relax in the knowledge that those involved are highly professional. In an area of less than 150 square meters, two established

areas of media studies, an interaction design institute, an area of new media studies, a department for staging space, a department specialized in visual communication, and an institute for interactive video production all come together, each contributing their particular expertise to create a surprising overall effect. Of course, such teamwork is nothing new for companies today. But what is new is the fact that this cooperation is taking place between academic institutions to contribute to the exploration of previously undiscovered territory in the college and university landscape.

We are united by the common impulse of going on a journey. And this feeling is stronger than that it has been for a long time in the uncertainty surrounding today's Swiss college and universities. It is liberating not to succumb to the defensive feeling of helplessness spreading in our country as it faces the rest of the world, and to resist the competition which pits one institution against another.

We have packed our bags and are ready to embark upon our great adventure together, despite the many objections and initial skepticism. The agreements have been signed, and we will not fail to play the part we have agreed to in this dynamic process. At the start of this process, we spent time just becoming accustomed to the idea and, perhaps most difficult of all, gaining confidence and trust. During this time, the intensive involvement of our main sponsor and of our publisher were no doubt the greatest help.

In the face of our initial budget limitations, we became creative. By coordinating three different financial sources, we were able to put our plan of a traveling exhibit featuring a tent and three Airstream trailers into action. This innovative course of action meant that two of our trailers had to be registered in Europe (outside of Switzerland) as they were being financed with European research funds. At the same time, one of the Airstreams was paid for using funding from HyperWerk and was registered in Switzerland. Once we began negotiating with the Department of Motorized Vehicles, it became clear how just ambitious our plan of carrying our exhibit across borders was, given the different regulations in Switzerland, Europe, and the United States. We realized that it was not going to be as easy as we had originally thought – indeed, sometimes our world could be just a little more practical and cooperative.

The potential for collaborative work is seldom realized to the fullest in institutions of higher education, while they combine an enormous treasure of time, involvement and knowledge that seems to be just waiting for a joint purpose. Our greatest hope for MetaWorx is not to show the world what these institutions can do, but to show just how radical such academic group projects can be. By this, our focus is not those predictable academic projects which have already lost their vibrancy by the time they have reached the paper writing stage. Rather, it is our opinion that institutions of higher education should work more for the benefit of their students than they have been doing, by supplying the framework in which student projects can be pursued. By bringing together all our individual abilities and talents in a unified, supportive environment, we place ourselves in the strategic position of getting involved to an extent which far outshines that of the average institution.

Institutions must begin to play a greater role in society as well. By doing so, they place themselves in a much better position to demand those resources necessary to push forward those ideas which can have a true impact upon the society around them. Although the effects of this process upon the social reality are as yet unclear, what is clear is the fact that the pressure placed on institutions from both inside and outside academia should increase if they are to reach their full potential to implement dynamic ideas. For this reason alone, MetaWorx is of paramount importance.

In point of fact, for some time now, the virtual campus has been in service, and we see it as representing the pragmatic use of interactive networking for definite, everyday cooperation. However, to establish a corresponding collaborative social culture, more attention-grabbing events and interactive projects are needed. To replace the comfortable yet stagnating silence which comes from working in isolation, we need to promote mutually beneficial cooperation between partner institutions. This is yet another reason why MetaWorx was created, to form a durable, successful interactive union devoted to transforming opportunity into creative reality.

Like all revolutionary ideas, this new form of intercollegiate cooperation is bound to meet with a certain degree of criticism and skepticism. For that reason, we rely on the protective zone of our public. This is why this event should be sensational and inspire goodwill. After all, we are bringing together an amazing spectrum of medial ability for its production that should appeal to the public, and we plan to take advantage of this.

As artists and designers working in and with digital interactivity, we know precisely how, where, and when our work can affect proactive change in our social reality. Not everyone is conscious of this potential, however. In this day and age, we are witness to widespread blindness in the public consciousness concerning the transformations which are occurring even at this very moment. This blindness does not appear by chance. There has never been a wave of transformation this powerful and all-encompassing yet so quiet and inconspicuous as the one we are witnessing now. For evidence of this assertion, we need only to look to our own environments of higher education. Although considerable energy is being spent in an effort addressing the new relations which have formed in reaction to the new media by initiating new projects such as the virtual campus, there are still far too many who respond to the wave of earthshaking change by trying to erect new walls founded in the same outdated principles to replace those already crumbling down within the educational landscape. Instead, we have recognized that the best reaction to change is flexibility. Academia must accept that the fundamental parameters of education along with the majority of roles involved in collecting and disseminating knowledge have shifted with the concomitant changes in the form and function of knowledge. The internet phenomenon is perhaps both the best expression and realization of this process of change.

From our perspective, this need to virtualization is best understood in light of the dissolution of the old and out-dated limitations of the campus. It is precisely this mixing of the inside and outside, the here and the there, the specialization and reorganization of interests, which is typified by the google-like spatial deconstruction that threatens not only power monopolies, but also institutional hierarchies wherever they be found.

MetaWorx offers the opportunity to have an effect on the educational future via design. Working from the meta-level, our goal is to set an example with our experimental project model and to present our results in a public, open forum. In our opinion, even the most basic questions surrounding design can not be addressed until the issue of design is functionally approached.

Interacting areas of responsibility

From the core of our experience with MetaWorx so far, we may say that the processing of an extensive joint product requires reflecting on our own strengths and weaknesses, our own potential and our limits. At the same time, we hope that the results of MetaWorx reveal our potential in transdisciplinary work that we supposed to be available. At the moment when this text was being written, the overall effect remains hidden to us in the merciful mist of the future.

Of course, our achievements have not been without challenges. Afterall, as the project director can attest, it is not always easy to keep cool in the explosive center of synergetic forces which is generated from bringing together different expertise and departments. All the more reason for us from the very beginning to insist upon and sustain a clear division or project responsibilities based on different partner expertise. As a result, we have been able to rely unconditionally upon the professionals who have come together in MetaWorx. Spurred by their own professional pride and drive for personal excellence in their own discipline, each partner was motivated to give her very best within an open-minded team. Based on this increasingly strong foundation, there is any reason to believe that the promise of this dynamic collaboration will continue to find its innovative fruition.

A new conception of space through interaction

It is well known that the Internet has dramatically altered our perception of space. The actual functions of real space are shifting along with the growth of decentralized and asynchronous forms of exchange, as new tools are creating new processes. This development should lead to new spaces of interaction and to new forms of interaction in space: City spaces, public spaces, social spaces, exhibition spaces, travel spaces, work spaces, living spaces – they are all affected.

MetaWorx will provide the bold, expressive test platform for this innovative purpose. It is not by accident that we have chosen our three Airstream trailers as an unambiguous sign of change and movement. We see these trailers as an expression of our longing to break free and to dare to dream. This longing for something different, something new, some beyond the familiar, beyond the common constraints of the present, is something shared by all avid users of the internet. Of course, we are mindful of the fact that an uncontrolled desire to explore new frontiers at all costs can have disastrous consequences, as can be seen in the uncontrolled, irresponsible *Go West* phenomenon which led not only to atrocities in the past, but which is also not without consequence for the cruel realization of the globalization movement at present. With all this in mind as well, we are ready to move on to meet the future head on.

In our interactive caravans, we can take everything we need with us on our journey. Our trailers make it possible for us to carry with us all the necessities for interacting with the world around, from one station to the next. From a European perspective, the icons for this interface may appear strange indeed. From the AC to the TV, the high tech microwave and the low tech mosquito net, we are prepared for everything that comes our way along our journey. And of course, we will not miss the opportunity to have a bit a fun, disguising and transforming some of the functional trailer exhibit items. After all, the whole message that MetaWorx is trying to convey is that digitally enhanced systems of interaction are changing the entire world, with all its objects and customs. What's more, this change will continiously become more intensive and less inconspicuous in the years to come.

Interaction with the viewer audience

The StatementStation was designed for interaction with the participating audience and should make its debut in the context of Meta-Worx in the form of a large-sized installation. The installation, which is a commemoration of Hyde Park Corner, has a rebellious touch. In using the StatementStation, the average person should first be enabled to preserve their opinion on video in a high-quality recording. Then they can put the recording directly into the Internet and will receive a transmittable version of a virtual round of discussion as an automatically edited DVD. This is an ideal tool for citizens' action groups. In this way, an oppositional position will have been marked out in relation to the e-government's rather technocratic approaches for solutions. This shows that digital technology does not necessarily need to lead to a police state.

In our opinion, the enormous potential of interactive systems has all too seldomly been harnessed to support democracy. After hierarchical corporate structures were reduced, new opportunities for global alliances were created, and countless newsgroups were coordinated, the initial enthusiasm for the benefits of interactive systems began to wane. The StatementStation will rekindle that early enthusiasm felt during the time of alphanumerical interactive technology and direct it towards current media technology. What will in fact happen is that the successful principles of group dynamics in newsgroups

and discussion forums will be combined with video technology in order to create completely automatic documentary films on complex social processes of query. MetaWorx will not only provide a new collaborative exhibit of networked institutions, it will test a previously unknown way of associating with the public.

This book, the web platform, and the DVD are further elements of the documentation of interactive, cultural media work in Switzerland.

The web platform: testing a semi-virtual college in real space

The common belief about e-learning, that courses could be transferred into the world wide web in a cost-effective way, revealed itself to be unsuccessful. When considering the several larger attempts with virtual campus models that mostly only continued the obsolete forms of conveying information and therefore failed, it becomes very apparent that courses and content portrayed as e-learning modules in the Internet principally did not belong in an institution of higher education.

It goes without saying that the Internet is one of the greatest means of educating ever to exist, but this is true only when it is used in a way that fits the medium; as a means of organization, a platform of collaboration, or as a dynamic pool of information. Let us call the whole of the collaborative college and university departments and institutes that are working together, and who become a new unity through such a digital mixture of function, a semi-virtual campus. The participants will still be active in real spaces, though this space has been enhanced with significant qualities. MetaWorx creates the opportunity and the organizational framework, with which this model for a flexible educational landscape in the future can be played out and tested.

MetaWorx sets the pace for innovation

Digital, or digitally enhanced, interaction means the continual, mutual balancing of complex systems with each other. Even with a computer game, interaction involves more than simple mouse clicks: It represents the continuous feedback loop of human perception through a simulation model. Digital and digitally enhanced interaction requires clear principles of direct democracy, relaxed hierarchies, and the principle of the market. All of these factors are dependent on the speed of balancing needs and opportunities.

The opposite of interaction are those programs designed to generate impulses so loved by politicians. These impulses seem to misrepresent the market and also appear to be destructive, as it can be observed not only in the field of developmental aid, but also in the area of personal finance. What is actually happening is that people in power insist that the amiable *watering can principle* should be despised. But what is so wrong in everyone benefiting? Isn't the watering can's appropriate function and friendly intention exactly to leave traces while functioning in a beneficial manner? Does the preferred visibility of effects not gain in significance when the invisible things are pushed aside, beyond the terminal moraine of visibility? True change spreads beneath the surface and occurs subcutaneously. No religious war has brought a church to its knees. Rather, it has always been the general state of society at large which has gradually changed their focus. Effective interaction takes place on a secret, invisible, and intangible level. It comes silently and is accepted as self-evident. Such powerful and quiet events must be considered in careful detail. They must be understood and even controlled with an artistic and gentle hand. Through MetaWorx, we want to pursue our goal of an interdisciplinary, digitally enhanced culture of interaction.

Interaction means more than a form of technology and more than a model of social behavior. Interaction connects both of these elements into an effective whole, which in our case, we call MetaWorx. The opposite also applies: MetaWorx conceives digital, or digitally enhanced, interaction as an up-to-date solution for society to determine its own direction. It remains both unclear and irrelevant whether or not the demand for this new offer is caused by current technology or the reverse. The main point is that a need in society and a technological service are meeting at the right moment. This unique combination then becomes the forceful basis in our breakthrough out of the post-industrial society of the past. Digitally enhanced interaction that is understood correctly and used well creates this common ground, on which the future forms and means of education and work may flourish. Only the wise captain is missing in this nice two-some. For us, this character is embodied in our interdisciplinary structure that should maneuver us around obstacles with elegance.

However, our three-level model of interaction, interdisciplinary work, and digital technology also serves as an opportunity to liberate ourselves from traditional structures that characterize our authorities and our educational and research landscape. We won't be able to talk about an *interaction society*, though we are trying it out here, until these structures have been done away with. We feel interaction society is much more precise and to the point than information society, which has never been very convincing.

A functioning interaction society needs the decisions and strategies from yesterday's leaders less and less as society is becoming more and more at balance with itself. Hopefully, the era of major social acts and the political muscle-flexing is over. Strategic impulses, five-year plans and support programs should soon be officially obsolete instruments. The continual balancing of instant communication characteristic for our decision and diffusion processes appears to be much more constructive and gentle. The lasting effect of decisions made on such a basis can scarcely be surpassed.

What can develop from a simple get-together

Could it have happened any differently? MetaWorx is not only the result of a friendly gathering of projects. More than that, it continues to function as a deliberate combination of media to create a surprising mix, representing a broad spectrum of hybrid media forms. This mixture ranges from a school notebook with internet links to dormitories with sheep games.

How MetaWorx supports interactive processes

This system may sometimes play host to a guest lecturer or a client, but other than this, the system is basically insular. This fact clearly depends on the sober reality of geographically based financing, through which local administrations have essentially established their own miniature kingdoms. Although no one would seriously think of starting an aerospace research program on the basis of regional financing, the financing of our college and university landscape is based on just this sort of dubious organization. Current research in the area of media, however, simply requires a national and international infrastructure that individual regions simply cannot supply. One may argue of course that comprehensive general programs for research provide exactly this. However, such forced cooperation only lasts as long as the funding does.

This is where the promise of MetaWorx lies; in establishing a basis for long-term, intercollegiate, horizontal cooperation which is truly liberating. Breaking free from the constricting ranks of in-house cultures represents those participating in MetaWorx the greatest hope. We have, therefore, created a framework that requires us to take sides publicly, meaning that either we have to withdraw or take an active role.

Not a research program, but a program for research

MetaWorx should not serve as competition for the already existing support structures in research but rather it should develop, for those participating, a previously unreachable quality in our joint appearance and production. However, there are, for example, such foundations as Science & Cité (www.science-et-cite.ch), which aims for a conveyance of college and university work that is representative of the general public's interests. Furthermore, almost every institution of higher education has employees specialized in public relations that try their hands at house newspapers and exhibits of last-year projects. These efforts are always well meant, but they are often not convincing. In the area of media art and design, those active in the concrete departmental work should be adequately qualified to work in their own areas in a convincing way and they should not let these be taken care of by a third person. Those working in media are lucky enough to be able to use their research time in order to develop and test a

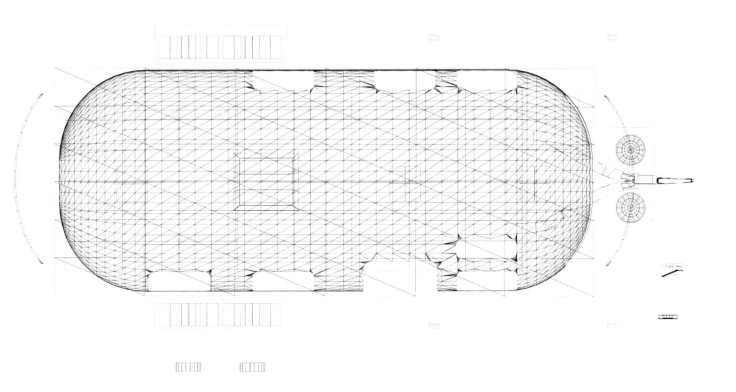

convincing message. MetaWorx contributes its ideal framework to this, with its regulated appearance. We have designed a long-lasting testing ground that should be more up-to-date, the more it is allowed to transform. In this way, MetaWorx positions itself as the actual process and instrument of research. It shouldn't take long until MetaWorx is seen as a researchable object of future-oriented didactics.

At a time when finances are particularly tight, the heretical question which must be asked is whether or not the ways of making decisions involving research projects should be re-examined. Shouldn't a top priority of research programs be the creation of a basic set of conditions, instruments, and rules which would make writing applications, finding partners, making decisions, implementing plans, modifying plans (to say nothing of the practical, artistic, and economic factors involved) more time and cost efficient? The first signs of this process may be found in the research landscape of the European Union, or at *www.cordis.lu*. But they are not to be found in Switzerland. It is quite clear that what would help our software industry, for example, is a supportive framework or system of production such as Sourceforge *www.sourceforge.net* which has been in successful operation for many years now.

Research should be understood as communal work that is directed at the future, where no applications must be submitted to commissions, but where those actively participating develop their shared projects in public for all to see. Of course, this dream model could only work if credible and efficient forms were developed for a comprehensible

system of monitoring. Interactive media create the ideal basis for establishing the transparency necessary for the public so that the abuse of such an open offer may be avoided. For reasons of practical implementation, the community of participants could choose their own moderator and coaches. Such a framework of research would also function as a job market and advertising platform, as a virtual community and, most of all, as a provocative challenge. MetaWorx will demonstrate how such a shared performance can be carried out on a very small scale. In our case, all negotiations were conducted together, and roles such as project leader, book designer, and trailer designer were all divided amongst themselves by those participating at one team meeting. But this is not what is so innovative about MetaWorx. What is unusual here is the fact that we do not have a clear, pre-defined project with milestones which must be carried out in accordance with a contract. Instead, we have a productive structure that is flexible enough to change. In short, it is a real education company.

Though this seems to be an odd idea, we believe that research projects should be fun – this is the only way to get knowledge workers to give their very best. Hardly any research program can actually claim such a friendly quality of open-mindedness, if we may say so. The forms, regulations, and reports are usually of unfortunate predominance. The impression may arise that the actual, subconscious purpose of state-supported research programs might actually consist in the obstruction of the very desire to conduct research. Once again, an interdisciplinary culture of interaction would do much to improve this situation. We do not need drained government workers but teams of gifted information designers working with comprehensible

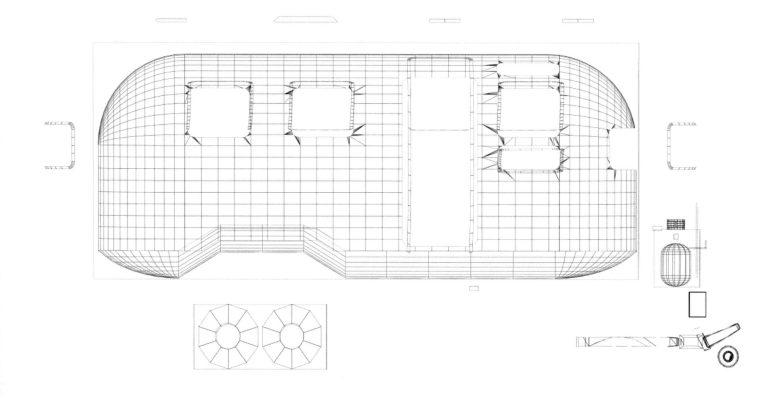

writers, and clever bookkeepers working with sociologists who make up the rules of the game. Such people would create humane, applicable basic conditions for a state-sponsored research culture. Today, we can only dream of this vision from the distance. For most of us involved in research, even filling out a tax form is more fun than going through the humiliating process of justifying our research projects on application forms.

In view of all that has been said thus far, it is in fact amazingly obvious how MetaWorx has been able to find its niche in the market. Growing almost organically after several months of germination and fertile talk between participants from all areas of media art and design, MetaWorx has been able to meet a need for dissemination that will only increase as the public's insecurity regarding the so-called information society continues to grow. What is vital for all of the participants is the continual expansion of their original pledge, because MetaWorx is about continual, honest self-appraisal in service of producing creative, innovative, and impressive media art and media design.

Interaction with the future

We are deliberately avoiding making statements of intention or making predictions for the future scenarios of MetaWorx 2005, because we hope that our next appearance will be different, unimaginably different, from our present trailer exhibition. In fact, the only thing we know for certain where our future is concerned is that our exhibit should follow a two-year rhythm. This rhythm was decided on because, even though we feel continuity is necessary for our production, we do not want to fall into a yearly routine. Moreover, given the fact that an annual rhythm already characterizes our normal, academic lives, we must admit that we are grateful to work with a different rhythm.

In order not to lose our continuity of public presence, however, we plan to organize events in the off years. This means that we plan to have our first conference in the fall of 2004, when topics concerning the design of an ideal state sponsored general program may be formulated for our research in the creative areas.

Another reason for our decision is that the generations in technology roughly last two years. We plan to be able to react creatively to this exchange with our tools. There is hope that MetaWorx might be the one to set the pace in the mid-term. But, it might also be the case that it becomes the agent keeping track of the design and keeping abreast of the changes which occur each technological generation. It is through this performance and accomplishment that the metalevel of our media work will make a difference for today and tomorrow.

Translated by Michelle Miles.

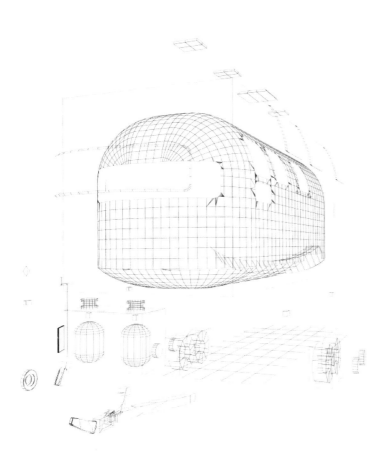

Bahnhofstrasse 102
CH-5000 Aarau

Phone +41-62 832 66 66
Fax +41-62 832 66 65
g-info@fh-aargau.ch
www.fh-aargau.ch

University of Applied Sciences Aargau FHA

Department of Design and Art

The Media Art study program

The Department of Design and Art at the University of Applied Sciences Aargau offers programs for Industrial Design and Media Art. These two programs are very closely intertwined in the foundational level of education, where students gain technical, practical, methodological, theoretical, and art/design knowledge. The project modules help to orient students in media artistic and interdisciplinary thinking and practice.

The program lasts 8 semesters and is divided into the foundational level (2 semesters) and the main undergraduate level (6 semesters). The program starts in October each year. In the 5th semester, students either spend an exchange semester at a foreign institution, or they work in an internship program in Switzerland or abroad. Students complete the foundational level with an intermediate degree (Vordiplom). During the 8th semester, students work on their diploma degree projects. On passing the diploma examination, students earn the title *Artist HGK*.

Media art – and the digital option

Media art is a very broad, open, and confusing concept. It only vaguely describes what training, education, and practice is conveyed by this label. Closely associated with it in this context are the three concepts of digitalization, interactivity, and interface.

The digitalization of information allows the greatest possible division of the world into small units. Digitalization makes new forms of interaction and interactivity possible through programming. Digitalization requires a great amount of research on new interfaces that goes far beyond just technical questions.

Media art unites text, image, sound, light, space, time, data, and codes in digital form and digital space. This opens the door to fields of action and realms of reflection, which were neither possible nor conceivable in classical art. The understanding of artworks, the concept of the artist, and the role of art in society are seen in a new light and are fundamentally changed.

Media art seeks out aesthetic and artistic examinations of the possibilities of information, communication, and computer technology. It experiments with these media systems, trying out new languages and dramatologies. It plays with new medial interrelations. A characteristic medium is the computer, which is both a tool and an independent medium at the same time. Works are created that are interactive, multimedial, virtual, and networked.

Digitalization, interactivity, networking, and interface are words that describe the option of a new way of accessing and dealing with the world and with art and artistic work. The purpose of an education in art in the context of this digital option is to research, apply, and reflect on this aspect. Art education helps to make the processes relevant for making artistic content accessible and leads to tangible artifacts of *art works*.

Media art seen in this light is unable to refer to the age-old pictorial tradition. The computer as tool and medium is relatively lacking in history.

Knowledge of the past is indisputably significant. However, a fundamental analysis of the specifics of this new technology is needed. This means that new aesthetic parameters must be defined. This is where theoretical and practical artistic work gains its research impetus. Art work is not research in the classical sense, but still behaves in an investigatory manner. The purpose and goal of an education that would be suitable for our times would be to educate curious, critically inquisitive, competent, disciplined, and socially responsible artists who could contribute to the long-lasting cultural, social, and political development of our society.

Offenburgerstrasse 1
CH-4058 Basel

Phone +41-61 695 68 05
Fax +41-61 695 68 05
www.fhbb.ch/kunst
info.biku.hgk@fhbb.ch

University of Applied Sciences Basel FHBB
School of Art and Design Basel HGK

Department of Visual Art / Media Art

Contrary to designers and scientists, artists are not confronted with tasks and topics in advance. They are their own customers. Their products are not aligned with a clear purpose. Art confuses. It provokes long debates and endless discourses. It produces friction, contradiction, and often expresses its creative potential only while being thought about. Since it must, in order to obtain significance, circumvent expectations and say no to over-hasty affirmations. Art exists within the free play with symbols. For that very reason, it engages in basic research through purpose and unprejudicedness.

The use of media in the arts is closely linked to this situation. Which, when, and how media are being employed is connected to the artistic research project. Media art as it is being imparted in our department, does not commit itself in advance to a particular media, but it is the artistic content which defines the choice of means in the end. In today's art practice, the use of electronic media is a familiar reality. Together with Geneva, our department has, within the Swiss colleges of higher education's landscape, produced a great deal of pioneering work in educating and mediating art with electronic media. In 1985, René Pulfer and Enrique Fontanilles established the first further education class for audio-visual design at the former School of Design Basel, which produced such well-known graduates as Pipilotti Rist, Muda Mathis, Käthe Walser, Renatus Zürcher, and many others. In the course of conversion into the University of Art and Design Basel, in 1999 / 2000, the further education class for audiovisual media was integrated, along with the other media, art, photography, installation, object, performance, experimental film, and interaction, into the course of study Visual Art / Media Art. With reference to the new media (computer, digital image processing, Web art), the new department has reacted to changes in the media situation with related pedagogical subjects in accordance with Philipp Gasser, Reinhard Manz, Reinhard Storz, Jan Lewe Torpus.

Consequently, our department's profile reflects above all today's system of visual art. For quite some time now, art has not simply been understood as a coded system which commits itself to clear formal statements. Today, art makes use of all available media, from technical, simply applicable drawing to the Internet. The open codes which a work of art combines today and which allow it to be interpreted in different directions, actually seem to be an effect of the different media which supersede each other in a work of art. The Mixed Media, practised in today's art, not only produces contacts between media in the sense of interfaces following the montage practice of modern age. In our times, it becomes an amalgamation in the sense of a superseding or fading of media and media techniques along with their conceptualizations and structural characteristics. Theoretical approaches which anchor themselves both within picture and film sciences and in narration theories, investigate how the supposed unambigenity of media changes towards media ambiguity. These theories, being concerned with intermediality, take as a basis a mutual reflection upon media and the arts.

In our department, this fact is being reflected both in the practical and theoretical teaching program as well as in the project-oriented forms of teaching. The Department of Visual Art / Media Art at the University of Art and Design Basel offers students a wide range of practical education and guidance with regard to technical skills. After all, knowledge and mastery of the materials still are prerequisites for an independent artist's career. At the same time, the importance of craftsmanship and technical skills is always aligned with the artistic idea. A specialized range of subjects in the field of video, film, and new media, offered by acknowledged artists and technicians not only impart information about techniques, but also about the theories of their artistic application, materiality, and communication.

Lectures, seminars, and forums for discussion with art and media theorists, cultural and literary specialists, allow students to develop their theoretical knowledge in media and their own reflective skills regarding art and media discourse. A glance into history teaches that responsible inventors of and researchers into pictures add to the cultural treasures of society.

Vogelsangstrasse 15
CH-4058 Basel

Phone +41-61 695 63 47
Fax +41-61 695 63 47
www.fhbb.ch/in3
in3@fhbb.ch

University of Applied Sciences Basel FHBB
School of Art and Design Basel HGK

Department of Interior Design IN3

Staging space (Die Inszenierung des Raumes)

In the "era of simultaneity," the experience of acceleration is also being felt in creative processes. Changes are occurring in increasingly shorter intervals, and information flows are becoming faster. Complex topics require interdisciplinary structuring, and borders between traditional subjects are becoming obsolete. These developments require new methods of teaching and research from colleges. Against this background, HGK offers a new, multi-disciplinary study program with the IN3 course of study. It includes the creative areas of architecture, design, and stage / set design (IN3 = INstitute 3). The focus of education is an examination of space. The spectrum ranges from cityscapes and landscapes all the way to the plastic appearance of furniture in interiors. IN3 provides students with the opportunity to develop their creative potential and communicates the necessary knowledge for applying this in concrete projects. IN3 is not a letterbox company for big names. Instead it stands for project-related studies opening the opportunity for students to put their theoretical skills to the test in actual practice.

Interior designers / set designers as pioneers crossing borders and frontiers

Spatial-set designers operate in the borderlands between architecture, exhibition, performance, installation, and event. The site for their inventions and designs is space. Their task – real and virtual – is to discover, design, construct, and enrich. The professional work of spatial-set designers requires the ability of individuals to work in teams and their willingness to cooperate with specialists from neighboring fields (e.g. film, theater or digital design). Using this multi-faceted know-how and the expected synergy, the work of designers reflects social perceptions and needs, competes with existing value systems, formulates independent artistic-aesthetic statements, and consequently establishes new standards.

IN3 – A Challenge

Education at IN3 is a complex challenge for students. It requires the willingness for personal development and presupposes talent, intu-

ition, and openness to the new. Above-average motivation, which should be expressed in the objectives formulated by students themselves, is one requirement. Another one is the students' involvement in confronting the contents of their studies as they initiate and develop unusual tasks. The ability to work in a team is considered as an essential condition at the institute for coping with complex design tasks.

Modular Educational System

Due to its multi-disciplinary character, the course of studies was designed in modules. This teaching system corresponds best to the great variety of materials. Students must acquire solid basic knowledge in all subjects offered in modular form. They become acquainted with the use and potential of the various tools and techniques at the same time that they acquire the ability to use both in very diverse ways in concrete design processes.

Within the framework of the IN3 course of study, the individual talents of the students are discovered and promoted. The studies support the training of design flexibility and the desire to innovate. To achieve this goal, continual changes of perspective are examined, new factors and changes are confronted, perception is stimulated, and forms of expression and understanding are encouraged. Enthusiasm for bringing the previously unimaginable into reality and for formulating innovative solutions are awakened in this way.

Work Methods of "Learning to See" basic studies (1st & 2nd semester)

The tools for the focal points of "space" and "set design" are worked out in the basic studies, during the first year at the institute. Students develop skills for designing spaces and scenes via the analysis of their own perception of space. A preliminary diploma is awarded at the end of the basic studies.

Conceiving – Shaping – Actual Practice
Main course of studies (3rd – 6th semester)

In the main course of studies, the conception and design of rooms, exhibitions, stage sets, performances, installations, and events is taught. The design of furnishings is always an integral component of these projects, which are worked out until they reach a stage in which they are ready to be implemented. Topic-specific workshops are held in conjunction with the semester projects and complement them. The second year of studies is completed with a second preliminary diploma. The final degree examinations are held at the end of the third year.

IN3-Diplom

As graduates of the IN3 course of studies at the HGK Basel, spatial-set designers are able to cope with complex artistic tasks, to handle the management of artistic aspects of a project, and to work in a team. Experienced in designing and implementing spatial concepts, they can provide a thematic idea with convincing spatial, contextual, and dramaturgic shape. They have a full repertory of techniques and design elements at their disposal, which they acquired during their studies. The technical college degree of "Designer" is awarded upon successful completion of the studies.

Vogelsangstrasse 15

CH-4058 Basel

Phone +41-61 695 67 71

Fax +41-61 695 68 00

www.fhbb.ch/vis_com

vis_com@fhbb.ch

University of Applied Sciences Basel FHBB
School of Art and Design Basel HGK

Department of Visual Communication vis_com

International Focus

The program of HGK Basel's course of Visual Communication: Interactive Media | Imagery | Typography has further developed the Basel School of Design's influential tradition and international focus. The program of studies offers Bachelors and Masters degrees, accepts exchange and guest students, conducts research and fosters development in the realm of design, as well as in third party design services. The school is proud of both a highly motivated international faculty and an equally motivated student body from Europe, North and South America, Japan, and Korea.

From Design Fundamentals to Individual Projects

Today's program of studies continually meets the challenges of technological, economic, and social change. Visual Design competence remains the program's main educational goal. The point of departure for the teaching of fundamentals in each discipline is the solving of clear selective assignments. The gradual expansion or exploration of design issues prepares students for their final individual projects. In these works, students prove their ability to define, formulate, and independently bring to life a significant project in visual communication.

New Technologies and Contemporary Culture

Technicalization and its effects are viewed as important factors in the contemporary development within the field of visual communication. The program of studies keeps pace with this development. Its purpose is to lend technology a humane and emotional form. Access to data, enabling us to utilize digital technology, needs experts capable of developing text and image information from this data to make it accessible and legible to a general public. The visual communication curriculum enables designers to actively participate in the forming of an information society by making specific contributions to contemporary visual culture.

Concept and Context

A globalized economy requires sensitive strategies and concepts for institutions and businesses. A prerequisite for their development is the thorough education of designers. Only those persons in firm grasp of economic, social, ethical, cultural, and intercultural competence are able to successfully fulfill this task. To avoid training designers to become mere skilled laborers, we offer conceptual insight and broadly based contextual knowledge over and above primary design competence.

Program of Studies

The modular education structure of the program of studies takes the above insights into account. Five differentiated educational modules are offered: Theory, Fundamentals, Typography, Semiotics / Imagery, and Interactive Media. A one-day theory program accompanies all six semesters. Each module consists of several offered courses, allowing students to select one area in which they can achieve a high level of design quality and competence without losing sight of the entire spectrum of possibilities within the field of visual communication.

Totentanz 17/18

CH-4051 Basel

Phone +41-61 269 92 21

Fax +41-61 269 92 26

www.hyperwerk.ch

info@hyperwerk.ch

University of Applied Sciences Basel FHBB

Department HyperWerk

Our goals

HyperWerk is a three-year course of graduate studies at the University of Applied Sciences in Basel. The full time study conducts research, applies the insights gained in a team environment, and supports the innovative development of interactive media. HyperWerk opens up interdisciplinary perspectives in the designing of new social realities, while concentrating on the areas of work and education. Interaction managers trained in meeting the demands of organizations that are experiencing change offer future-oriented solution strategies and team processes for physical and intellectual spaces. They therefore assume key functions on the level of project leadership.

Graduates of HyperWerk acquire a broad foundation in specialized knowledge in the transdisciplinary oriented, technologically enhanced, and communicatively organized design, and implementation of interactive processes. The students are also trained in fundamental social, cultural, and media theoretical issues. They learn autodidactic strategies during the course of their study while building up a network of relationships that will support the constant up-dating of their knowledge after they complete their studies.

A diverse team

Besides a good knowledge of the English language, the alternative requirements for acceptance are the following: passing an acceptance exam, obtaining a federally-recognized professional baccalaureate certificate (Berufsmatura), or gaining a federally-recognized professional baccalaureate certificate (Matura) with practical experience. An aptitude test is given for final acceptance. The ability to work in a team is very important to HyperWerk, and so is the mutual, productive complementation of knowledge team members contribute. There is no limit regarding students' age or vocational / academic background, as long as they are motivated, flexible, and resilient. The average age of students starting the program is currently 24 years. The overall age spectrum ranges from 19 to 48 years. The percent of female students is roughly 30 %.

HyperWerk is managed by a five-person team, seven employees in the non-teaching staff, and roughly 40 external lecturers from abroad.

An open structure

HyperWerk is a course of study that is oriented around topics, solutions, and actions. During their studies, students fill their individual semester schedules by choosing from a rich selection of courses. The balanced, individualized acquisition of knowledge in management, technology, and design is pre-requisite for the successful completion of the studies.

Workshops and projects form the basic elements of the studies. Students may also take seminars or courses that explore in-depth the theoretical and practical aspects of topics related to their studies. It is up to the students themselves to design their individual semester programs.

Project work in the course of study

The students' first experience with a project at HyperWerk is gained during the *introductory semester*, in connection with the mandatory participation in a short project. The topic of the project may be chosen from a series of suggestions that are developed by third-semester students. Students may also start participating in group projects (even strategic projects), or may begin developing their own projects. The main focus of project work in the *practical semester* should be on the participation in projects. The active participation in diploma projects is especially recommended as an important experience. In the first three weeks of the *test semester*, the students must develop the foundation for their own short project together with at least one other student in the same year. The short project is then presented to the new students and then supervised by project leaders for a maximum of four weeks. In the third semester, students are required to participate in a strategic project, provided they do not participate in an exchange semester or internship, which are both considered to be ideal for this semester. The practical grade for the preliminary examination (Vordiplom 2) is issued based on a completely independently developed and managed project that was completed in 4 weeks during the *practical semester*. In the *degree preparatory semester*, students may conduct research projects that may be developed into a final degree project for a diploma. The final *degree semester* consists solely of the degree project and the work directly leading up to receiving the diploma.

Studies based on practical experience

The close proximity to the institute HyperStudio eases integration into international research projects. One pre-requisite of each degree project is cooperation with at least one external partner. HyperWerk has several major, long-term oriented, strategic projects that are clearly located in a social context of exchange. A major factor determining our work is intensive cooperative networking with research and educational institutions from abroad.

The supportive framework

HyperWerk is a production found in a baroque villa with a courtyard and green house garden in the heart of Basel. We also have a loft right next door. HyperWerk has a guest apartment for visiting scientists and external lecturers. Our working quarters in the old abbey of Senones, France, is also very attractive and is a two hours drive away from Basel. HyperWerk has a company car available for this purpose.

9, Boulevard Hélvétique

CH-1205 Genève

Phone +41-22 311 05 10

Fax +41-22 310 13 63

www.hesge.ch/esba/

info.esba@etat.ge.ch

Universities of Applied Sciences Geneva HES-GE
School of Fine Arts ESBA

atelier zero1

The ESBA of Geneva offers academic artistic training in all the fields of visual arts, including those technologically oriented. A wide choice of creative practices and intellectual explorations are offered to its three hundred students. The school has gained international recognition through its dynamic opening onto the world, its commitment to re-inventing pedagogical strategies based on free choice, responsibility, and involvement of all.

The ESBA is affiliated to the *haute école spécialisée genevoise HES-GE* (Universities of Applied Sciences Geneva). The diploma its graduates earn is acknowledged nationally by the Swiss Conference of Cantonal Ministers of Education (CDIP). The school also has exchange programs with both the University of Geneva and the Federal Polytechnic School of Lausanne.

The ESBA takes an active part in the SOCRATES program within the European union, to which it is associated through the Central Office of Swiss Universities (OCUS) and the Federal Office of Culture (OFC). The ESBA is also an active member of the European League of Institutes of the Arts (ELIA), the International Association of Film and Television Schools (CILECT), the European Regional Association of Film and Television Schools (GEECT), and the International Association of Independent Art and Design Schools (AIAS).

P.O. Box _____
CH-8031 Zurich _____

Phone +41-1 446 23 53 _____
Fax +41-1 446 23 80 _____
www.snm-hgkz.ch _____
snm.sekretariat@hgkz.ch _____

University of Applied Sciences and Arts Zurich
School of Art and Design Zurich HGKZ

Department
of New Media SNM

Educational Goals

The aim of the Department of New Media is to train students in media authorship. Project-oriented study with an accent on research is meant to provide them with high-level basic qualifications in the broad field of digital culture. The centerpiece of the educational process is comprehension of the computer as a medium and elaboration of its specific qualities and potentialities. In this respect, students work out their own media-specific concepts and themes, and exercise artistic and/or design creativity in conceiving and setting up domains of digital information and interaction – spheres of electronic agency, collaborative environments and connective interfaces.

Students are trained to be able to plan, budget, realize and present independent, collaborative and interdisciplinary digital projects, to methodologically and theoretically reflect upon their artistic and/or design work, and to integrate them in the overall social process.

Course of Study

Basic program lasting 3 semesters / conference – declaration of major / study in major field lasting 4 semesters (including a one-semester internship) / 1 semester degree project.

Prime focus is on individual and teamwork-oriented *project studies*. Specialized *seminars* dealing with *content, design* and *technology* are integrated into these projects. Aside from their project work, students also attend *introductory and advanced courses* on technology as well as *seminars on media and culture theory*.

Curriculum

Basic Program: The basic program of study familiarizes students with the entire spectrum of medial, technical and artistic possibilities inherent in digital culture without any pressure to specialize in a particular area. The objective of training on this level is to give students an overview of the diversity of the media and their interrelationships, which enables them to carry out their first independent work in the form of a thematic project of limited complexity. At the same time, this phase should provide students with a sound basis on which to reach a decision as to a major during their advanced studies.

The three-semester basic program is dedicated to the subjects "Noting and Organizing", "Communicating and Mediating" and "Acting and Processing".

Major Program: The main course of study is highlighted by the conceptualization and execution of complex individual or group-oriented projects. An essential aspect of this is the in-depth cultivation of professional and creative techniques in conception and realization with respect to the major field of study the student has chosen. The media-specific majors currently offered include in-depth studies in "Media Poiesis", "Interface Strategies", "Media Culture Studies" and "Media Economy" as well as multi-disciplinary studies in "Information Design", "Network Technologies" and "Media and Culture Theory".

The SNM is closely affiliated with the HGKZ's Departments of Film, Photography, Theory and Fine Arts, whose classes may also be attended. An interdisciplinary curriculum is currently in the planning stage.

Internship: Students must complete an internship during their main course of study. This semester may be spent attending an art college or a university abroad or working at a government institution or a private firm.

Degree Project: With their Degree Project, students display their capability to work out a complex theme of their own choosing in an interdisciplinary fashion and to realize it in a computer or network mediated way that is appropriate to its content, to theoretically mediate an audience's encounter with it, and to be able to reflect upon its communicative potency and social impact.

Research and Development (R&D)

The focus of R&D activities at the SNM is on the conception, development and design of net-based information and interaction strategies. This work has led to the emergence of specialties in the fields of data and information visualization and management, interaction design (interface and ergonomics) and software development of informational architectures, collaborative working, as well as learning environments (groupware).

The department also regularly integrates advanced students in national and international R&D projects as a way to enable those who wish to work more intensively with the unique possibilities of computers and networks as media to acquire media-specific qualifications that enhance their prospects for future advancement.

Index of exhibits

2Screens	Daniel Brefin, Regula Burri, Simone Fuchs, Andreas Hagenbach, Regula Hurter, Gabriele Rérat / catalog, dvd	50
action sheep	Simon Hänggi / exhibition	
Adaptive Intranets?	Angie S. Born / catalog, webplatform, exhibition	104
Affective Cinema	Jan Torpus / catalog, dvd	53
Air.Terminal	Thomas Bircher / webplatform, exhibition	
allocator	Pascal Arnold, Rodrigo Derteano, Alina Cista, Ronald Widmer / webplatform	
Animation Machine	Dirk Koy / catalog, dvd, webplatform, exhibition	82
ASCII-art	Silvan Leuthold / catalog	146
BarrioCom	Andreas Springer / catalog, webplatform, exhibition	108
Betarhythmica	Anja Kaufmann / catalog, dvd, webplatform, exhibition	97
Bildautomaten	Andres Wanner / catalog, dvd, webplatform, exhibition	78
Call Me	Alex Muller, Filippo Vanini / catalog, exhibition	114
Codepoetry	Andrea Cruz / webplatform	
Conservix	Fabian Thommen / webplatform	
Creative Machine	Christoph Burgdorfer, Nicholas Schärer / webplatform	
deep_sleep	Matthias Branger, Marie Wargnier / exhibition	
deif chair	Christian Schefer / catalog, webplatform	93
Dendron	Sam Sherbini / catalog, exhibition	107
Der Outsider	André Gwerder / webplatform	
don't beat - TALK!	Matt Inauen / catalog, dvd, webplatform	94
dot:in	Benjamin Füglister / catalog, webplatform, exhibition	110
Draussen	Patrick Juchli / catalog, dvd, webplatform	96
Drawing Machine	Roman Schnyder / catalog, dvd, webplatform, exhibition	72
Echo	Martina Loher, Pascal Robert, Fabian Stalder / catalog, exhibition	120
En passant	Ursula Meyer-König, Simone Vogel / catalog, exhibition	32
Enter Propaganda	Michael Huber / catalog, webplatform	98
fax.boot.force	Felix Eggmann, Max Rheiner / webplatform	
Findus	Rachel Bühlmann / catalog, exhibition	27
FlugiFlüg	Stephan Haltiner, Priska Ryffel / catalog, exhibition	30
Follow me / Lighting	Oliver Betschart / catalog	65
FragWerk	Peter Olibet / catalog	102
Future Building	Steffen Blunk / catalog	67
Groupinion	Rafael Freuler, Anja Gilgen, Matthias Käser, Beat Muttenzer, Rodolfo Semprevivo, Andreas Springer / webplatform	

In Bed With Me	Marc Mouci / catalog	52
In search of time	Nathan Aebi / catalog, dvd, webplatform, exhibition	86
Instant Gain in Grace	Dr.Irena Kulka / catalog, dvd, webplatform, exhibition	95
Interacting Squares	Roman Schnyder / catalog, dvd, exhibition	71
Interactive Landscapes	Thomas Bircher / catalog, exhibition	88
Interfaces	Matthias Gerber / catalog	62
JayWalker City Furniture	Daniel Pfister / catalog, webplatform	100
l'étang noir	Clara Borbely, Charlotte Greber, Rebecca Mori, Marc Mouci, Peter Spiellmann, Bruno Steiner / catalog, dvd	50
Lebensraum	Michael Aschwanden / catalog, exhibition	43
Light Object Generator	Dirk Koy / catalog, dvd, webplatform, exhibition	84
Loogie.net TV	Marc Lee / exhibition	
Love Heroes	Felix Eggmann / catalog, exhibition	140
Luxus4all.org	Mario Purkathofer / catalog, webplatform	144
Mahlzeit	Marc Dietrich / catalog, webplatform	99
Megaton	Anja Kaufmann, Constanze Kirmis, Marco Jann, Marc Champion, Denis Grütze, Thomas Bach / webplatform	
More than meets the eye	catalog	111
move	Andres Wanner / catalog, webplatform, exhibition	80
Moveables	Bruno Steiner / catalog, webplatform	49
My own rock and roll show	Benoit Guignat / catalog, dvd, exhibition	131
NETinfo	Armon Ruben / catalog, exhibition	106
Netz_Raum	Patrick Rothmund / catalog	66
NoA	Angie S.Born, Christoph Bütler, Hanspeter Portmann, Armon Ruben, Christian Schumacher, Sam Sherbini / webplatform	
Noisaikk	Roland Roos, Valentina Vuksic / catalog	137
(No) Logo	Steffen Blunk / catalog	60
_okay✓	Manou Vonwiller / catalog, exhibition	36
ONYX. 0+33	Manuel Schmalstieg / catalog, dvd, exhibition	125
play2	Beat Muttenzer, Michel Pfirter, Arne Schöllhorn, Rodolfo Semprevivo / webplatform	
Re:tour	Stefano Vannotti / catalog	142
Renderzone	Hans-Jörg Sauter / catalog	64
SchappeLan	Hanspeter Portmann / catalog, dvd, webplatform, exhibition	101
Scribit	Matthias Käser / catalog, dvd, webplatform, exhibition	105
Sexual Intelligence	dd / webplatform	
Shooting Stars	Oliver Wolf / exhibition	
Slave & Master	Anne-Lea Werlen, Carmen Weisskopf, Christoph Burgdorfer, Cindy Aebischer, Marco Klingmann, Mascha Leummens, Roger Wigger, Thomas Comiotto, Nico Dreher, Andrea del Carmen Cruz Gonzales / catalog, dvd	148
StatementStation	catalog, webplatform	111
Storytool	Kurt Kuene / webplatform	
Technical Flower	Roman Schnyder / catalog, dvd, webplatform	76
The Video Orchestra	Silvia Bergmann, Katja Loher / catalog, dvd, exhibition	54
TinyTin	Alfred Orla, Théo Quiriconi / catalog	117
TraceNoiser.org	Roman Abt, Annina Rüst / webplatform	
Trauma Zone	Stephan Perrinjaquet / catalog, exhibition	122
T-SPLITTER	Ron Lux, Ronald Widmer / webplatform	
V.O.N.S. numériques	Anja Gilgen / catalog, webplatform	109
Visual Programming	Roman Schnyder / catalog, dvd, webplatform, exhibition	74
voice-trans-it	Philippe Lehmann / catalog, dvd, webplatform, exhibition	40
winomat	Glenn Hürzeler / catalog, dvd, exhibition	103

Copyright
Imprint
Acknowledgement

All images and project texts
have been produced by the artists
themselves, unless it is stated
otherwise.

Any other trademark or registered
label not listed here are owned
by their respective owners.

A CIP catalog record for this book is
available from the Library of
Congress, Washington D.C., USA.

Bibliographic information published
by Die Deutsche Bibliothek
Die Deutsche Bibliothek lists this
publication in the Deutsche
Nationalbibliografie; detailed biblio-
graphic data is available in the
Internet at http://dnb.ddb.de.

This work is subject to copyright.
All rights are reserved, whether
the whole or part of the material is
concerned, specifically the
rights of translation, reprinting,
re-use of illustrations, recitation,
broadcasting, reproduction on
microfilms or in other ways, and
storage in data banks. For any
kind of use, permission of the copy-
right owner must be obtained.

© Copyright 2003 by
Association MetaWorx, Totentanz 17,
CH-4051 Basel, Switzerland, and
Birkhäuser – Publishers for Architec-
ture, P.O.Box 133, CH-4010 Basel,
Switzerland

Printed on acid-free paper produced
from chlorine-free pulp. TCF ∞
Printed in Germany

ISBN 3-7643-0089-2

9 8 7 6 5 4 3 2 1

Association MetaWorx Vera Bühlmann, Enrique Fontanilles, René Pulfer, Michael Renner,
Mischa Schaub, Giaco Schiesser, Félix Stampfli, Andreas Wenger

Corporate Design FH Aargau, Department of Design and Art
Livio Dainese, Christian Gehri, Silvio Koeng, Wutaya Nemarat,
Urs Rutschi (students) / Danilo Silvestri, Prof. Félix Stampfli (lecturers)

Catalog Responsibility and organization
Vera Bühlmann, Philipp Stamm
Text editing
Vera Bühlmann, Basel
Lectorship / Proofreading
Klaus Wassermann, St. Gallen,
Iman Makeba Laversuch, D-Freiburg i. Br.
Design concept
HGK Basel, Department of Visual Communication
Dirk Koy / Philipp Stamm (lecturer for typography and type design)
Composition, typographic design, layout
HGK Basel, Department of Visual Communication
feinherb, Visuelle Gestaltung. Basel
Claudia Derteano, Julia Schibler (students) / Heidrun Osterer

DVD ESBA Geneva, atelier zero1
Enrique Fontanilles, Cyrille Kazis

Exhibition interface FH Aargau, Department of Design and Art / Prof. Félix Stampfli
and organization HGK Basel, Department of Interior Design / Prof. Andreas Wenger
FHBB Basel, Department HyperWerk / Mischa Schaub
HGK Zurich, Department of New Media SNM / Aleksandar Četkovič,
Gregor Huber

Webplatform HGK Zurich, Department of New Media SNM
www.metaworx.info Aleksandar Četkovič, Gregor Huber, Monika Wisniewska

MetaWorx – FH Aargau, Design and Art: Prof. Félix Stampfli
representatives of the HGK Basel, Visual Art / Media Art: Sibylle Omlin, Reinhard Storz
departments HGK Basel, IN3: Prof. Andreas Wenger
HGK Basel, vis_com: Prof. Michael Renner, Roman Schnyder
FHBB, Hyperwerk: Mischa Schaub
ESBA Geneva, atelier zero1: Enrique Fontanilles
HGK Zurich, New Media: Prof. Giaco Schiesser, Aleksandar Četkovič

Acknowledgement MetaWorx emerged in cooperation and support by
Dominik Landwehr, Migros Culture Percentage, further supported by
the Lotteriefonds Basel-Landschaft.